The Camera

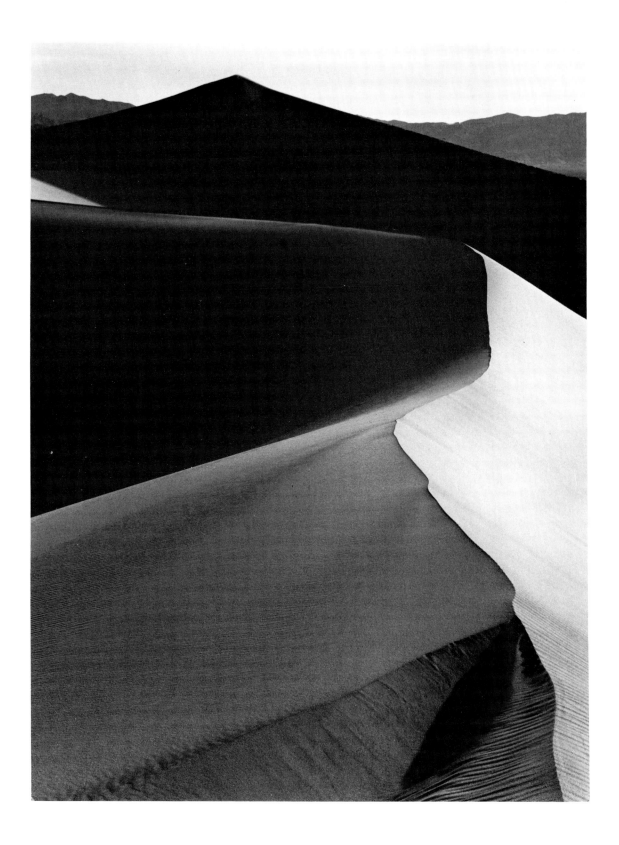

The Camera

Ansel Adams

with the collaboration of Robert Baker

A NEW YORK GRAPHIC SOCIETY BOOK

Little, Brown and Company / Boston

Frontispiece: Sand Dunes, Sunrise, Death Valley National Monument, California, ca. 1948.

Copyright © 1980 by the Trustees of the Ansel Adams Publishing Rights Trust

First edition. This is the first volume of *The New Ansel Adams Photography Series.*

Eighth printing, 1987.

Designed by David Ford
Technical illustrations by Omnigraphics
Printed and bound by Murray Printing Company

Grateful acknowledgement is made to Verve and Simon & Schuster for permission to use the excerpt on page 110 from *The Decisive Moment* by Henri Cartier-Bresson, 1952.

New York Graphic Society books are published by Little, Brown and Company, Inc. Published simultaneously in Canada by Little, Brown and Company (Canada) Limited.

Library of Congress Cataloging in Publication Data

Adams, Ansel Easton, 1902–1984
The camera.

(*His* Ansel Adams photography series; book 1)
 Includes index.
 1. Cameras 2. Lenses, Photographic
I. Baker, Robert 1945- II. Title
TR145.A38 bk.1 [TR250] 770s [770′.28] 80-11402
ISBN 0-8212-1092-0 (Book 1)

Acknowledgments

The friends and associates who have helped me over many years are too numerous to list, but I would like to voice my heartfelt thanks to all.

I would like to express special appreciation to Bob Baker, my associate and editor, for his careful and dedicated assistance. He has provided an important measure of clarity and accuracy without which a work of this kind could not achieve its objectives.

I am also deeply indebted to Jim Alinder for his very valuable reading of the text and captions. My photographic assistants also deserve special thanks: Alan Ross, in particular, made all the negatives of equipment that appear herein, with a single exception by John Sexton, who also made the prints for reproduction. I would also like to thank Andrea Turnage, who kept everything moving with great efficiency, and Victoria Doolittle for her transcribing and typing of the texts.

My associates at New York Graphic Society, especially Floyd Yearout, Janet Swan, and Nan Jernigan, were most cooperative in every respect, and I extend to them my warmest thanks and appreciation.

Most of the equipment that appears in this book was loaned by my friend and longtime supplier, Adolph Gasser of San Francisco. I am also grateful to the following individuals and companies for their assistance with equipment: Art Hall of International Camera Technicians (Mountain View, California), Fred Picker, Berkey Marketing, Calumet Photographic, Hasselblad (and Braun North America), Olden Camera, E. Leitz, Pentax, Polaroid Corporation, Unitron (Sinar), and Vivitar.

And, of course, my warmest appreciation to my readers. This book is addressed to those who study and practice photography, and their comments and suggestions will be most welcome.

<div align="right">A.A.</div>

Contents

Introduction ix

1 Visualization 1

2 Small-Format Cameras 9

3 Medium-Format Cameras 21

4 Large-Format Cameras 29

5 Lenses 43

6 Shutters 79

7 Basic Image Management 95

8 Hand-Held Cameras 109

9 Cameras on Tripods 123

10 View-Camera Adjustments 141

11 Meters and Accessories 163

12 Special-Purpose Equipment and Techniques 179

Appendix 191

Index 197

Introduction

This volume introduces my new series of technical books, The New Ansel Adams Photography Series. The concepts of the original Basic Photo Series which preceded it have been strengthened and clarified, and the information brought up to date in reference to current equipment and processes. More important than the current state of photographic materials, however, is the individual's approach to photography. The concept of *visualization* is the foundation of this and all the projected books of the series. To visualize an image (in whole or in part) is to see it clearly in the mind prior to exposure, a continuous projection from composing the image through the final print. Visualization is more accurately viewed as an attitude toward photography rather than a dogma. It assumes that the photographer has total freedom of expression, and is in no way restricted by my own, or anyone else's, ideas of the art. My intention is to help the reader acquire the tools and attitudes that contribute to creative expression, but not to dictate that creativity.

It seems that one can define all the qualities of a work of art except that essence which is self-evident in the art itself, and which creates a resonance of thought and feeling beyond verbalization. I attempt in these books to suggest the importance of craft and its relation to creativity in photography. As for the creativity itself, I can only assert that it exists; that there is a magical potential that can be demonstrated only by reference to those works that possess it, through all ages, in all media.

If everyone possesses some measure of this intangible quality called creativity, photography is unprecedented as an outlet for its

expression. Yet at times it seems that the very freedom and accessibility of photography are self-defeating. Thoughtful application is often submerged by avaricious automation of equipment and procedure. The challenge to the photographer is to command the medium, to use whatever current equipment and technology furthers his creative objectives, without sacrificing the ability to make his own decisions. The impression prevails that the acquisition of equipment and the following of "rules" assure achievement. Edward Weston's definitive statement, "composition is the strongest way of seeing," should clarify the meaning of visualization and put aside the notion that *any* rules are more than artifice.

It is not my intention to present rules in these books, but guidelines that may serve the student in developing his abilities. It is similarly pointless for the reader to attempt to adopt a style of work from my examples. My work represents *me,* not "photography as it should be." It is much more important that the reader seek an understanding of the potentials of the medium, and let the issues of personal "style" and "creativity" emerge by themselves, as they inevitably will if properly nourished.

It must be said, however, that photography is partly a language, and the practitioner may not have the ability or desire to go beyond the conversation stage. A snapshooter can rely on automation for all he does with a camera, and need make no apologies for the pleasure he derives from his pictures. On the other hand, an amateur (in the original sense of the word, i.e., one who participates for love of the medium) will develop more understanding and ability in proportion to the additional effort he expends. The serious professional or creative photographer needs the maximum of craft and imagination, as well as an acute eye and response. Many progress through several of these stages, beginning with simple observation of the world around them, followed by deeper levels of perception and greater involvement. If I can, through these books, help others learn to see more "strongly" and project themselves in their work, I shall be pleased.

My own evolution in photography followed a rather complex path. I was trained as a pianist, and received my first "serious" camera (a Kodak Speed Graphic 2¼ x 4¼ roll-film camera) about sixty years ago, a gift from an affluent cousin. When I entered photography professionally, about 1930, I found that much of the severe discipline instilled in me in my music education carried over into my new work. I hesitate to imagine what my photographs

might have been without this insistence on excellence from my music teachers.

Joining with friends of similar conviction in 1931–1932, I participated in the formation of Group *f*/64, a visual manifesto of "straight" photography intended to combat the shallow "salon" approach then prevalent. My father, as well as my dear friend and patron Albert Bender of San Francisco, had conveyed to me a sense of responsibility to my audience and to my profession. The philosophy of "pass it on" reflected a considerable degree of social awareness. I felt strongly the obligation to pass on what I had learned, through writing, teaching, and professional activity. I wrote some ponderous critical articles, fought unrealistic jousts with the world, and developed an almost fanatic attitude toward rigorous style and perfection of craft.

I was asked to write an article for the English *Modern Photography* magazine, followed by a request from the publisher to do a book for their How To Do It series, titled *Making A Photograph*. To the surprise of many, including me, this work was quite successful. It contained tipped-in letterpress reproductions that were very fine for the time (1935), and well presented my early technique. I developed the Zone System some years later, during the period when I taught at the Art Center School in Los Angeles. The educational potentials there and at the workshops I conducted in Yosemite Valley stimulated me to begin work in 1945 on the five volumes known as the Basic Photo Series.

Some friends and colleagues have questioned the time I have spent over the years in writing, teaching, and other activities besides photography itself. I find, however, that such work keeps me in touch with the world; it would be quite impossible for me to live in a shrine dedicated only to my creativity. I have also undertaken much work of the "nuts and bolts" variety of photographic assignment. Some shudder at the thought of soiling their delicate perceptions with such "materialistic rubbish," but I honestly found that this work taught me much, not only practical craft, but the application of whatever degree of imagination the character of the work would permit. So it is with my other activities besides photography *per se*, including writing this new series; as each depends on my photography, each also has contributed to it.

The present volume is the first fully revised edition of Book 1 of the Basic Photo Series, although a partial revision appeared in 1970. Complete revisions of the other books in the series are in prepara-

tion. A reader familiar with the old books will find this new series different in a number of respects, yet dedicated to the same principles of craft and creativity. In preparing it, I have worked closely with a full-time editorial associate for the first time, and Robert Baker deserves much credit for his many valuable contributions to the work. We have changed the organization of material in the series: In this volume, the reader will find expanded sections on certain cameras and equipment and on the processes of visualization and image management; at the same time, the information on the darkroom contained in my earlier Book 1 will be found in later volumes of this new series. Within this revised structure, we have re-written the text entirely, both because of new developments during recent years and to present newly organized, fully developed descriptions of the equipment, procedures, and concepts of contemporary photography. Our intention has been to make the material more accessible both for continuous reading and for reference, and, perhaps, to remove a certain amount of the mystery from photography. We have used cross-references and references to illustrations to help the reader understand complex issues. These references appear in the margin with a triangle (◁) in the text indicating the specific subject of the reference.

I have also wanted to bring added emphasis to the idea of visualization. In this first volume I have limited the discussion of visualization to *image management,* a term that has been used occasionally in the past to relate to the entire scope of photography. I find it a useful term to refer specifically to the optical image formed by the lens, and the controls available to define and shape that image. Used in this sense, image management is independent of the film, exposure, and processing considerations (including the Zone System), issues that will be taken up in Books 2 and 3 of this series.

We shall also discuss herein the basic types of equipment, but I find it difficult (if not dangerous) to give recommendations regarding specific cameras and materials. I would therefore like to make it clear that mention of particular equipment does not imply inferiority of other products. The quality of most photographic apparatus today is very high, especially among the lenses, and any recommendations I might make would have little meaning given the rapid rate at which equipment evolves in our time.

I shall try, instead, to convey some understanding of the nature of various camera designs and their capabilities, in the hope that the photographer will consider these discussions in the context of

his or her individual intentions and style. I urge, again, avoiding the common illusion that creative work depends on equipment alone; it is easy to confuse the hope for accomplishment with the desire to possess superior instruments. It is nonetheless true that quality is an important criterion in evaluating camera equipment, as are durability and function. Inferior equipment will prove to be a false economy in the long run. As his work evolves, the photographer should plan to alter and refine his equipment to meet changing requirements.

Ideally, the photographer will choose basic equipment of adequate quality, with nothing that is inessential. It is certainly preferable to work from simple equipment up, as needs dictate, than to "overbuy" equipment at first. Starting with basic equipment allows the photographer to develop a full understanding of the capabilities of each unit before advancing to other instruments. We will follow this approach in discussing camera types, working from those that offer the greatest operational simplicity, the small-format cameras, to the view camera, which requires more sophistication of the operator, but offers limitless possibilities for creative control.

The world does not need more books on equipment. It is my intention in this book to stir excitement for photography and its craft in terms of personal expression. Too many people merely do what they are told to do. The greatest satisfaction derives from the realization of your individual potential, perceiving something in your own way and expressing it through adequate understanding of your tools. Take advantage of everything; be dominated by nothing except your own convictions. Do not lose sight of the essential importance of *craft*; every worthwhile human endeavor depends on the highest levels of concentration and mastery of basic tools.

The next time you pick up a camera think of it not as an inflexible and automatic robot, but as a flexible instrument which you must understand to properly use. An electronic and optical miracle creates nothing on its own! Whatever beauty and excitement it can represent exist in your mind and spirit to begin with.

Ansel Adams
Carmel, California
January 1980

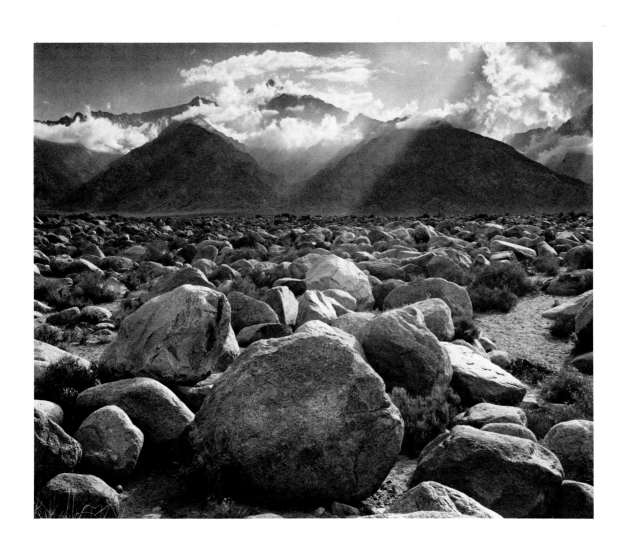

Chapter 1 **Visualization**

The term *visualization* refers to the entire emotional-mental process of creating a photograph, and as such, it is one of the most important concepts in photography. It includes the ability to anticipate a finished image before making the exposure, so that the procedures employed will contribute to achieving the desired result. This much of the creative process can be practiced and learned; beyond lies the domain of personal vision and insight, the creative "eye" of the individual, which cannot be taught, only recognized and encouraged.

Photography involves a series of related mechanical, optical, and chemical processes which lie between the subject and the photograph of it. Each separate step of the process takes us one stage further away from the subject and closer to the photographic print. Even the most realistic photograph is not the same as the subject, but separated from it by the various influences of the photographic system. The photographer may choose to emphasize or minimize these "departures from reality," but he cannot eliminate them.

The process begins with the camera/lens/shutter system, which "sees" in a way analogous, but not identical, to that of the human eye. The camera, for example, does not concentrate on the center of its field of view as the eye does, but sees everything within its field with about equal clarity. The eye scans the subject to take it all in, while the camera (usually) records it whole and fixed. Then there is the film, which has a range of sensitivity that is only a fraction of the eye's. Later steps, development, printing, etc., contribute their own specific characteristics to the final photographic image.

If we understand the ways in which each stage of the process will

Figure 1–1. *Mount Williamson, from Manzanar, California.* I made this photograph from a platform on top of my car, using a 19-inch lens on 8x10 film. The camera was pointed slightly down, and the elevated camera position provided a greater overlook of the foreground than would have been possible from ground level.

shape the final image, we have numerous opportunities to creatively control the final result. If we fail to comprehend the medium, or relinquish our control to automation of one kind or another, we allow the system to dictate the results instead of controlling them to our own purposes. The term *automation* is taken here in its broadest sense, to include not only automatic cameras, but any process we carry out automatically, including mindless adherence to manufacturers' recommendations in such matters as film speed rating or processing of film. All such recommendations are based on an average of diverse conditions, and can be expected to give only adequate results under "average" circumstances; they seldom yield optimum results, and then only by chance. If our standards are higher than the average, we must control the process and use it creatively.

As we develop a deeper understanding of the controls available, we can go a step further and begin "applying" them mentally before making an exposure. Knowing the effects of the various stages of the process, we can attempt to see the subject as it will appear in the final print, as transformed by camera, film, and development controls. We can visualize several different interpretations of a single subject, and then carry to completion the one closest to our subjective, "artistic" intentions. Obviously, the more refined this ability becomes, the more subtle and precise the results will be. This is visualization at its most creative and effective.

An initial difficulty faced by most photographers is viewing a full-color subject and "seeing" it as a print in values of gray. Learning this ability takes time, but there are several techniques that can help. Whenever possible, return to the subject with a photograph of it and study the two together. An excellent way to practice is to use Polaroid black-and-white film, so that a print can be seen immediately while still viewing the subject. It will also be helpful to make deliberate overexposures and underexposures, to see how the values of each part of the subject change. (Polaroid films, however, do not have the same scale of values as conventional print materials, and so should be considered an approximation of the final result in conventional terms; the Polaroid images can be beautiful in themselves.) I recommend using a Wratten #90 viewing filter, which eliminates most color considerations when viewing the scene and gives the impression of the gray values that obtain with unfiltered panchromatic film.

The other major obstacle for the beginner, learning to visualize the three-dimensional world as it is recorded in the two dimensions

of a photograph, is closer to the subject of this volume (controlling image values will be discussed in Book 2). The camera imparts its own level of abstraction ("departure from reality" as we see it with our eyes) to the photograph, lending qualities of shape and scale, for example, that frequently differ from our visual perception. I use the term *image management* to refer to the considerations and controls that affect the optical image, as seen on the ground glass or viewfinder and projected on the film. By fully understanding the characteristics of the camera and lens, we can learn to visualize the optical image. In later chapters I will mention some techniques, such as using a viewing "frame," that will help in learning this aspect of visualization.

I do not want to make the process of visualization sound unduly difficult or arcane. Some photographers, in fact, possess intuitively an ability to visualize, although they may not think about it consciously or employ such a term. For others it requires some effort; however, it is possible that anyone who practices photography diligently for many years will eventually arrive at an understanding of the process and materials similar to that achieved through the visualization concept. It is my hope that, by discussing the techniques and craft of photography, and the thought processes involved in their application, I may be able to help some photographers fully comprehend the medium in a shorter time, and with much less frustration, than is offered by the trial-and-error approach.

There is no question that a 4x5 or 8x10 view camera calls for a different kind of "seeing" than a hand-held 35mm camera. Ideally, a photographer develops a personal style and works with a camera format that complements it. But a photographer who uses several camera types will often find that his very perception changes when he is carrying a small camera instead of a large one, and vice versa. Knowing the characteristics of each camera type can help us appreciate its advantages, while coping successfully with its drawbacks. To fully encompass the functions of the camera, we will begin with the simplest.

THE PINHOLE CAMERA

An elementary camera can be made by locating a pinhole at one end of a light-tight box and a sheet of light-sensitive material at the

Figure 1–2. *Pinhole forming an image.* Light is reflected in all directions from each part of the subject. For each subject point, however, the pinhole restricts the light falling on the film to a small area, producing an image-circle of that point. These overlapping image-circles cumulatively form the total image.

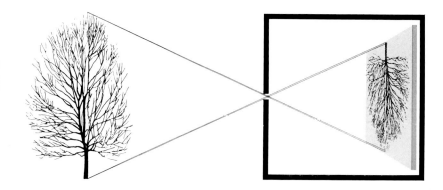

Figure 1–3. *City Hall, Monterey, California.* (A) Photographed with a 1/64-inch pinhole. Note that the foreground is rendered with the same definition as the distant objects, a characteristic of pinhole images.

(B) Photographed with a 1/100-inch pinhole. The loss of sharpness with the smaller pinhole is caused by diffraction.

A

B

See Figure 1–2

other end. The pinhole projects an image onto the film,◁ although it is not a satisfactory image for most photographic purposes. If we add some means of covering the hole to limit the exposure time (the equivalent of a shutter), and a device for aiming at the subject (a viewfinder), we will have the essential elements of a true camera.

Light from any single point of the subject passes through the pinhole and falls only at one location on the film. As shown in Figure 1–2, the image of each point of the subject is not a true point, but a small circle or disc. The complete image is made up of these overlapping circles falling on the film from all the points of the subject. The pinhole does not "focus" the light, and the image is never truly sharp.

The sharpness can be increased somewhat by reducing the size of the pinhole, since each image-circle then becomes smaller. There is, however, a certain minimum size beyond which further reduction of the pinhole produces a loss of sharpness because of dif-

See page 74

See page 46

See page 44

See Figure 1–4

See page 48

Figure 1–4. *City Hall, Monterey, California.* (A) This image was made with a pinhole located 6 inches from the film.

(B) Replacing the pinhole with a 6-inch lens yields a photograph of the same subject area. The overall sharpness is considerably better, and the exposure time required is much shorter. Both images are the same in their geometry and perspective, if the lens aperture is positioned in the same plane as the pinhole.

fraction.◁ Using a very small pinhole aggravates another major problem with pinhole photography, the very low brightness level of the image. Since sharpness is usually the primary concern with pinhole cameras, it is best to use a rather small hole (about 1/64 inch in diameter) and anticipate long exposure times because of the weak image. If the pinhole is located 10 inches from the film and is 1/64 inch in diameter, its equivalent f-stop number◁ would be about f/640, a very small aperture (passing about 1,500 times less light than a setting of f/16!).

Since the pinhole does not focus the light, the distance to the film is not critical in affecting image sharpness, as it is with a conventional lens, and there is no need to "focus" a pinhole camera. The primary effect of altering the pinhole-to-film distance is to change the area of the subject covered on the film and thus the size of the image. Moving the film closer to the pinhole will produce an image of a wider subject area (at the same time the image will become both brighter and somewhat sharper as the image-circles become smaller). Moving the film away from the pinhole gives a narrow-angle view of the subject, comparable to changing to a lens of longer focal length.◁ Another result of the fact that the light is not focused is that all parts of the subject are about equally sharp;◁ the depth of field◁ is virtually unlimited.

The pinhole image has its own aesthetic which is worthy of consideration. For those who wish to experiment with pinhole photography, a few suggestions will be helpful. To obtain optimum results it is important that the pinhole be smooth, and drilled in a *very thin* material. A card or piece of metal even 1/64-inch thick

A

B

Figure 1–5. *Pinhole assembly.* The pinhole is bored in very thin gold foil, and the foil mounted behind a small hole in the disc, which screws into the standard lens threads of the shutter. For viewing, I remove the pinhole and set the diaphragm at its smallest aperture; the resulting image is much brighter than the pinhole image, though less sharp. It is sharp enough, however, for composing the picture.

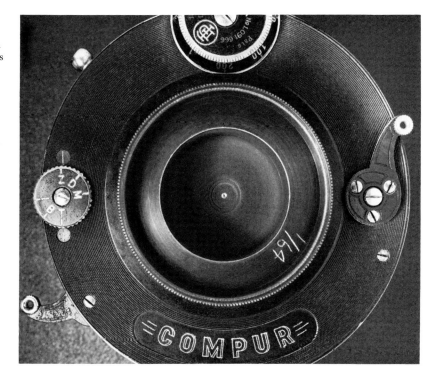

will cause vignetting of the image. The ideal material for the pinhole is thin gold leaf, which can then be attached to a larger supporting aperture; for basic experiments, ordinary aluminum foil will produce a workable pinhole. I have a set of metal pinholes that have been carefully routed out on a precise lathe to a thickness of about 1/200 inch. The holes thus have very smooth edges and are precisely circular. These pinholes are then mounted in a shutter for convenient exposures at time or bulb settings.

You can compose the image with a lens of any focal length, provided you then locate the pinhole at the plane of the lens's aperture. Or you can use the diaphragm of the shutter (without lenses), stopped down to its smallest aperture, to form its own "pinhole" image for composing. This image will be brighter than the pinhole image and rather fuzzy, but good for *approximate* viewing.

THE BASIC CAMERA

Substituting a lens for the pinhole cures two major problems at once. The lens has a very much larger area than the pinhole, and

Figure 1–6. *The elements of a camera.* The components common to all cameras include:

(A) The lens. Like the image from a pinhole, the image formed by the lens is inverted on the film.

(B) The film plane. The film must be held flat at exactly the right distance behind the lens for precise focus. If roll film is used, the camera will contain a film advance mechanism. Sheet films or film packs are inserted in the appropriate holders, which are then inserted in the camera back.

(C) Focus mechanism. By moving the lens closer to or farther from the film, focus can be obtained at different subject distances.

(D) The diaphragm. The photographer adjusts the diaphragm to control the amount of light admitted by the lens, in effect reducing the diameter of the lens.

(E) The shutter. Used in conjunction with the diaphragm, the shutter controls the amount of time light is admitted to the film.

(F) The viewfinder. A viewfinder or other viewing system is required to indicate to the photographer what area will be shown in the final picture.

These components are housed in or on the camera body, a light-tight supporting structure.

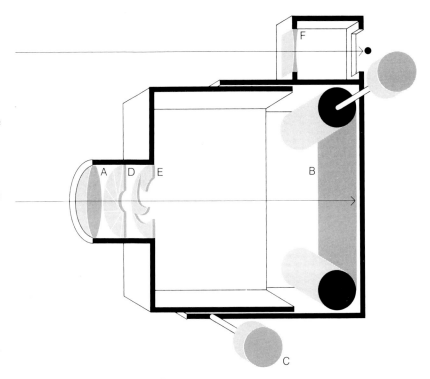

See page 74

See page 48

See Chapter 6

thus the image is many times brighter, with correspondingly shorter exposures. Because of its property of focusing the light from the subject, the lens also makes possible a much sharper image. A single-element lens of the type shown in Figure 1–6 is only partially successful in producing a sharp image on the film because of inherent aberrations.◁ Thus all cameras except the most basic use compound lenses, in which the aberrations can be corrected to a far greater degree than with a single-element lens. A lens also requires a mechanism for focusing on subjects at different distances.◁

With a pinhole, a simple cap (or even a piece of tape) suffices for opening and covering the pinhole to control exposure times. With the much shorter exposures encountered with a lens, however, a shutter is required to provide accurate exposures of fractions of a second. In a basic camera, the shutter may be only a simple spring and lever arrangement with a single setting. More advanced shutters are highly complex, and allow precise control of the exposure time over a range of, typically, one second to 1/500 second, or more.◁

The next major component added to the camera is a means of controlling the intensity of light reaching the film, called the dia-

See page 46

phragm. This mechanism allows us to reduce the effective diameter of the lens (the aperture), thus reducing the amount of light that strikes the film. The aperture is carefully calibrated (in f-stops) to provide known exposure changes.◁

The addition of an accurate viewfinder and other refinements completes the basic "box" camera, from which have evolved the entire array of modern cameras. The degree of sophistication in modern camera design is such that we must consider the basic camera formats separately to fully describe the mechanical and subjective characteristics of each.

*The ◁ pointer is used throughout to indicate a cross reference. Page number is given in the margin.

Chapter 2 # Small-Format Cameras

The modern small camera can function as an extension of the eye in "reaching out" into the world. The flow of life, the rapidly changing relationships of objects and realities, seem to come into an embrace with the photographer's eye and imagination. This view of the world is far more fluent than is possible with a view camera. Yet it is this very fluency that is the greatest challenge of small-format photography, for the photographer is called upon to assess the moving elements of a scene and integrate them into an effective still photograph in fractions of a second.

Figure 2–1. *Georgia O'Keeffe and Orville Cox, Canyon de Chelly, Arizona.* I used a 35mm Zeiss Contax and 50mm lens to make this photograph. I was standing precariously on a slanting ledge and did not control the horizontal tilt of the camera. A conversation was in progress, and I waited for a moment of peak interest; the 35mm camera is ideal for such photographs. It is interesting to note that, although this photograph was made over forty years ago (in 1937) with the old thick emulsion film, it enlarges well and has excellent tonal qualities.

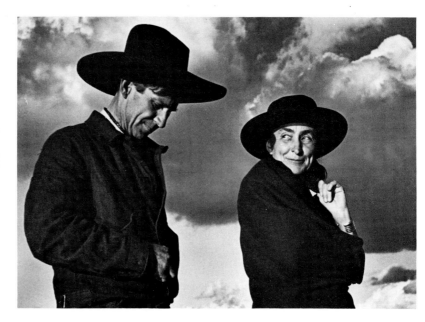

The increasing degree of automation found in small cameras can serve as an aid in this process, since it permits greater concentration on subject and less on mechanics. But with some cameras, it is difficult to impose manual control even if you want to. The "average" photographer is expected to be content with the relatively high percentage of acceptable exposures achieved on a purely automatic basis. I firmly believe, however, that there is no avoiding the need to master the equipment and processes if you hope to create intense images that are consistently above the average. In selecting a camera, you should be fully aware of its capabilities, including the advantages and limitations of automation, but I certainly recommend avoiding those that do not allow you to overrule the automatic functions when the circumstances warrant.

35mm CAMERA TYPES

The 35mm camera produces an image of 24x36 mm (about 1x1½ inches). The film is contained in a cassette, usually allowing 20 to 36 exposures per roll. The cameras are specifically designed for ease and speed of operation; in most cases they incorporate a lever for rapid film advance and shutter cocking, and controls so placed as to be easily operated while the photographer is viewing through the camera.

The two types of 35mm camera differ primarily in their means of viewing the subject. *Viewfinder cameras* are those that have a viewing system completely separate from the picture-making lens system. These cameras, except the most basic, include a *rangefinder,* an optical system for focusing the lens on the principal subject.

Single-lens reflex cameras permit viewing the subject through the same lens that is used to make the picture, so the image the photographer sees is precisely the one recorded on film.◁

See page 15

See Chapter 6

Nearly all 35mm cameras use a focal-plane shutter,◁ which is located just in front of the film. This design is independent of the lens, and permits interchanging lenses without affecting the shutter operation. The lenses are attached to the camera using a threaded flange or a "bayonet" system; the latter is quicker to operate, and therefore preferred by most photographers.

Viewfinder Cameras

The most basic viewfinder cameras have only a simple optical system to allow the photographer to see the approximate picture area. There may be no provision for focusing, or a simple scale for setting the estimated distance to the subject. The lens that makes the image on film is entirely separate from the viewing system, which is always "in focus."

More sophisticated cameras include a rangefinder, a separate optical system coupled to the lens focus setting. The rangefinder forms two separate images of the subject from two positions on the camera,◁ and is linked to the focus setting in such a way that, when the two images of a subject coincide in the viewfinder, the lens is focused. With many early 35mm cameras, the rangefinder was separate from the viewfinder. The photographer looked through one eyepiece for focusing and a separate one for viewing and composing. With current cameras, the rangefinder image is superimposed within the viewfinder image.

As with all camera designs, there are favorable and unfavorable aspects of the viewfinder/rangefinder camera type. Such cameras are usually very compact and quiet to operate, since there is no moving mirror or prism of the kind needed for single-lens reflex cameras. The viewing image is usually bright, making precise focusing easy even in dim light situations or with "slow" lenses.◁ In low-light conditions it is also easier to focus a wide-angle lens with a rangefinder than with a single-lens reflex camera, since the focus is relatively uncritical and hard to see with a reflex system,

See Figure 2–3

See Chapter 5

Figure 2–2. *35mm rangefinder camera.*

Figure 2–3. *Rangefinder optical system*. The viewfinder image, seen through the window at the left end of the camera, includes a small superimposed rangefinder area controlled by the prism at the right. The prism is coupled with the lens focus setting and rotates in such a way that the image it forms comes into alignment with the primary viewing image when the focus is correct. The structure may differ with different makes, but the principle remains the same. The greater the distance between the rangefinder windows (sometimes referred to as the rangefinder base length), the more accurate the system is likely to be.

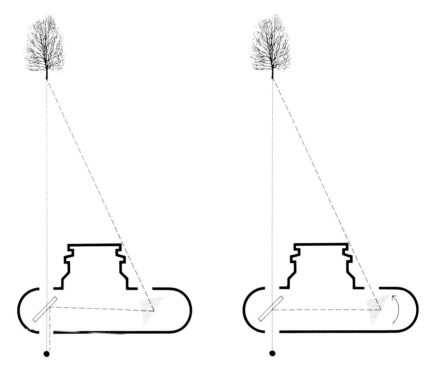

Figure 2–4. *View through a rangefinder camera*. When the two superimposed images are aligned, as in the drawing at right, the focus is correct.

even one employing a split-image focusing aid. Viewfinder cameras also permit continuous viewing of the subject, without the viewfinder "black-out" that occurs with a single-lens reflex when the mirror swings up to pass the light to the film.

The primary drawbacks of viewfinder cameras relate to the fact that the viewing image is entirely separate from the picture-making image. The viewfinder gives very little information about the image except to indicate the approximate borders of the picture area; it is usually very difficult to "read" precisely the corners and edges of

Figure 2–5. *Parallax*. Parallax is caused by the difference in position of the viewing lens and the picture-making lens. One result can be incorrect framing of the image, although most rangefinder systems have a built-in field compensator to correct the framing. The other problem, one that cannot be corrected by the field compensator, is the difference in position of a nearby object seen against a more distant one. Only moving the camera lens to the finder-lens position before exposure will correct this difference. In addition, viewing the subject from a position away from the camera can produce a large amount of parallax. We should compose our images from as close to the lens axis as possible. Single-lens reflex and view cameras do not have parallax problems. The Hasselblad Super-Wide camera provides a clear illustration of parallax similar to that encountered with 35mm rangefinder cameras.

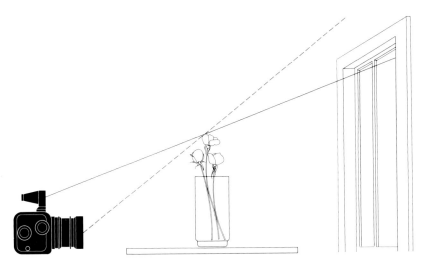

See Figure 2–5

the viewing area. With some cameras I have been aware of very inaccurate indications of the image area.

The greatest single problem with this design is *parallax*. Parallax occurs because the viewfinder lens and the picture-making lens occupy different positions, sometimes separated by several inches, and thus they do not "see" precisely the same image. Most rangefinder cameras have built-in field compensation (often erroneously called parallax correction), which adjusts the *framing* of the image area of the viewfinder when the camera is focused at short distances. This compensation, however, does not take into account the relationship of nearby objects seen against more distant ones. It is impossible for the viewfinder lens to see these relationships in precisely the same way as the camera lens, since they are separated by one or more inches.◁

When precise juxtaposition of two objects at different distances is desired, the camera must be moved, after composing the image in the viewfinder, to bring the camera lens into the same position during exposure that the viewfinder lens occupied during composing. If the front viewfinder element is directly above the lens, for example, the camera must be raised before exposing by an amount equal to the distance from the center of the camera lens to the center of the viewfinder lens. If the viewfinder has the automatic framing adjustment mentioned above, the picture should be composed with focus set at infinity, and the parallax managed by moving the lens to the position of the finder objective prior to exposure.

High-quality viewfinder cameras, such as the Leica, can be equipped for interchanging lenses, each lens having a ground rear

Figure 2–6. *Alfred Stieglitz, New York (c. 1940)*. I used a 35mm Zeiss Contax II and 50mm Tessar lens. The exposure was about 1/10 second, hand-held, in the available gallery light, chiefly window illumination.

flange that mates with the rangefinder system. The viewfinder contains separate frames which come into position to indicate the image area of the lens in use, usually for the 35mm, 50mm, and 90mm lenses; or 50mm, 90mm, and 135mm lenses. At the longest focal length the viewing area becomes quite small, and accurate composition may be especially difficult. For very short or very long focal lengths, an accessory viewing system may be necessary, while the camera's viewfinder window is used only for rangefinder focusing. In such situations it may be preferable to change to a single-lens reflex camera, since the full viewing area is used regardless of focal length.

In spite of these limitations, there have been a number of very high quality viewfinder cameras made in the 35mm format. The Leica, or discontinued Canon and Nikon viewfinder models, for example, are frequently available as used equipment at moderate prices.

See page 16

Care must be taken with rangefinder cameras to be sure that the focusing mechanism of all interchangeable lenses matches the rangefinder of the camera in use. The interchangeable lenses made for viewfinder cameras are usually lighter and more compact than those for single-lens reflex models, since the latter include an automatic diaphragm.◁ *Note:* The camera should not be allowed to point toward the sun for long periods, since the lens can focus the sun on the shutter curtain, causing damage from heat. It is wise, with any camera, to replace the lens cap when the camera is not being used.

Single-Lens Reflex Cameras

The single-lens reflex design now overwhelmingly dominates among high-quality 35mm cameras for a number of reasons. The greatest single advantage of this design is that it allows the photographer to see the image formed by the camera lens itself. Thus parallax is eliminated, and the photographer can check visually the approximate depth of field◁ and the effect of changing lenses or using a bellows, polarizer, or other accessory. The viewing image is "full frame" in the viewfinder whatever lens is used, and has a direct, tangible quality not found with a viewfinder system. (There are some cameras where the viewing image is about 10 percent smaller than the image on film. I suggest checking carefully to determine whether the full image area is represented.)

See page 48

Figure 2–7. *35mm single-lens reflex camera.*

See Figure 2–8

Viewing through the lens is made possible by locating a mirror in the path of light transmitted by the lens, so that the image is diverted to a focusing screen at the top of the camera.◁ This ground-glass image is viewed by the photographer through an optical system that usually includes a prism (roof pentaprism), which provides viewing directly along the line of sight to the subject, and corrects the orientation of the image (the image seen on the ground glass without the prism is reversed left-to-right). When the shutter release is pressed, the mirror swings out of the way and a shutter, usually of the focal-plane variety,◁ operates to expose the film. In all current cameras, the mirror then returns immediately to the viewing position, so there is only a brief black-out period during the time of exposure, when no image can be seen in the viewfinder.

See page 83

See page 46

Viewing and focusing are facilitated by the use of an automatic diaphragm, which remains at the largest aperture◁ for viewing but closes down to the aperture set by the photographer just before the shutter opens. This system provides the brightest possible image for viewing and focusing. (The actual brightness is determined by the efficiency of the viewfinder optics and the maximum aperture of the lens employed.) Viewing with the lens at maximum aperture further enhances the accuracy of focusing because the focus setting is most critical when the lens is at its largest aperture; the image is seen to come into focus more clearly and decisively than at a smaller aperture. Most cameras are equipped with a lever that allows the lens to be manually stopped down to the picture-making aperture for a visual check of the approximate depth of field.◁

See page 48

Figure 2–8. *Single-lens reflex optical system.* The mirror, located in front of the film, deflects light entering through the lens upward to a focusing screen. This image is then reflected through a prism to the eye for viewing. Most modern single-lens reflex cameras employ a pentaprism to give an upright and rectified viewing image. When the shutter release is pressed, the mirror swings up against the viewing screen and light passes to the film for exposure, controlled by a shutter located just in front of the film plane.

See Figure 2–9

Various focusing aids can be incorporated in the viewing screen; usually a split-image device is set in the center of the field. A straight line in the subject passing through this area will appear broken or split if the lens is not focused on it, and the line becomes continuous when the focus is correct.◁ "Microprisms" are another common aid: these exaggerate the visual effect of slight focusing errors to help the photographer see clearly when he has achieved correct focus. Other viewfinder screens are intended for special applications, such as a rectangular grid pattern useful with architectural or other rectilinear subjects, or screens for photomacrography. In some cases a change of screen may be required when using very long lenses.

The great popularity of single-lens reflex design is due to the fact that the photographer sees the precise composition of the image, regardless of the focal length of the lens, or the use of polarizers, close-up systems, or other attachments. For this reason, single-lens reflex cameras can be used with zoom lenses, telescopes, microscopes, and other optical systems.

The drawbacks of this design are comparatively minor, and relate to the presence of the mirror in the viewing system. The need for a mirror adds mechanical complexity, vibration, and noise, and causes the black-out of the viewing image already mentioned.

In recent years, increasing emphasis has been placed on compactness of camera design. Since smaller size is usually achieved at the expense of operational features, the photographer usually must choose, according to personal preference, the best balance between compactness and light weight, and camera capabilities. The feel

of a camera in the hand and the accessibility of controls must be taken into account.

Current cameras are also designed as modular "systems," often with a great number of interchangeable components. The photographer who intends to add to his equipment gradually must be especially careful in his initial choice of camera line, viewing the decision as the first step in a long-term acquisition. In addition to lenses, the camera system is likely to include a variety of viewing screens and prisms, bellows, and, frequently, motor drives. The motor drive permits rapid sequences of exposures, up to five frames per second, or simply advances the film rapidly after each exposure. Smaller versions of the motor drive, called auto-winders, permit exposures at about two frames per second, or automatic film advance for individual exposures. Some cameras can be fitted with large magazines holding hundreds of exposures, a useful accessory with the motor drive.

AUTOMATIC EXPOSURE SYSTEMS

Although they must be judiciously employed for optimum results, the automatic exposure systems that are increasingly a part of camera design do offer advantages in situations where quick camera operation is important. Most such exposure systems measure the light transmitted by the lens itself, so they always read all or a specified part of the area covered by the lens in use.

The terms *averaging, center weighted,* and *spot reading* are used to describe the nature of the exposure reading. As its name implies, an averaging system reads the entire image area and averages the values. A center-weighted system makes the exposure determination primarily according to the light values in the central portion of the picture area, with lesser influence by peripheral areas. The assumption is that the most important subject areas are usually in the central portion of the viewfinder (a questionable assumption from my point of view). A spot-reading system measures only a small central portion of the image area, usually indicated as a small circle on the focusing screen.

With a basic metering system, the photographer adjusts shutter speed and aperture until a needle or array of lights (LED's) in the

Figure 2–9. *View through single-lens reflex camera.* The viewing field shows exactly the image that will be photographed when the shutter release is pressed. The split-image circle at the center of the field functions like the superimposed image of a rangefinder: when focus is correct a straight line passing through the field will be unbroken.

viewfinder indicates correct exposure. An automated camera will set one of these functions unassisted once the photographer has pre-set the other. These systems are designated "shutter speed priority" or "aperture priority" to indicate which control the photographer adjusts, and there are arguments in favor of each approach. With shutter speed priority, which some photographers find more convenient, the camera automatically sets the diaphragm located in the lens assembly; thus only lenses that are specifically matched to the camera's automatic controls can be used. With aperture priority, a wider selection of lenses is usually available, since the automation of the shutter remains intact despite lens changes.

In either case the photographer must monitor the indicated setting that will be made by the camera to be sure it is appropriate for his subject. Depending on the aperture chosen, for example, the exposure system may choose a shutter speed that is too slow for a moving subject. There is almost always an indicator to show the approximate value of the automated setting, and the photographer in this case must choose a larger aperture to permit a shorter exposure time. A few cameras have a "program" that allows the camera to set *both* the aperture and shutter speed, and some cameras give the photographer a choice of several metering modes.

I want to emphasize that excessive reliance on automation can lead to incorrect exposures as well as correct ones. Conditions such as strong back- or side-lighting, or contrast that differs from "average," can mislead any of the exposure systems described. Most cameras permit manually increasing or decreasing the exposure over a total range of two to four f-stops, and I strongly recommend that you avoid any camera without such a provision. I once experimented with a very fine camera of leading make that had a built-in spot reading exposure system of remarkable accuracy—I checked it carefully with a fine photometer. Nowhere in the instructions, however, was it explained that reading a dark or light area of the subject within the central-spot area could produce incorrect overall exposure (exposure determination will be fully discussed in Book 2 of this series). The fact that essential information needed to use the automatic exposure system intelligently was not presented in the instructions led, I am sure, to many poor exposures in spite of the very high quality of the exposure system itself. Unfortunately, many current instruction manuals are equally unclear. However sophisticated and accurate they may be, automated cameras cannot replace creative sensibility and understanding in photography.

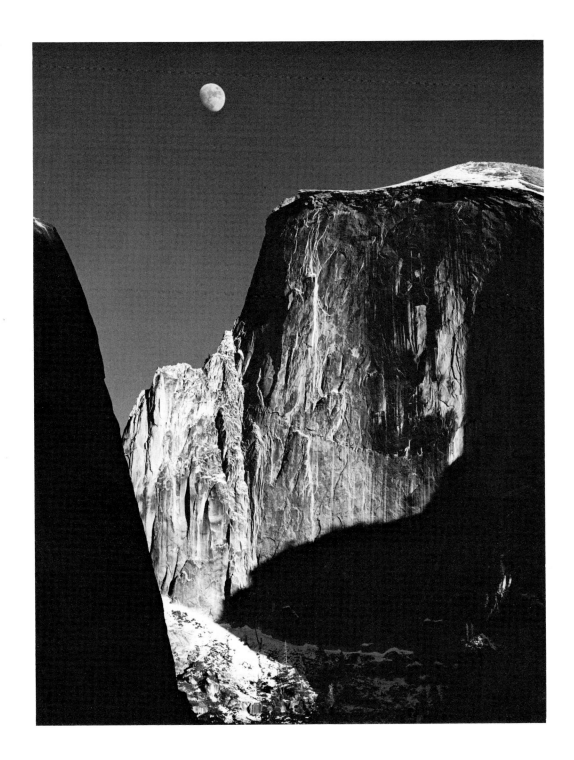

Chapter 3 Medium-Format Cameras

The term *medium format* is loosely applied to cameras larger than 35mm but smaller than 4x5 format. In function, as in size, most of these cameras represent a compromise between the rapid operation of a 35mm camera and the static, fully controlled approach of a 4x5 or larger view camera. The negative size, several times larger than 35mm, results in improved sharpness and less grain in enlargements for the same final image size.

Nearly all medium-format cameras today use roll film in 120 size, although there have been some examples of sheet-film cameras within this size range. The latter bear a closer relationship to the large-format cameras discussed in the next chapter than to current medium-format cameras. A roll of 120 film usually gives 8 to 16 exposures, depending on the image area, and is spooled with a paper support. With some earlier cameras, frame numbers were printed on the back of the paper support and read through a small window in the camera back. Many cameras can be adapted to use 220 size film, which eliminates the paper support and thereby doubles the film length and number of frames per roll. Obviously, if there is a back "window" on the camera it must be sealed when such a backless film is used.

The traditional image size is 2¼ x 2¼ inches (6x6 cm), but in recent years increasing numbers of cameras have appeared using a rectangular, rather than square, format. These include the "ideal format" (so called because its proportions enlarge directly to an 8x10 inch print) of 1⅝ x 2¼ inches (4.5x6 cm) and 2¼ x 2¾ inches (6x7 cm). The 2¼- square format requires visualizing images in a square area, or, as I prefer, visualizing the cropping in the square field to make a rectangular image.

Figure 3–1. *Moon and Half Dome, Yosemite Valley.* I made this photograph using a Hasselblad camera with 250mm Sonnar lens and an orange filter. With the camera secured to a tripod, I waited until the moon rose to a favorable position for a balanced composition. I made several exposures, at intervals of about one minute, and the movement of the moon between exposures gives each a somewhat different aesthetic effect. The moon moves surprisingly fast through the sky, and exposure times must be quite short to secure a sharp image when using a long lens.

MEDIUM-FORMAT CAMERA TYPES

Twin-Lens Reflex

The twin-lens reflex was for many years a standard of the photography world. The design, developed by Rollei, became an acceptable press and documentary camera in the years when the 4x5 press camera was standard and the 35mm was viewed by many as too small for professional work.

As its name implies, the twin-lens reflex uses two lenses of identical focal length to form separate viewing and photographic

Figure 3–2. *Twin-lens reflex camera.*

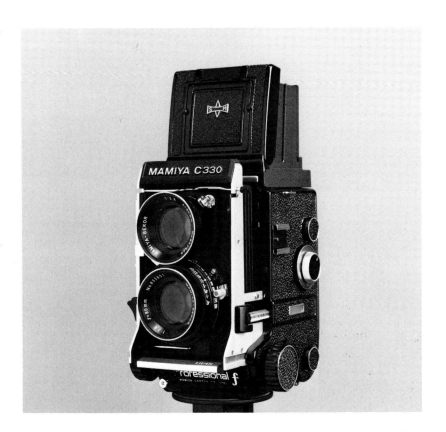

See Figure 3–3

images.◁ The photographer views a ground-glass image, but it is formed independently of the image on film. The two lenses are coupled, however, so that when the viewing image is sharply focused, the image from the primary lens is focused at the film plane.

Unless an accessory prism is attached, the viewing image is laterally reversed (i.e., reversed left-to-right). Such viewing can be confusing at first: following a subject seen to move toward the left edge of the viewing screen requires turning the camera to the *right.* Because the viewing lens has no diaphragm, the depth of field◁ of the viewing image bears no relation to that of the image on film.

See page 48

Since separate lenses are employed for viewing and photographing, the twin-lens design exhibits the parallax effect.◁ Similar field compensators to those found on 35mm rangefinder cameras are often used, but here, too, juxtapositions of near objects against distant ones are not corrected. When precise alignment is required, we must move the camera up so that the picture-making lens moves into the position occupied by the viewfinder lens during composition and focusing.

See page 13

Most twin-lens cameras are available only with "normal" lenses, although Rollei and others have marketed cameras or attachments

Figure 3–3. *Twin-lens reflex camera, cross section.* Separate lenses of identical focal length are used to form the viewing and picture-making images. The two lenses are contained in a single focusing mount so that, when the viewing lens focuses the subject on the ground glass, the primary lens focuses it at the film plane. The image seen on the ground glass is reversed left-to-right because of the mirror. As the viewing lens is a few inches above the taking lens, parallax is unavoidable.

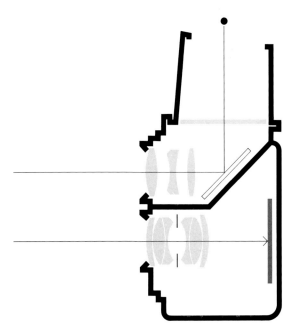

to provide long and short focal lengths. Some Mamiya models permit interchanging lenses, by replacing the entire front panel containing both viewing and photographic lenses.

The twin-lens reflex has been eclipsed by the popularity of single-lens reflex cameras. Excellent results are possible with some models of this design, however, and they often represent the least expensive way for a photographer to begin working in medium format.

Single-Lens Reflex Cameras

See Figure 3–4

See Figure 3–7B

Most medium-format single-lens reflex cameras resemble the Hasselblad in their basic "box" construction,◁ although a few, like the Pentax, resemble enlarged 35mm cameras.◁ The advantage of the box configuration is that it is totally modular: the camera body contains the reflex viewing mirror and other mechanisms, and the photographer attaches film magazines, lenses, and viewfinder systems as desired. Cameras of this variety are designed as "systems," with a wide selection of interchangeable components.

Unlike 35mm single-lens reflexes, many medium-format cameras use a leaf shutter◁ which is part of the lens assembly, since it is difficult to design an efficient focal-plane shutter for the larger

See page 82

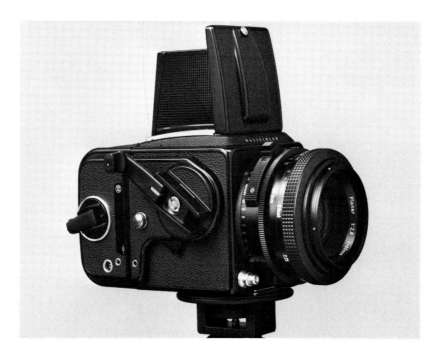

Figure 3–4. *Medium-format single-lens reflex camera. The Hasselblad 2000 FC.*

image size of 120 film. The leaf shutter has the advantage of being able to synchronize with electronic flash at all shutter speeds,◁ plus the fact that failure of the shutter disables only the attached lens, not the entire camera. Since the leaf shutter is located ahead of the viewing mirror, its cycle is quite complex: the shutter, which is open for viewing, must close as the mirror rises, then open and close for the exposure. In addition, there is a light protective blind at the film plane which opens just before the shutter gives the exposure, unless the mirror performs this function. The mirror is

See page 86

frequently not of the instant-return type now universal with 35mm cameras, so that the return of the mirror to its "down" position and reopening the shutter for viewing occurs only when the film is advanced.

Several models do have focal-plane shutters, including the remarkable electronic shutter in the Hasselblad 2000 FC. Any camera in which one shutter is used with all lenses has one major advantage: once calibrated, it functions identically with all lenses. (Precise exposure requires calibration of the actual shutter speeds, which may differ from the indicated speeds by 10 percent or more. Only one calibration need be performed with a focal-plane shutter, whereas each lens that has a leaf shutter will require separate calibration.) The absence of a shutter may also reduce the cost of each lens.

Figure 3–5. *Medium-format single-lens reflex camera, cross section.* The primary lens is used for both viewing and picture making. A mirror deflects the light to a ground-glass focusing screen during viewing. When the shutter release is pressed, the mirror swings up and a shutter, usually mounted in the lens, controls the exposure of the film.

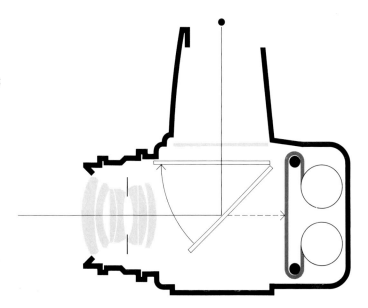

The viewing image is formed on a ground-glass screen at the top of the camera body. Various viewing attachments, such as a folding or solid hood to shield the screen from light, help the photographer see and focus the image. The photographer looks down at the ground-glass with such a finder, aided by a built-in magnifying lens. Viewed directly in this manner, the image is reversed left-to-right, as with a twin-lens reflex. To eliminate lateral reversal, prism attachments are popular, and some are available with a metering system to make through-lens readings from the ground-glass image. All such prisms are large and add considerably to the bulk and weight of the

Figure 3–6. *Blair Stapp, Artist (Moss Landing, California).* This is an informal portrait made with the Hasselblad, using a 150mm Sonnar lens. The weathered paint on the large tank in the background suggests non-objective painting. Although I like this photograph as a black-and-white image, I believe it would be more effective in color.

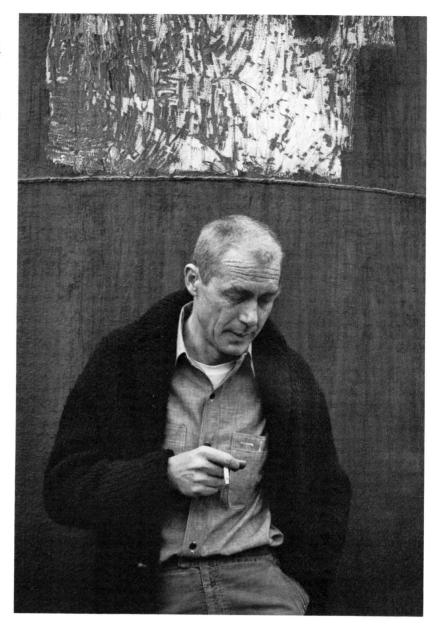

camera. To reduce the bulk, a few show only about 80 percent of the image, omitting the border areas.

Focusing is usually accomplished by rotating a control ring on the lens barrel, or by lens extension using a bellows system. The bellows construction of the Rolleiflex SL66 permits close focusing distances with most lenses, and also provides for a limited degree of lens tilt for control of the plane of focus.◁

See Chapter 10

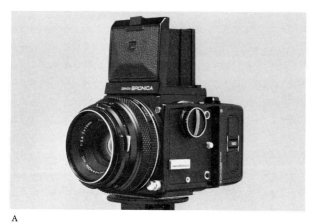

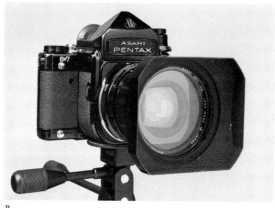

A B

Figure 3–7. "Ideal format" cameras. These two cameras represent different approaches to the so-called ideal format, a rectangular image area whose proportions enlarge directly to 8x10.

(A) The Bronica ETR is typical of compact single-lens reflex designs. The reduced format, 1³/₄x2¹/₄ inches, permits design of a smaller and lighter camera than the conventional 2¹/₄-square format.

(B) The Pentax 6x7 derives its name from the 6x7 cm format, larger than the image of a 2¹/₄-square camera (6x6 cm). Several cameras have been marketed in medium format that resemble over-sized 35mm cameras rather than having a "box" configuration. My personal preference is for the square format. It allows me to compose in horizontal or vertical format, and I have no difficulty visualizing the image in any proportions I desire.

See page 189

Interchangeable film magazines are a great advantage, since, after inserting a darkslide to protect the film from light, the photographer can remove a magazine part-way through a roll of film. It is thus possible to interchange film backs loaded with different emulsion types—fast and slower films, or color and black-and-white. This method can also help overcome one of the limitations of roll films, the inability to give different development times to individual exposures. Separate film backs can be loaded with the same film and marked according to the intended development, to be interchanged as required by subject contrast conditions (see Book 2). To achieve the same versatility, the 35mm photographer must carry separate camera bodies or complete cameras. Double exposures can also be made, either by using a separate setting (as with the Hasselblad 2000 FC), or by removing the film back and resetting the shutter without advancing the film. Adapter backs for using Polaroid film are also available for most cameras with interchangeable backs.◁

It should be noted in passing that there are examples of other camera designs, such as the few specimens of rangefinder medium-format cameras. But it is not possible or desirable to try to list here all the cameras and options available. I consider it more valuable to present some of the issues involved in choosing a medium-format camera intelligently. The photographer who uses this format does so because he finds that the compromises involved work to his benefit. He may achieve better image quality than is possible with a 35mm camera, with greater mobility than a 4x5 camera permits. No one camera is suitable for all kinds of photography, but for those who confront a wide variety of subjects and working conditions, with demands for high image quality, a medium-format camera may be a logical choice.

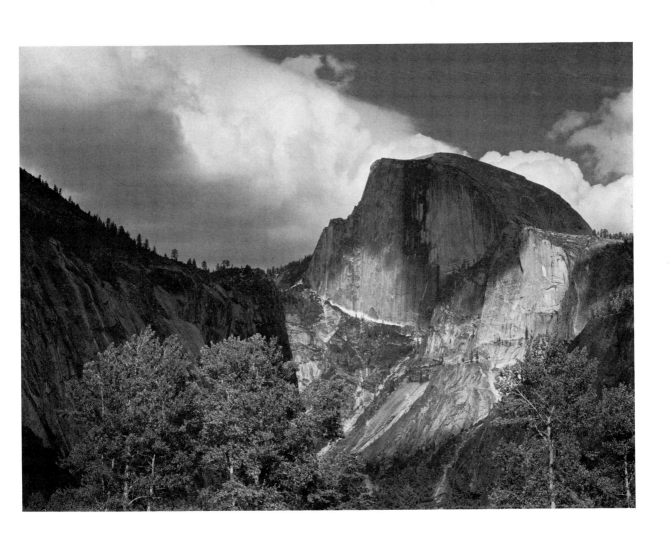

Chapter 4 **Large-Format Cameras**

Large-format cameras are heavier and more cumbersome than their smaller counterparts, and almost always require the use of a tripod. They offer a number of advantages, however, including larger negative size, full control of the position of the lens and film planes, and the ability to process each negative individually. Standard film sizes include 4x5 inches, by far the most popular, plus 5x7, 8x10, and 11x14 inches. A few larger sizes have been made, as well as some view cameras with a 3¼x4¼ format.

There is no question that using a view camera requires some physical stamina. In my earlier years I backpacked through the mountains with an 8x10 view camera, 2 lenses, 12 double film holders, tripod, filters, focusing cloth, etc. I finally resorted to using a pack animal on the trails, and gradually reduced the weight and size of my equipment. Now, when asked what camera I use, I reply, "The heaviest one I can carry!" Obviously, this is not the equipment for casual snapshots, but I believe that the greater effort and restrictions of the large camera lead to precision of seeing and a higher level of mechanical perfection.

Figure 4–1. *Half Dome, Cottonwood Trees, Yosemite Valley.* I used a 12-inch Dagor lens and 8x10 film. The camera was pointed upward slightly, and no adjustments were used to eliminate the small convergence (see Chapter 10). Theoretically, perhaps the image should have been precisely aligned, but I often find in practice that a small amount of convergence is visually effective.

Before discussing the physical structure and function of large-format cameras, we should consider the nature of visualization with such instruments. With a smaller camera we see the subject through a viewfinder, and release the shutter at the desired moment of exposure. A view camera favors a far more contemplative approach, partly because it is slower to operate. Setting up the camera always requires a certain amount of time—moving the camera into the optimum position, leveling it, making the adjustments. In addition,

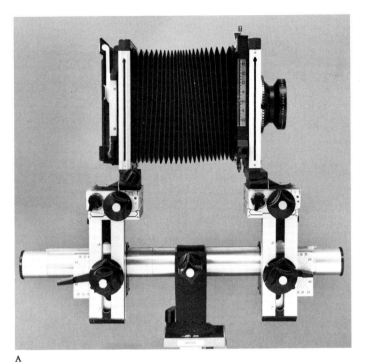

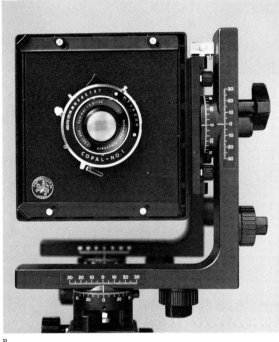

A

B

we see the image on a ground-glass screen that is in precisely the same position the film will occupy when we are ready for exposure. A further time delay is thus introduced, since we must insert the film holder, close the shutter, and set the aperture between the acts of composing and exposing the image.

The large ground-glass image is an entity in itself, a different experience from using the viewfinder. On the ground glass the image appears upside-down, and we must learn to view it in this position (unless we resort to a reflex viewing attachment, which I find cumbersome). We soon learn to "understand" the upside-down image, however, and it has a certain abstract quality that makes us more aware of its structure and its borders, as we are not dominated by the obvious dispositions of the subject. In effect the ground glass divorces us from the realistic appearances of the world as seen in the rectified small-camera finder. The ground-glass image thus exists as a thing in itself, specifically photographic and not merely a simulation of the "view" before the camera.

Although my mind assures me that I should be able to visualize a fine image no matter what camera I use, I find a particular conviction and pleasure in viewing a large view-camera image on the ground glass. These images are a delight to behold, even if no photograph is made! And while it may be theoretically possible to make

Figure 4–2. (Left) *View camera.* (A) The Sinar camera shown is an example of a sophisticated monorail design.

(B) The Horseman view camera has an unusual L-shaped standard to support the lens and ground glass assemblies.

Figure 4–3. (Right) *View camera, cross section.* The lens assembly and film plane are connected by a flexible bellows. Viewing and focusing are done by examining the image projected on the ground glass at the rear of the camera. The holder, containing unexposed roll, pack or sheet film, is inserted prior to exposure. The dimensions of the holder and its position in the camera are critical; the film must occupy precisely the plane where the ground glass was located during viewing and focusing, and the holder must provide a light-tight seal with the camera back.

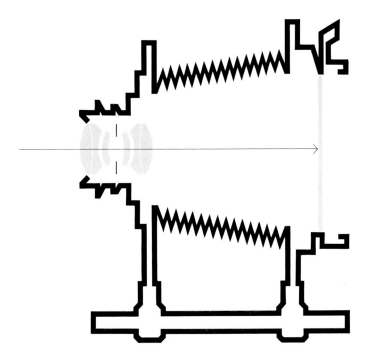

an enlargement from a small negative that is effectively as sharp as an 8x10 contact print, still the eye tells us there *is* a difference, if not optically, at least in perception and feeling.

LARGE-FORMAT CAMERA TYPES

View Cameras

The view camera, the most versatile of the large-format cameras, is usually of monorail construction, meaning that the primary camera support is in the form of a rail. To the rail are attached the front and rear standards, which support the lens and film, secured in such a way that they can slide freely along the rail and lock firmly in any desired position. Nearly all monorail cameras are modular, permitting the addition of larger or smaller backs, different bellows, extensions of the rail, and other attachments.

The alternative design is a "flat bed" construction, seen in early cameras and in some made today, with the lens and film standards mounted on a solid or open bed. With the lens support retracted,

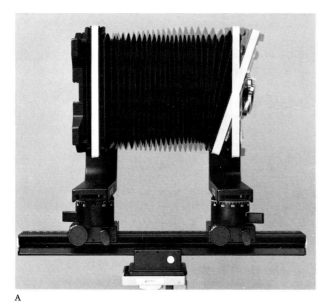

A

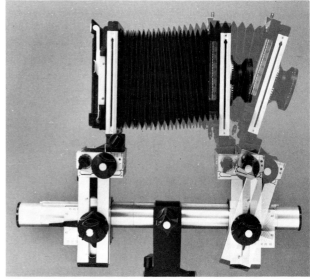

B

the bed folds up to protect it, and the ensemble is quite compact for carrying or storage.

These camera adjustments (sometimes called camera movements) allow the lens and film to be moved vertically or laterally in relation to each other, or to be tilted. By careful use of the adjustments, the photographer can control the optical image to an extraordinary degree.◁ In general, cameras designed on the monorail principle offer the greatest degree of adjustment capability. Those that emphasize portability, such as the flat-bed press and "field" cameras

See Chapter 10

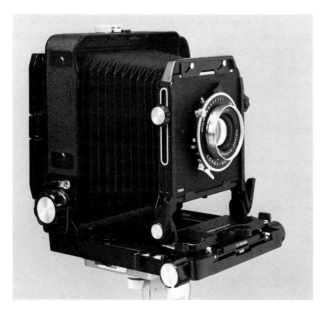

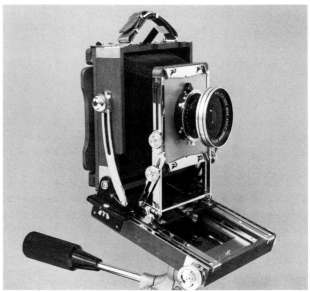

Figure 4–4. (A) *Axis tilts.* Tilts that pivot the lens or film near its center line (i.e., near the lens axis in the case of the front tilt) require little readjustment of focus.

(B) *Tilts from base.* If the standards pivot near the monorail or camera bed, the focus must be readjusted after using the tilt to compensate for the displacement of the lens. The Sinar camera shown permits either kind of tilt, but most cameras provide only one.

See page 153

Figure 4–5. (Left) *Flat-bed camera.* The example shown is the Toyo field camera. The flat-bed design permits such cameras to fold into compact units for portability, although at the expense of full adjustments. The back tilts from the camera bed and may not have other adjustments.

Figure 4–6. (Right) *Drop bed adjustment.* When using a short focal length lens, projections at the camera front can intrude into the picture area. With a flat-bed camera, the drop bed is used to keep the camera bed clear of the image area. The lens is then tilted parallel with the back.

See Figure 4–5

described below, usually provide more limited adjustments. A portrait view camera requires only minimal adjustment capability.

The pivots for tilting the front and rear standards are located either through the midpoint of the lensboard and camera back or lower, at the rail or bed.◁

With any such camera, it is essential that all locks on the focus control and the adjustments be secure, and that the camera itself be quite rigid once the locks are set. With some cameras, loosening a lock may cause the front or rear standard to flex and tilt, making accurate adjustment very difficult. The locks at the camera back, in particular, must be secure enough to withstand the pressure of insertion and removal of film holders and darkslides without shifting. To prevent "creeping" of the front or back assemblies, especially when the camera is tilted, all locks should be set firmly, but not tight enough to risk stripping the threads. From personal experience I can vouch for the exasperation when, after making a picture, I realized that one of the assemblies had shifted because of inadequate locking, ruining the exposure. Usually, unless we are using Polaroid Land materials, we learn the sad truth only when we get to the darkroom!

Press Cameras

The press camera differs from a view camera in being intended primarily for hand-held use. It is similar to a flat-bed view camera in its box construction, but includes a viewfinder and usually a rangefinder to permit hand-held exposures. Ground-glass viewing may also be possible by securing the camera to a tripod and opening a protective cover at the back of the camera. A similar design, often called a *technical camera,* extends the adjustment capability of the classic press camera, but retains the ability to be operated either hand-held or on a tripod. Press cameras are seldom made today, but used ones can represent a good value for the beginning photographer who wants to work in large format.

Field Cameras

The term *field* implies a camera that is designed to be easily portable.◁ This can be either a monorail or flat-bed design, constructed in such a way that it folds into a relatively small unit. Inevitably,

some compromises are required in these designs, usually in the form of limited adjustment capability.

VIEW CAMERA COMPONENTS

Bellows

The standard bellows of a view camera is an accordion-pleated box of square or tapered shape, usually made of leather or a synthetic material. Its function is to enclose a light-tight space between the lens and film, with the ability to flex to accommodate focusing and the various camera adjustments. The length of the bellows will determine both the maximum focal length lens that can be used with a particular camera and the close-focus limit with any given lens, as follows: In order to focus at infinity, a lens must be located at its own focal length from the film, and thus a lens whose focal length is longer than the maximum bellows extension simply cannot be focused. If the bellows will extend to *twice* the focal length of a lens, the lens can be focused to produce a 1:1 reproduction of the subject (hence the term "double extension" bellows, referring to one that can be extended to twice the focal length of a "normal" lens).◁ Many view cameras permit the addition of supplementary bellows units when greater extension is needed.

See page 55

With very short focal length lenses, the lens-to-film distance is small, and the collapsed bellows may become quite rigid and interfere with the use of lens and film plane adjustments. In such cases the best solution is to use the so-called bag bellows, a loose-fitting unit that does not limit the adjustments with short lenses. The use of a recessed lensboard, which positions the lens behind the front standard of the camera, may suffice for achieving focus, but seldom permits full use of the adjustments unless a bag bellows is also used.

There are a few problems to watch for when using a view camera with bellows:

Bellows folding or sag. A long bellows, especially one that is old and much used, may sag under its own weight and cut off part of the image (called vignetting). The tapered bellows found primarily on some older cameras had less tendency to sag simply because it

weighed less for a given length (it also had the advantage of "nesting" together as it folded, so it could collapse more tightly than the square bellows). The square bellows is more common today because it permits the use of identical front and rear standards. Sometimes small rings are attached which can be fastened to hooks on the front assembly to stretch and tighten the bellows. It is also possible to support the bellows from below with an appropriate card or wedge between it and the camera base, to lift the bellows to the proper position. Many modern cameras achieve long bellows extensions by using an intermediate standard attached to the monorail for support. Photographers who are in the habit of hanging the focusing cloth over the top of the camera may find that its weight resting on the bellows causes sag and thus vignetting of the image.

A bag bellows, used either with a very short lens extension or with the standards adjusted away from the center position, may fold in such a way as to cut off part of the image. This problem will be visible on the ground glass, or by removing the ground glass and inspecting the bellows itself. The remedy is to gently pull the corners of the bellows outward, or remove the camera back and press the bellows into proper shape. If you remove the back, you can easily confirm the source of image cut-off by looking at the lens from each corner of the film plane.

Light leaks. The modern monorail camera is designed to accept interchangeable bellows units; the attachment clamps are relatively simple, but require periodic checking. The bellows frames must be accurately seated and clamped securely, or fogging of the film will result. With bag bellows, I have had a few accidents when I inadvertently racked out the camera front beyond the capacity of the bellows to expand. The bag bellows is of limited extension, and can be ripped away from its frames if extended too far while focusing.

Eventually, any bellows will become worn or strained, and minute holes or cracks can begin to admit damaging amounts of light. This is especially true with older leather bellows, which tend to dry out and crack in time, but even modern synthetic bellows may fail because of stress along the creases. A leak can be found by taking the camera into the darkroom, removing the back, and holding a light inside, with the shutter closed and the dark cloth draped over the back. Move the light along the four edges of the fully extended bellows, and also carefully check the mounting of the bellows at the front and rear standards. Should a small pinhole be

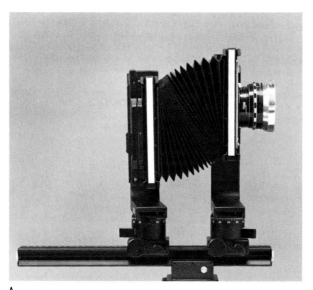

A

B

found in any part of the bellows, it can be temporarily repaired with a piece of opaque tape. I have had bellows that gave almost a planetarium effect when examined this way! My discovery of the leaks was delayed because most of them were concealed when the bellows was only partly extended.

Internal bellows reflections. The interior of the bellows will reflect some scattered light to the film, usually along the edges adjacent to bright subject areas. In the 1940s, Edward Weston and I were both troubled with this effect, which caused an increase in density along the edges of our films. A good view camera lens projects an image much larger than the film itself, to allow for adjustments;◁ as a result there is always a considerable amount of "wasted" light that falls on the bellows, and is reflected to the film. This internal flare will be reduced if the bellows is as large as possible in cross section. (Weston and I both had 10-inch-square bellows on our 8x10 cameras; a larger bellows would have reduced the problem.)

See Chapter 10

The most effective solution is to shield the lens from extraneous bright light. If the sun is just outside the picture area, its image will fall on the camera back or bellows and almost certainly produce flare. An efficient lens shade—ideally of bellows construction so it can be extended as required by the lens in use and the degree of lens and film plane adjustments—is a necessity when using a view camera. Be sure that all interior camera surfaces, and the inside of the lens shade, are "flat black." A textured flat-black surface is most

Figure 4–7. *Use of the bag bellows.*
(A) A conventional bellows permits
only limited displacement of the
lens before the bellows itself inter-
feres with further adjustment.

(B) The bag bellows permits
greater adjustment; in this case
both the rising front and swing
back are used. The bag bellows is
required only with short focal
length lenses (see Chapter 5), such
as the 121mm Super Angulon
shown. With longer lenses the in-
creased distance between front and
rear standards permits full adjust-
ment with a conventional bellows.
White strips were attached to the
camera to show clearly the position
of lens and film planes.

effective at reducing reflections. I once had a medium-format cam-
era with interior surfaces painted a deep, but shiny, black; the flare
was appalling. Obviously, the designer never made a picture with
that camera!

Camera Back and Ground Glass

The frame of the ground glass is held in place against the camera
back by springs, which permit the film holder to be inserted. It is
essential that the springs be of adequate strength to ensure that the
film holder is firmly pressed against the back regardless of the posi-
tion of the camera. Only when the film holder is pressed against
the flange in the back is the film positioned in precisely the plane
occupied by the front surface of the ground glass during focusing;
weak springs will cause loss of sharpness, as well as light streaks on
the film. (Some cameras are equipped with the Graflock back, which
has sliding tabs that are used to lock a film holder in place. The
Graflock back is designed to facilitate the attachment of roll-film
backs, Polaroid backs, and other special-purpose film holders.) Most
view cameras permit the back to be attached in either the horizontal
or vertical position; a few provide a revolving back, which can be
set at intermediate positions. With some cameras I have seen, tilting
the back either forward or backward when the back is in the hori-
zontal position causes the supports to interfere with insertion of
the film holder or removal of the darkslide.

One surface of the ground glass is textured (ground) to provide
a plane for focusing the image. It is important that the ground
surface face the lens, since this is the surface where the image is
formed, and it must occupy exactly the plane of the film when the
holder is inserted. In some cases, the ground glass will incorporate
a Fresnel lens, whose purpose is to provide even illumination over
the entire picture area. The Fresnel surface is made up of a series
of small concentric rings, and it functions like a lens in directing
light to the eye for focusing.

Particularly in some older cameras, the corners of the ground
glass may be cut off to permit the movement of air when the bel-
lows is expanded or collapsed. Obviously, this interferes with seeing
the corners of the image. It is better, instead, to have small holes
drilled in the ground glass if needed to permit air flow (with most
cameras, however, vents are provided). For focusing on the aerial
image (i.e., the image in space, rather than the image projected on

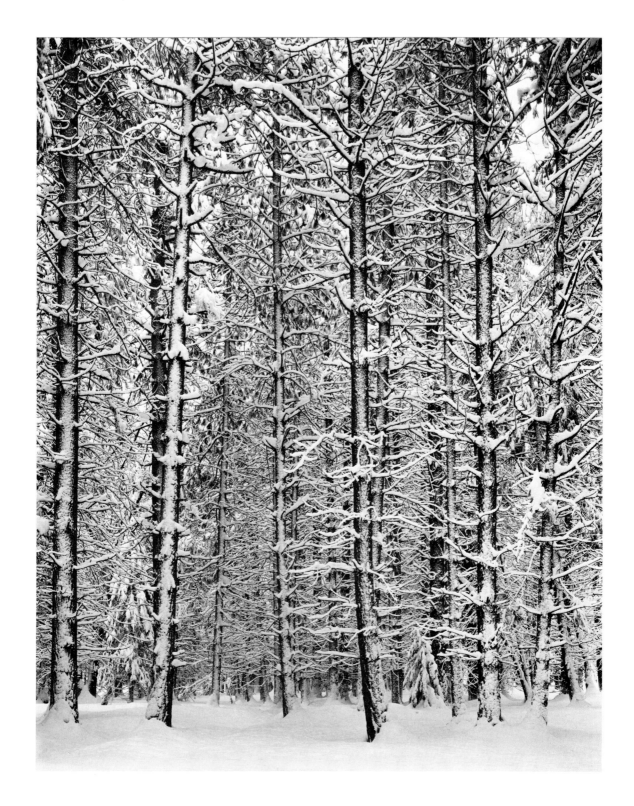

the focusing screen), we can attach a very fine wire across such an air hole on the inner (ground) surface. If we focus our eye on the wire, using a magnifier, the aerial image will be visible with maximum sharpness and clarity.

Lensboards

There are a few standard lensboard sizes, but most view cameras have boards designed specifically for them. Not only must they be the right size for a snug fit, but their thickness is important: if the lensboard is not tightly held in the front assembly, light leaks are probable. A recessed lensboard may be desirable for short-focus lenses, but attaching a cable release to the recessed shutter may present problems.

The shutter is usually mounted in the lensboard, and the lens elements threaded into the shutter. The shutter attachment must be precise and properly flanged to prevent light leaks. The mounting of the lens components is critical, since the alignment and separation of the elements is part of the lens design and must be maintained *exactly* in adapting the lens to a shutter. Only a trained technician should attempt to mount the lens. Always check older lensboards to be sure that previous mounting screw holes are fully sealed. On one trip to the Canadian Rockies, I had a secondary pinhole image on the ground glass which, after about ten days' work, I traced to an unfilled screw hole!

Film Holders

The standard film holders for 4x5 and larger cameras contain two sheets of film, one on each side of the holder, secured beneath separate darkslides to shield them from light. Special film holders are also available for using film packs (with 16 sheets per pack), roll films, and Polaroid films◁ with most view cameras.

The conventional sheet film holder has a cloth-hinged flange at the end opposite the slot for the darkslide. With the darkslide fully or partly removed, this flange can be opened for loading the holder with film. The film is inserted emulsion side up, determined by locating the film's identifying code notch in the upper right hand corner. Be very careful not to sharply bend or buckle the film while loading, as this will damage the emulsion, and to touch only the extreme edges of the film. Once the film is in place, the hinged flange is closed and the darkslide inserted to lock it in place. If the

See page 189

Figure 4–8. *Pine Forest and Snow, Yosemite Valley.* I used a 12-inch Dagor lens and 8x10 film. It is a straightforward image that required little adjustment of the camera except careful leveling and use of the rising front (see page 141).

film is not in proper position the hinged flange will not seat properly, and the darkslide cannot be fully inserted.

The top edge of the darkslide has a black side and a white side; the white edge can be identified in the dark by raised dots which can be felt with the fingers. Convention dictates that the white side face outward when the holder is loaded with unexposed film, and the black side when the film has been exposed, or when the holder is empty. In practice this requires that you expose *only* film holders that have the white side facing out, and reverse the darkslide as you make each exposure. Mistakes here will lead to unfortunate results! Some photographers depart from this procedure, and when working with others, it is wise to have a meeting of the minds on this subject.

My own method of loading sheet film is to stack the exposed holders on the left, alongside an empty film box to receive the exposed film. I place a box of unexposed film to the right. In total darkness, I take one of the black separating papers (if packed with the film) out of the box on the right and place it over the exposed film as each sheet goes into the "exposed" box. If I have exposed sheet films for different amounts of development, I keep separate boxes for such groups, arranging them carefully to avoid mixing up the films. Then I dust the holder carefully and insert the fresh film. I check the darkslide for proper orientation by feeling the raised dots, and then replace it in the holder, being certain it seats *fully* within the hinged flange. After checking to be sure all the film boxes are closed, I turn on the light and examine the newly loaded holders to be sure all have the darkslide inserted in the proper direction.

The film holders should be thoroughly cleaned periodically. A brush and can of compressed air (available at camera stores) may be used, although I find a small vacuum cleaner superior to a blower. The vacuum *collects* the dust rather than scattering it about! In dry, dusty climates I would advise using this procedure each time the holders are to be loaded. Note also that the rapid withdrawal or insertion of the darkslide can produce electrostatic effects under dry conditions, attracting dust and/or producing static marks on the film.

In very dry climates, additional grounding may be needed when using a wooden tripod or one with rubber tips. I lead a flexible wire from the camera base to ground, running it along one leg of the tripod. Electrostatic charges will scatter dust throughout the bellows and deposit it on the film when the darkslide is withdrawn, unless the camera is well grounded.

Each film holder should be numbered on both sides in the panel provided. I once attached small numbered labels to the holders, but these interfered with their proper seating, as I discovered after finding light streaks on the film. A good technician can make smooth notches with a fine drill along the edges of the flanges that hold the film. These will be visible at the extreme border area of the negatives, and will serve to identify each negative with the holder and with notes made on exposure and development. The notches must be *very* smooth on the underside or they will scrape the film, and the resulting particles will collect on the negatives as dust specks.

When the holder is inserted in the camera, it must be properly seated, that is, the light-trap ridge on the holder must fit securely into the groove on the camera back. If the holder is not fully inserted, or is pressed beyond the light-trap groove, fogging of the film will result. Sometimes the older wooden holders are warped, or the light-trap ridge is worn or dented, spoiling the light seal. As mentioned, weak springs can also cause fogging, especially if a heavy film holder like the Polaroid 4x5 back is used with the camera tilted upward.

Unintended exposure or light streaks on the film (fogging) can also be caused by deterioration of the light-trap material that seals the darkslide, by improper seating of the darkslide, or, occasionally, by cracks or punctures in the slide itself. Darkslides are not necessarily interchangeable from one holder to another, and a small difference in size can cause improper seating and fogging. To avoid damage, the slide must be inserted *straight* into the holder without buckling. In the field, never allow sunlight to fall directly in the darkslide slot, especially as the slide is being inserted.

Film pack and roll-film holders are generally designed to fit under the ground glass, or are attached by a separate locking mechanism like the Graflock system. These holders usually include a darkslide, and precautions similar to those for sheet-film holders are advised regarding the seating of the holder, avoiding light leaks, etc. Polaroid Corporation manufactures several backs for use with view cameras; they are described in Chapter 12.

Film holders of any kind must always be protected from dust, moisture, and heat. Store holders in a closed camera case, and never lay them on the ground. Should a holder be dropped or otherwise damaged, it should be inspected by a good camera technician; a nearly invisible crack or separation can result in light leaks. With Polaroid film holders, be especially careful to keep the roller mechanism clean.

Chapter 5 **Lenses**

There is something magical about the image formed by a lens. Surely every serious photographer stands in some awe of this miraculous device, which approaches ultimate perfection. A fine lens is evidence of a most advanced technology and craft. It is not surprising that we should develop a real affection for equipment that serves us well, but in spite of all the science and technology that underlies our medium, the sensitive photographer *feels* his images in a plastic sense. We must come to know intuitively what our lenses and other equipment will do for us, and how to use them. In this chapter I shall present the essential facts concerning lenses. There is no need to fully delve into the science of their design and manufacture, any more than a pianist must know the techniques of piano manufacture. But the photographer who understands the concepts of lens function will certainly benefit in his work.

In earlier years some lenses were definitely superior to others; their images proclaimed their differences. I have a Voigtlander 12-inch process lens that is superb, despite its age of more than seventy years, and I have done some of my best work with Zeiss Protars, nearly forty years old. More recently, the computer has moved into the industry, and practically all lenses made within the last decade or two are excellent—often more precise than even the most exacting practical photographer requires. They are, in fact, usually better in their capacity for preserving fine detail than our standard contemporary films and papers can record.

Figure 5–1. *Dawn, Autumn, Great Smoky Mountains.* I used a 13-inch Zeiss Protar lens on 5x7 film to photograph these trees from the opposite hillside. The long focal length of the lens (for this format) lends a rather stately two-dimensional effect which seems appropriate to the subject.

IMAGE FORMATION AND FOCAL LENGTH

A lens has two important properties not shared by the pinhole. First, it can gather light over a large area (the front surface of the lens), thus producing an image bright enough for practical photography. Second, it focuses the light to produce a sharp image of a subject plane. A pinhole does not focus the light, and has no definite focal length.◁

See page 3

The focusing of light rays occurs because light passing from one medium (such as air) into another (glass), or from one glass type to another, changes speed at the interface where the two meet. If the surface is at an angle to the path of light, the light ray will also change direction. The change of direction, known as *refraction*, can be controlled by varying the shape and composition of the glass (or plastic) elements of a lens.◁

See Figure 5–2

One of the most important characteristics of a lens is its *focal length*. Technically, this refers to the distance from the *rear nodal point* of the lens (usually close to the aperture plane) to the plane where subjects at infinity come into focus.◁ Knowing the focal length is important not only because it identifies the distance of the lens from the film (for distant subjects), but because it provides a measure of the image size and subject area in relation to the film format. If you use a short focal length lens to photograph a subject, you will obtain an image of a greater area of the subject, and each part of the subject will be smaller in the photograph, than if you use a longer lens. When I first became aware of the lens and the image it forms in relation to the subject, I thought of the lens as "embracing" the outer world.

See Figure 5–3

Figure 5–2. *Image formation by a simple lens*. Light from a subject point falling on any part of the lens surface is focused at a single point behind the lens, and the total image is the accumulation of all such points. By comparing this illustration with Figure 1–2, the effect of replacing a pinhole with a lens can be seen. The lens "gathers" light over its entire surface, producing a much brighter image, and it focuses the light to produce a sharper image than the pinhole.

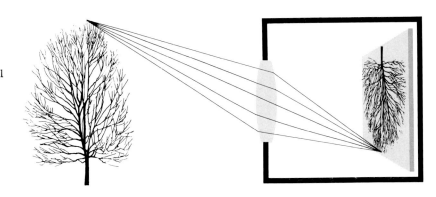

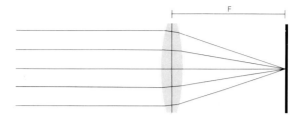

Figure 5–3. *Lens focal length.* Light from a subject point at infinity produces parallel rays, which are refracted by the lens to focus at a single point. The distance from the lens to this point is the focal length of the lens.

It is important to understand that *all lenses of the same focal length give images of the same size* for a given subject and subject distance. If a 4-inch lens produces an image one inch high of a certain subject, the image size will remain one inch regardless of whether the lens is on a 35mm camera or a 4x5 camera. However, on the 35mm camera, the one-inch image will fill the frame (about 1x1½ inches), while it will occupy only about one quarter the height of the 4x5 film.◁ Thus this subject will be isolated on 35mm film, while it will appear in the midst of its surroundings in the 4x5 format.

See Figure 5–11

We should also understand that *image size is proportional to focal length.* If, while making a photograph, you change to a lens of double the focal length of the first, each object will double in size in the image. At the same time the total width of subject area covered by the longer lens will be half that of the shorter lens. Thus when you change from a 6-inch lens to a 12-inch lens with a 4x5 camera, or from a 50mm lens to a 100mm lens with a 35mm

Figure 5–4. *Compound lens.* A lens of one element (a "simple" lens) has inherent imperfections, many of which can be corrected or neutralized by using a number of lens elements. The rear nodal plane of the compound lens is the position at which a simple lens of equal focal length must be located to produce equivalent focus. The lens aperture is usually positioned close to this nodal plane.

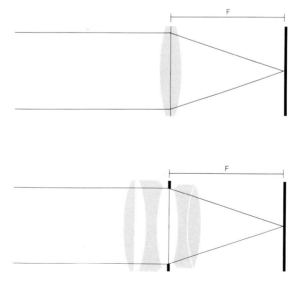

camera, you can anticipate that each part of the subject will double in size in the image.

It should also be clear that a 6-inch lens used with a 4x5 camera will "see" the same subject area as a 12-inch lens used with an 8x10 camera; the image size is doubled with the longer lens, but each dimension of the format is also doubled. (Do not confuse linear dimensions with area. Going from a 4x5 negative to an 8x10 negative doubles the *linear* dimension of each side of the format, but the total *area* is quadrupled. Linear dimensions are used in photography when considering magnification and image size.) We will return to these concepts related to focal length after discussing other basic principles of the lens.

APERTURE

The lens aperture is simply the diameter of the lens opening, expressed as a fraction of its focal length. Thus a lens of 4-inch focal length with a diameter of one inch has a relative aperture of 4/1, or 4. The aperture designation is expressed as f/4, indicating that the aperture is the focal length/4. Another 4-inch lens that has a diameter of ½ inch would be an f/8 lens.

The aperture indicates the amount of light that the lens will transmit to the film. Since the aperture is expressed as a fraction of the focal length, *all lenses set at f/8 (or any other aperture) transmit the same intensity of light to the film.* This amount of light is proportional to the *area* of the lens aperture (and therefore to the *square* of the diameter); the f/4 lens described is twice the diameter of the f/8 lens, but transmits four times as much light.

The aperture inscribed on the front of the lens mount is the largest for that lens. For practical photography we need a means of reducing the aperture to give us control of the intensity of the light reaching the film. In early days, a metal plate or separate tabs with holes of different diameters, known as Waterhouse stops, were frequently provided. By sliding the plate or exchanging tabs, different lens openings could be selected. The adjustable aperture today takes the form of an iris diaphragm, a series of metal blades that make different size lens openings depending on the setting of

a control ring. The series of lens stops used almost universally to-day to provide a standard exposure sequence is as follows:

f/1 1.4 2 2.8 4 5.6 8 11 16 22 32 45 etc.*

These standard aperture numbers are known as major stops, or whole stops, and are in geometric sequence. *Each stop transmits twice or one-half the amount of light of the adjacent value.* Larger f-stop numbers represent *smaller* apertures; f/11 is a smaller number than f/16, but admits twice as much light. The aperture scale on a lens will usually also have intermediate positions between the whole-stop divisions, in increments of either one-half stop or one-third stop. (One-third stop intervals correspond to a change in film speed from one ASA index number to the next; see Book 2.)

When setting the aperture on a lens you should always approach the f-stop from the same direction, moving the index mark *down* the scale toward the desired setting. There may be a certain degree of slack in the mechanism that can cause slightly different lens openings at the same setting, depending on whether the f-stop is approached by stopping down from larger apertures or opening up from smaller ones.

The f-stop relates exposure to the effective diameter of the lens, but disregards certain other factors, primarily the efficiency of the lens in its actual transmission of light. Since lenses of many elements are less efficient than those of few elements—because of reflection of light at each surface and the optical density of the glasses—attempts have been made to develop a scale that indicates the actual transmission of a lens. A scale of "t-stops" has sometimes been substituted for f-stops to indicate light transmission. These values are seldom seen today, except in some lenses for cinematography, primarily because the efficiency of lenses has been greatly increased by lens coating techniques. The t-stop values, while fine for determining exposure, also distort other mathematical values that relate directly to the true f-stop, such as depth of field and hyperfocal distance.

*The full aperture designations include decimals (f/11.3, f/22.6, etc.), but these are usually omitted as not of practical significance. Note also that each f-stop number increases by a factor of 1.414, the square root of 2, since the light transmission depends on the *area* of the stop. The older European aperture sequence was f/4.5, f/6.3, f/9, f/12.7, f/18, f/25, etc. The numbers are different, but the *ratio* of the stops is the same.

Figure 5–5. *Focus*. The image of a distant subject comes into focus closer to the lens, and the image is proportionately smaller, than that of a nearby subject. The focusing mechanism of a camera permits adjusting the lens-to-film distance so that a focused image can be obtained over a wide range of subject distances.

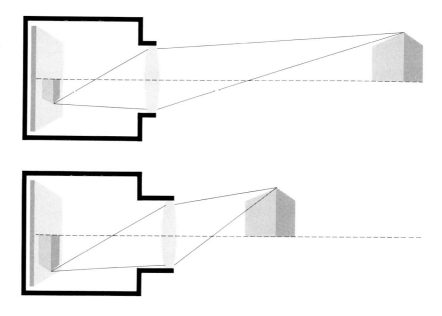

FOCUS AND DEPTH OF FIELD

See Figure 5–5

As the distance from the camera to the subject changes, the distance behind the lens where the image is sharply focused also changes. The image of a nearby subject is sharply focused farther behind the lens than that of a distant subject.◁ Focusing the lens involves adjusting its distance to the film to produce a sharp image of the subject. Focusing with a small camera is usually accomplished by rotating a ring on the lens barrel; with a view camera, the length of the bellows is adjusted by moving the front or rear standard.

We can achieve critical focus for only one plane in front of the camera, and all objects in this plane will be sharp. In addition, there will be an area just in front of and behind this plane that will appear reasonably sharp (according to the standards of sharpness required for the particular photograph and the degree of enlargement of the negative). This total region of adequate focus represents the

See Figure 5–6

depth of field.◁ It is a property of lenses that as we reduce the aperture used for exposure, the depth of field increases. Thus, if it is important in a photograph to have areas close to the camera appear approximately as sharp as more distant ones, we select a small aperture.

There are two other factors that affect the depth of field: the focal length of the lens (change to a shorter focal length lens if you need more depth of field) and the subject distance (move away from

Figure 5–6. *Depth of field*. The images of three subject points at different distances come into focus at different distances behind the lens. If focus is set at point *a*, the more distant point *b* comes into focus in front of the film plane, and the light "cone" forms a small disc on the film instead of a point. Thus *b* is not in focus on the film. Similarly, the image of point *c*, closer to the camera, focuses behind the film plane, and thus is also not a point but a small disc.

(A) When the entire lens area is used (i.e., at maximum aperture), the discs (called circles of confusion) are relatively large.

(B) By stopping down the lens to a smaller aperture, the size of the circles of confusion is reduced. If the circles become small enough to appear as points, the images are considered in focus, and points *b* and *c* fall within the depth of field of the lens at that aperture.

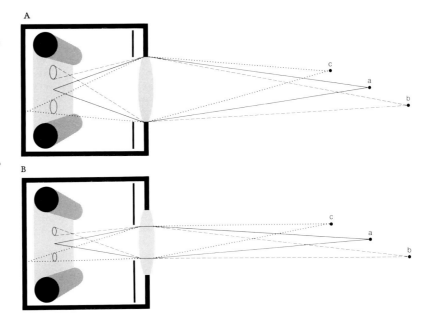

See Chapter 10

the subject to increase depth of field). These three factors, aperture, lens focal length, and subject distance, give us considerable flexibility in managing depth of field. In addition, the lens and film plane adjustments of a view camera,◁ while they do not actually change the basic depth of field, do permit us to align the plane of sharp focus to coincide with the most important plane of the subject.

The factors affecting depth of field are governed by the following principles: (1) The depth of field doubles if the *f-number* is doubled (e.g., from f/8 to f/16). (2) If you double the subject distance, the depth of field increases by *four* times; triple the distance, the depth of field increases by *nine* times (depth of field is proportional to the *square* of the distance). (3) If you reduce the focal length by one half, the depth of field increases by *four* times (depth of field is inversely proportional to the square of the focal length).

We must remember that the depth of field relates to an acceptable degree of sharpness; in actuality, only the plane focused upon is truly sharp. Acceptable sharpness is also affected by the degree of enlargement of the negative and the distance from which the final print is viewed. An enlargement that looks well at 5 feet might be definitely unsharp at reading distance. Standard depth of field tables and scales are all based on certain assumptions regarding these factors.

The reason smaller apertures increase depth of field is shown in Figure 5–6. The image of a "point" in the subject should be a

"point" on the film. If the subject is not exactly in the plane of critical focus, however, this image becomes a small blurred disc, called a circle of confusion.* The size of any circle of confusion becomes smaller as the aperture is reduced, making the image ap pear sharper. We define limits of the size of these circles of confusion that we consider to be acceptably sharp focus, even though they are not quite as sharp as at the critical focus plane. If, by stopping down the lens, we make the blur-circle of a point smaller than this defined size which is considered "acceptably sharp," then the point now falls within the depth of field range at that aperture. Changing to a shorter focal length lens, or increasing the subject distance, has a similar effect on the size of the blur-circles, reducing them throughout the photograph and bringing a greater area into acceptably sharp focus. The most commonly accepted standard for circle of confusion size is about 1/100 to 1/200 inch *in the final print;* obviously, it must be smaller in the negative if enlargement is planned. For the 35mm format, the circle of confusion on the negative must be about 1/1000 inch.

Depth of Field Scales

Depth of field scales are engraved on the barrel of most small camera lenses, and tables are available for estimating the depth of field with any lens. The scale on a lens barrel is made up of pairs of index marks, one pair for each f-stop.◁ If you have set f/22 as your stop, find the pair of lines that correspond to f/22. The distances on the focusing scale that lie between this pair of lines will be "acceptably sharp" (according to the definition of sharpness used to create the scale).

See Figure 5–7

You can also use the scales to work "backwards" to find what f-stop you need to encompass a certain depth of field range. If, for example, your important subject areas are all between 6 and 15 feet from the camera, find the two index lines on either side of center that span this range of distances on the focusing scale, and set the f-stop that corresponds to these marks.

You will note from examining such a scale that the near limit of depth of field is always a shorter distance *in front* of the primary

*Even with the finest optics there is no such thing as a "point" image. The image of a true point is always a minute circle because of inevitable diffraction effects of the lens. However, a lens of fine definition gives a minuscule circle or disc which we accept as a "point."

Figure 5–7. *Depth-of-field scale.* The top row of numbers is the distance scale, and immediately below it is the depth of field scale. The aperture numbers appear in pairs on either side of the mark indicating optimum focus. Numbers on the distance scale that lie between the pair corresponding to the aperture chosen are within the depth of field region; the image is acceptably sharp within these limits. In this case, the optimum focus is at about 3.4 feet, and depth of field extends from 3 feet to 4 feet at f/22.

focus plane than the far limit is *behind* it. This fact leads to a common rule of thumb for depth of field: For many situations, you should focus about one third the way from the nearest object that must be sharp to the farthest. Since the exact focus may vary in some cases, you should check the ground glass carefully with a magnifier.

I have also found it generally true that, if critical focus must be sacrificed somewhere, the near objects should be given preference in focus at the expense of more distant ones. A slight unsharpness in the foreground is often more disturbing than in the distant parts of a scene (of course there are always exceptions to this, or any, general principle).

Figure 5–8. Lewis Hine, *Carolina Cotton Mill.* A good example of creative use of limited depth of field (selective focus). The decisive focus on the principal subject accents both the social message and the aesthetic impact. (Courtesy International Museum of Photography at George Eastman House.)

There are situations when it is desirable to emphasize a certain subject by isolating it from its surroundings; *minimum* depth of field is one way to accomplish this. By selecting a large f-stop, the depth of field will become small, and foreground and background objects will definitely be out of focus and may be less distracting This effect, called differential focus or selective focus,◁ can be enhanced by any means that reduces depth of field: changing to a long focal length lens, decreasing the subject distance, or using a larger aperture.

See Figure 5–8

Hyperfocal Distance

When a lens is focused at infinity, the near limit of depth of field is called the *hyperfocal* distance for that aperture. It can readily be determined by using the scales on a lens barrel: set the focus at infinity and read the hyperfocal distance opposite the index mark for whatever aperture you are using. If you then set the focus for this hyperfocal distance, the depth of field will extend from one half the hyperfocal distance to infinity.◁ For example, an 80mm lens on a medium format camera has a hyperfocal distance at f/22 of about 18 feet. If we set the focus at 18 feet, the depth of field at f/22 will extend from about 9 feet to infinity.◁ By focusing at the hyperfocal distance, we achieve the maximum depth of field range for any aperture.

See Figure 5–9

See Figure 5–10

Focus Shift

Some lens designs, particularly the single components of a convertible lens,◁ will undergo a shift of the focus plane as they are stopped down. This shift is difficult to detect on the ground glass, since the image is usually too dim at small apertures for careful evaluation. The best procedure to check for focus shift is to focus the camera, at full aperture, on a scintillation or specular "glare" spot (the reflection of the sun on a distant automobile chrome bumper, for example). As the lens is stopped down this glare spot will become less bright, but should be bright enough to check for sharp focus even at the smallest apertures. Use a good focusing magnifier to ensure precise focus. If the image requires refocusing at small apertures, the amount of adjustment required can be noted or marked on the camera bed. This refocusing will be very slight, and will have no effect on exposure or practical image size, assuming distant objects are photographed. For close subjects, it may be necessary to place a

See page 64

Figure 5–9. *Hyperfocal distance.*
When the focus is set at infinity,
the near limit of depth of field is
called the hyperfocal distance for
the aperture used. If the focus is
then set at the hyperfocal distance,
the depth of field will extend from
one-half the hyperfocal distance to
infinity. Focusing at the hyperfocal
distance gives maximum depth of
field whenever subjects at infinity
must appear sharp. The hyperfocal
distance is closer to the camera
when the lens is stopped down.

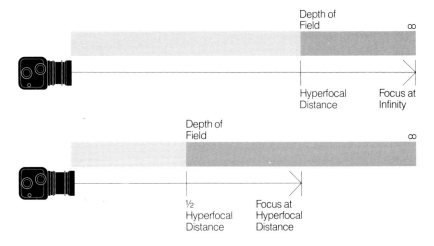

bright light source in the subject plane to permit a final focus adjustment at the picture-making aperture. Focus shift may be due to spherical or chromatic aberrations;◁ in the latter case it can be corrected by using monochromatic filters, but perhaps at the expense of unwanted filter effects in the print values.

See page 75

Infrared Focus

Figure 5–10. *Determining hyperfocal distance using the depth of field scale.* (A) The focus is set at infinity. At f/22, the hyperfocal distance indicated is about 18 feet. (B) When 18 feet is set as optimum focus, the depth of field extends from about 9 feet (half the hyperfocal distance) to infinity, as seen opposite the f/22 marks on the depth of field scale.

Some lenses in focusing mounts are marked with a separate index mark showing the correct infinity focus setting when using infrared film. Since a lens designed for visible light wavelengths refracts the invisible infrared radiation to a different extent, this focus compensation is necessary. The required adjustment is normally to advance the lens about 1/70 of its focal length, and this compensation can

A

B

be marked on a view camera bed. Infrared filters isolate the long wave-lengths, but do not correct the focus. Some lenses are fully corrected into the infrared region, and thus require no refocusing.

I would like to remind you again that the above descriptions of focus and depth of field relate to very important properties of the lens. Their practical applications depend on the character of the work being done and the degree of precision required. Experimentation is very important; we can learn to "feel" the effects of depth of field and other optical properties. Try to develop a sense for the way the lens acts in three dimensions, as well as in relation to two-dimensional "framing."

ANGLE OF VIEW AND COVERAGE

The terms *angle of view* and *coverage* are frequently confused through different usage by small-format and large-format photographers. With a small camera we are concerned only with the angle of view, that is, the angle of subject area projected *on the film*. This value is related to the focal length of the lens, and is usually expressed in degrees measured either along the film diagonal or the longer border. Small-format photographers thus use the term *wide-angle lens* to refer to one with a shorter than normal focal length, since it projects a wide subject area on the film.

With a view camera there is another important measure, namely, the size of the total image-circle projected by the lens. All lenses, regardless of format, project a circular image, and the rectangular film format must fit within this image-circle. With a small camera, a high-quality image is required only within the film area, and the remainder of the image-circle is disregarded. A view camera, on the other hand, requires an image-circle considerably larger than the film area, to allow freedom to use the camera adjustments.◁ A lens's

See Figure 5–11

covering power or *coverage* refers to this total image-circle; it is a fixed quantity, regardless of the film format, and is not a function of focal length. A lens whose image-circle just covers an 8x10 area can be used with an 8x10 camera, but without the capability of using adjustments. The same lens would provide ample coverage for using adjustments on a 4x5 camera. Large-format photographers frequently use the term *wide angle* to refer to a lens of great coverage, regardless of its angle of view within the film area.

Figure 5–11. *Angle of view and coverage.* The word *coverage* is used to describe the total image-circle projected by a lens. Thus the circular image area represents the total coverage of the lens shown, regardless of what camera or film format is used. The image definition and brightness are usually reduced near the edge of the circular field.

Angle of view refers to the area seem on the film. Thus the lens would have a narrower angle of view if used with a 4x5 camera than with an 8x10 camera, even though the total lens coverage and image size do not change. For view-camera use a lens's total coverage must be significantly larger than the film format if adjustments are to be used (see Chapter 10).

Thus all 90mm lenses have the same angle of view for a given film format (assuming they *cover* the format), since angle of view refers to the subject area projected *on the film*. But different 90mm lenses for 4x5 cameras may have very different coverage (total image-circle), depending on various design factors.

With all 90mm lenses, the size of a given subject will be the same, since image size depends on focal length.◁ However, the total area of the subject projected on the film will increase if the film size increases.◁ Thus a 90mm lens has a wide angle of view on a 4x5 camera, but a narrow angle when used on the 35mm format. This 90mm focal length is considered shorter than "normal" for 4x5 photography, and longer than "normal" for 35mm.

See page 45

See Figure 5–11

LENS TYPES

The Normal Lens

A "normal" lens is defined as one whose focal length is about equal to the diagonal of the film format. Such a lens will have an angle of view of about 50° to 55°, comparable to what we consider normal human vision. A 50mm (2-inch) lens is considered normal for

35mm cameras (although the actual film diagonal is about 42mm); 80mm is normal for 2¼x2¼ format; and 150mm to 165mm is normal for 4x5. (Focal lengths, or other dimensions, can be converted from millimeters to inches and vice versa by remembering that there are about 25mm per inch. Thus a 50mm lens is about 2 inches in focal length, and a 150mm lens is roughly 6 inches.)

Among small-format cameras, the normal lenses are usually the "fastest" available (i.e., they have the largest maximum aperture), although some shorter lenses may also be very fast. The normal lens may also include provision for very close focusing. These "macro" lenses are not usually faster than about f/3.5 to f/4, although they may be very sharp at normal as well as close focusing distances.

In general, I do not find the normal lens especially desirable, functionally or aesthetically. The angle of view and depth of field characteristics do not seem favorable to me in interpreting space and scale. In my experience, lenses of shorter or longer focal length are usually preferable in an aesthetic sense. I frequently find that the "normal" concepts and performances are not as exciting as those that make an acceptable departure from the expected reality. A short-focus lens makes possible exciting near-far images, exaggerating the differences of subject scale and depth. A long lens favors more accurate "drawing" of the features of a portrait, and gives a quasi-abstract impression of two-dimensionality with distant objects. On the other hand, some photographers prefer to use only the normal lens (sometimes for reasons of economy!), and visualize all their images in reference to its properties of focal length and angle of view.

Short Focal Length Lenses

Figure 5–12. *Yosemite Falls and Azaleas.* I used a 5-inch Goerz Dagor lens on 5x7 film. Tilting the lens (see Chapter 10) and using a small stop (f/45) produced great depth of field. Unfortunately the lens coverage was not sufficient for the degree of tilt employed and vignetting resulted. It is sometimes difficult to see vignetting on the ground glass unless careful examination is made.

Lenses of shorter focal length than normal project a wider area of the subject (65° or more) on the film, and thus are commonly called wide-angle lenses, particularly by small-format camera users. Short lenses are extremely useful when photographing a broad landscape, or in situations where space limitations make it impossible to encompass the desired subject area with a normal lens. Photographing the interior of a building, for example, frequently requires a short lens.

Short-focus lenses are characterized by greater depth of field than the longer lenses. In addition, they are more tolerant of camera and

See page 117

subject movement,◁ so a small camera with short-focus lens can be hand-held at relatively slow shutter speeds. (This does not mean we can be careless!)

Because of the short distance from the lens to the sharply focused image, these lenses must be positioned closer to the film than a normal lens. With single-lens reflex cameras, which have a mirror between the lens and the film plane, a short-focus lens of conventional construction would interfere with the upward swing of the mirror. This problem is averted by *retrofocus* design, in which the lens-to-film distance is actually greater than the focal length (meaning the rear nodal point is behind the lens itself). A different solution is employed by some models of the Bronica, a medium-format single-lens reflex camera. This camera has a mirror that drops away from the lens, rather than swinging up past it, so that very short

Figure 5–13. *Dennis Purcell and Rails, San Francisco.* This photograph was made with a 90mm Super Angulon lens on Polaroid Type 55 Land film. The strong perspective effect in the rails is caused by the close position of the camera, which in turn is made possible by the short focal length lens. There is no distortion in the head because it is on the lens axis.

focus lenses can be used. However, a secondary shutter is required in this camera to cut off light coming through the viewfinder (this function is handled by the upswinging mirror itself in conventional designs). When short-focus lenses are used with view cameras, a recessed lensboard may be required to position the lens close enough to the film; a bag bellows is recommended if adjustments are to be used to any extent.

Long Focal Length Lenses

Long lenses have an angle of view on the film of about 35° or less. They are useful when photographing distant objects or scenes, since they enlarge the image on the film. A moderately long lens, about double the normal focal length, is usually preferred for portraiture because it permits photographing the subject at a distance that produces pleasing perspective and allows the photographer to avoid "crowding" close to the subject.

See page 52

Long lenses have the effect of significantly reducing the depth of field of a subject. This makes them the obvious choice when selective focus is desired,◁ but more often the lack of depth of field is a problem and requires the use of small apertures. In addition, as the lens magnifies the image it also magnifies the effect of camera movement and vibration. Small cameras will therefore require the use of very fast shutter speeds or a tripod to minimize blurring of the image. With a view camera, it is sometimes necessary to use a second tripod (preferably one with adjustable center post) just to stabilize the lens. Thus long lenses frequently confront the photographer with competing demands for fast shutter speed, to reduce the effects of movement and vibration, plus small apertures for adequate depth of field. Particularly when the camera is to be hand-held, these conflicting requirements may dictate the use of high-speed film.◁

See page 120

The term *telephoto* is sometimes applied loosely to all long lenses. Actually, a telephoto lens is the opposite of a retrofocus lens: it is physically shorter and closer to the film than its focal length indicates (the rear nodal point may be in front of the lens). Long lenses of conventional design soon become large and unwieldy, and telephoto design is one way to reduce this problem.

A greater reduction in lens size and bulk is accomplished with the mirror, or catadioptric design. These lenses use mirrors in place of some lens elements, thus achieving a folded light path that

Figure 5–14. (Left) *Cottonwood Tree Trunk, Santa Fe.* This was made with a 19-inch lens on an 8x10 negative, with the camera pointed up about 35°. Because the distance to the subject was considerable and a long lens was used, no obvious convergence occurs. The surrounding scene was complex, and the long lens allowed me to isolate the tree trunk without intrusions.

Figure 5–15. (Right) *Catadioptric lens.* The catadioptric, or mirror, lens has a solid disc at the center of the front element where a secondary mirror is located. The lens shown is an 800mm Vivitar; a conventional lens of equivalent focal length would be far larger and bulkier.

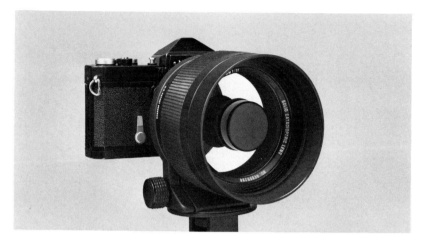

permits extremely compact designs. A mirror lens does not have an adjustable aperture, however, and so may be supplied with built-in neutral density filters to control the light intensity. Another characteristic of the mirror lens is the nature of its "flare spots" from a light source within or near the picture area. With a conventional lens these are solid discs in the shape of the aperture, but with a mirror lens they are donut-shaped. The single large aperture with such lenses limits the depth of field; they are thus favorable to distant subjects, or to closer subjects where strong selective focus is desirable or acceptable.

Zoom Lenses

The zoom lens has become increasingly popular in recent years because of the popularity of single-lens reflex cameras and the great improvements in optical coatings and computer-assisted lens design. A zoom lens is one whose effective focal length can be varied through a specific range, thus altering the image size. Once primarily used for the longer focal lengths, zoom lenses today frequently include short through moderately long focal lengths, the intention being to replace the most often used focal lengths with a single lens covering the same range. A true zoom lens should not require refocusing as its focal length is changed. Such lenses usually have maximum apertures of about f/2.8 to f/4. Unfortunately, some zoom lenses do not provide the highest image quality; I recommend careful checking at all focal lengths and focus distances before purchasing one.

A

B

A

B

Figure 5–16. *Gas tank and signs, San Francisco.* (A) Using the Hasselblad 40mm lens, with the camera carefully leveled.

(B) Made with the Hasselblad 30mm fish-eye lens. What appears as "distortion" is actually geometrically accurate, considering the extreme coverage of the lens and the flat field of the negative. If we separate ourselves from our concept of "reality," we find that a quite beautiful sense of movement can be created with such a lens.

"Macro" Lenses

This term has gained currency among small-camera manufacturers and users, referring to a lens that can be focused at close subject distances. The term *photomacrography* refers to photography at magnifications around 1:1 (life size), ranging from perhaps one-quarter life size to a magnification of 5 or 10. Beyond this range a microscope is usually required, and the term *photomicrography* applies.

A small-camera "macro" lens usually is limited to about 1:1, and may need a supplementary extender to reach that figure. Most are designed for distant photography as well as close-up work, and good examples can be among the sharpest lenses available for general small-camera work. Some macro lenses, usually of about 100mm focal length for 35mm cameras, are intended only for use with a supplementary bellows, and these may not focus to infinity. The bellows or extender may not engage the automatic diaphragm mechanism of a single-lens reflex camera.

The 120mm Zeiss Planar for medium format is especially designed for close-up work, within about 10 feet. For more distant subjects it should be stopped down; at f/16 it performed well for me at infinity focus. More information on close-up photography will be found in Chapter 12.

Figure 5–17. *Portuguese Church, Davenport, California.*

(A) Made with the 30mm Hasselblad fish-eye lens, this photograph shows the curvature of lines that results. With such a lens, a straight line that passes through the center of the image area should be straight, but all others are curved. The picture is intentionally cropped to remove distracting areas at the top and bottom.

(B) A detail of the same church, made from a closer distance than A. The design possibilities with a fish-eye lens are very great. Note that the sky in the upper left corner is lighter than on the right because it is approaching the position of the sun. The extreme angle of view encompasses a broad expanse of sky and reveals these natural differences.

Other Lenses

Fish-eye lenses. These are lenses of extremely short focal length and wide subject area (up to 180° on the diagonal or more). Some produce only a circular image within the format area, but others give a full rectangular image. Those that extend close to the film plane of a single-lens reflex camera will require that the mirror be locked in the up position. Fish-eye lenses produce a large degree of apparent distortion, although lines through the center of the image will always be straight if the lens is of good quality. The first impression given by a fish-eye lens is one of great distortion, but it soon becomes apparent that the effect is logical, especially from very close viewing distances, since all or most of a 180° hemisphere is covered. These lenses can lend an exciting visual effect, but their use can also become an easy cliché. The depth of field is, of course, very great.◁

See Figure 5–16

Symmetrical lenses. These view-camera lenses consist of two lens components of identical focal length that, when combined, result in a single lens of shorter focal length. When a single lens component is used alone, it should be placed behind the diaphragm. A separate aperture scale is usually engraved on the lens barrel for use with the single component. The most widely available example is the Schneider Symmar; a 150mm, f/5.6 Symmar converts to 265mm focal length with one component removed, and the maximum aperture becomes f/12. The single component of a symmetrical or convertible lens usually does not give as sharp an image as the combined lens, and focus shift can be expected. ◁

See page 52

Convertible lenses. These are view-camera lenses made up of two components that are capable of functioning alone or in combination to produce a shorter focal length than either unit singly. Thus a single Zeiss Protar lens may be made up of two cells of identical or different individual focal lengths. If two unequal elements are used, the longer focal length component should be placed before the diaphragm and the shorter one behind it. When used alone, however, a cell should be behind the diaphragm. As with symmetrical lenses, focus shift can be expected.

Portrait and soft-focus lenses. The term *portrait lens* usually signifies one of moderately long local length with somewhat soft definition, considered by some photographers to be a desirable quality in portraits. The soft quality can be produced by deliberately undercorrecting one or more lens aberrations. ◁ Some lenses, such as the old Graf Variable, become sharper as they are stopped down, providing some control of the degree of diffusion.

See page 74

Diffusion attachments are also available for conventional lenses to serve the same purpose. The Softar attachments for the Hasselblad, for example, are available in different "powers" of diffusion, and can be combined for greater effect. Portraits made with such a lens will minimize wrinkles and skin textures. Using diffusion lenses on the camera tends to flare the light areas of the subject, producing a glow in facial and other light values. Diffusion can also be used on the enlarger lens while printing, but the result is a flare of the *dark* areas of the print, an effect I find unnatural and depressing.

Process and enlarging lenses. Process lenses are of the highest quality, and are designed for exacting copy and engraving purposes.

See page 76

Since the subject is always flat, they are designed to have very flat fields◁ at relatively close focusing distances only. To obtain the required quality, it is usually necessary to limit the maximum aperture to about f/8 or f/11, but long exposures are not a problem in copy work. There has always been debate whether the use of process lenses is advantageous with distant subjects. In comparison with modern standard lenses I can see no advantage whatever, and perhaps this myth should be laid to rest once and for all. Process lenses do have magnificent optical quality, but small apertures are required for distant subjects. (One process lens I had showed a definite focus shift at about 30 feet from the subject.) Process lenses also do not have much coverage. Enlarging lenses, similarly, are not designed for distant subjects, and must have very flat fields in the magnification ranges encountered in photographic enlarging, since both the subject (the negative) and the image (on the printing paper) are flat.

See Chapter 10

See page 143

Perspective-control lenses. First introduced for the Nikon 35mm single-lens reflex camera, these lenses derive their name from the fact that they allow certain adjustments with a small-format camera similar to the rising, falling, and sliding front assembly of a view camera, and they can be used following the same principles.◁ A more accurate name, in my opinion, would be *convergence-control* lenses.◁ Most such lenses are restricted to a limited "shift" of the lens in any one direction, while keeping the lens axis perpendicular to the film plane. Some, however, also permit tilting the lens to adjust the plane of focus. The ability to shift the lens laterally (parallel to the film) is especially useful when photographing architecture and other subjects that must be geometrically accurate, or nearly so, on the film. Instead of pointing the camera upward or sideways to photograph the building, the camera is kept level and the lens shifted, thus preserving the rectangular shape of the structure. Lenses that provide a tilting adjustment allow the photographer to focus on a subject plane that is not parallel to the film, such as a landscape with a long receding foreground and important distant elements. The bellows construction of the Rolleiflex SL66 permits some tilt of the lens.

Supplementary and converter lenses. Supplementary lenses attach to the front of a lens assembly to permit close focusing distances.

These lenses are identified by a "power" expressed in diopters,* and when such lenses are combined, their powers are added. If you want to use supplementary lenses, it is usually best to acquire a set made by the manufacturer of your primary lens and specifically matched to it. In general, better image quality obtains by using a bellows or other lens extender, or a special macro lens, than by achieving close focus using supplementary lenses.◁

See page 179

Converters alter the effective focal length of a lens, and usually are mounted between the lens and the camera body. A typical converter can produce a 2X increase in focal length, accompanied by a loss of one or two stops in the maximum effective aperture. Like supplementary lenses, converters have often been of mediocre quality, although recently some manufacturers (for example, Nikon) have developed converters for use with specific lenses. Since lens design is extremely critical, it is obvious that adding on an optical accessory can interfere with image quality, unless the attachment is designed specifically for the original lens.

CALIBRATING APERTURES

I have frequently been surprised to find lens aperture markings that are incorrect, particularly in the small stops. With normal focal length lenses for 4x5 cameras, the larger stops can usually be assumed to be correct, at least through about f/22. Incorrectly marked apertures in the range of f/22 through f/64 can cause serious exposure errors when these stops are used.

To check the aperture markings of view-camera lenses it is easiest to use a focal-plane exposure meter, such as the Sinarsix or Calumet, which have probes that can be inserted under the ground glass at the approximate focal plane. With the Sinar meter, the probe is contained in a holder that is inserted in the camera back like a conventional film holder. A darkslide shields the meter probe from light entering the camera from the ground-glass side.◁

See Figure 5-18

The camera should be directed at a white card placed in sunlight (at a non-glare angle), and the aperture opened to its largest whole-

*Diopter is a term used chiefly by opticians to express lens power, the reciprocal of its focal length in meters. A +3 lens is a positive converging lens with a focal length of 1/3 meter; a −2 lens is a negative diverging lens with a focal length of 1/2 meter. A positive supplementary lens shortens the focal length of the camera lens, and a negative supplementary lens lengthens it.

stop value. Focus the lens at infinity, since you do not want any texture focused. Adjust the angle of the card or the lens focus position, if necessary, until the meter needle falls precisely on a high number of the scale, and then check that the needle moves exactly one unit for each stop closed down. For example, if the meter reads 17 at f/8, then it should read exactly 16 at f/11, 15 at f/16, 14 at f/22, and so on. If it does not, make a small pencil mark on the aperture scale for the position that does produce the expected reading. These

Figure 5–18. *Calibrating apertures.* The most direct procedure with a 4x5 camera is to use a focal-plane meter like the Sinarsix. The probe reads only a small circular area very close to the plane of the ground glass, and is usually positioned at the center of the field to make readings as the aperture is changed.

marks will represent the new calibration of the aperture; they should be permanently marked *only* after verifying the results of the meter test through a series of actual exposures, or by precise calibration by a competent camera technician. With a small camera, apertures can be calibrated by making test exposures, or by a camera technician.

LENS EXTENSION

As stated earlier in this chapter, the lens must be moved farther from the film plane as the subject distance decreases. As the lens is moved farther from the film, the intensity of light on the film

surface is reduced, in somewhat the same way that moving a lamp away from a wall reduces the intensity of light on the wall. The f-stop ratio is an accurate measure of the light reaching the film only for relatively distant subjects, when the lens-to-film distance is about equal to the focal length of the lens. For close subjects, the f-stop must be corrected to account for the fall-off in illumination caused by the lens extension. This effect becomes significant whenever the distance from lens to *subject* is about 8 times the focal length of the lens, or less. (Remember that any camera with through-the-lens metering reads the exposure at the film plane, and so automatically compensates for the extenson of the lens.)

The lens extension factor, or bellows factor, for correcting such exposures is:

$$\text{Lens Extension Factor} = \frac{(\text{Bellows Extension})^2}{(\text{Focal Length})^2}$$

With a view camera, bellows extension is usually measured from the lensboard to the film plane. This will be accurate provided the lensboard is located at about the rear nodal point of the lens. You can check the accuracy of this measurement by carefully focusing the camera on a very distant subject, and then measuring from the inner surface of the ground glass to the lensboard, to see if this distance is about equal to the focal length of the lens. If it is not, find a point on the camera front standard or the lens barrel that is one focal length in front of the ground glass, and use this point for measuring bellows extension.

Figure 5–19. *Maximum bellows extension.* Most flat-bed cameras, like the Wista field camera, have shorter total bellows extension than monorail cameras. Even so, with a 6-inch lens fitted to the camera, images larger than life size (1:1) can be recorded.

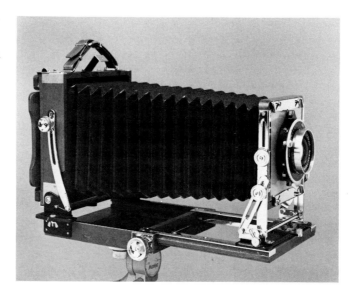

Macro lenses for small-format cameras usually include a scale for adjusting the exposure depending on the lens extension, and bellows or extension rings are accompanied by scales or tables for correction. (Some lenses give better performance when reversed for mounting on a bellows, so the rear element faces the subject; check the manufacturer's instructions.) You can also determine the total extension with any lens by measuring the distance the lens is extended from its infinity focus position and adding that figure to the focal length.

Note that the resulting quotient is a *factor* by which the indicated exposure must be multiplied to get the correct exposure. A factor can be multiplied by the shutter speed to obtain a corrected shutter speed, or it can be converted to f-stops to correct the aperture setting. For example, if we are using a 6-inch lens on a view camera, and the measured distance from the lens to the film plane is 8½ inches, the factor would be $8.5^2 \div 6^2$, or about 2. If the indicated shutter speed is 1/30 second, multiplying by 2 gives 2/30 second, or 1/15. To correct the aperture we would convert the factor to f-stops, or *one* stop (since one stop produces a 2x exposure

See page 47

change).◁ We would thus open the lens one stop from the indicated aperture, achieving the same exposure increase as changing from 1/30 to 1/15 second. You can adjust either the aperture or the shutter speed in this way, but don't do both! Even the most experienced professional will sometimes overlook this extension factor; I have done so many times, with resulting underexposure.

One situation that often arises in close-up photography is making a 1:1 (life-size) copy of an object (although obtaining precisely 1:1 magnification is very difficult). This is a special case where, for

See Appendix

optical reasons,◁ the lens-to-subject and lens-to-film distances are both equal to twice the focal length of the lens, and the extension factor is always 4, or two stops.

REFLECTIONS AND FLARE

In the days before lens coating was perfected, each air-to-glass surface in a lens wasted about 4 to 5 percent of the light striking it because of reflection. For a lens of 6 air-to-glass surfaces, this meant that less than 80 percent of the light was transmitted. With current optical coatings, a lens of 12 air-to-glass surfaces transmits more light and creates less flare than an uncoated lens of 4 surfaces.

A

B

Figure 5–20. *Flare* (Colton Hall, Monterey, California).

(A) Made with an uncoated lens, this image shows the overall reduction in contrast that results. The shadow areas receive additional exposure because of the scattered light. With color film, the flare can impart a color cast to the photograph, depending on the dominant colors of the scene.

(B) The use of a coated lens reduces the flare and increases overall contrast. The difference is sometimes quite subtle and may not be clearly reproduced in the illustrations.

Figure 5–21. (Left) *Reflections in lens elements.* Each reflection of the light source represents an air-to-glass surface of the lens. The lens shown is fully coated, reducing the effect of such reflections. Without coating, modern lenses of many elements would not be possible because of high flare levels and low transmission.

Figure 5–22. (Right) *Bellows lens shade.* An efficient lens shade is essential for reducing the amount of scattered light that reaches the film. Strong light sources just outside the picture area are the most troublesome. A bellows lens shade of the type shown can be carefully adjusted to keep light from such sources from reaching the lens. Care must be taken that the lens shade does not intrude on the edges of the image.

Modern zoom lenses, which may have 16 or more such surfaces, obviously were impossible before optical coating. Coated lenses also make the use of f-stops as a measure of light transmission very accurate, since the number of elements in a lens has little effect on the total transmission of light.

Coating the lens surface has two advantages: it increases the actual transmission of light so the lens becomes more efficient, and it reduces the amount of scattered light within the lens assembly, some of which inevitably reaches the film as *flare.* A large amount of flare striking the film will increase the overall negative density to a quite noticeable degree. If uniform over the entire film surface, its effect will be somewhat similar to that of pre-exposure (see Book 2); the density of the low values is raised, causing an increase in shadow detail, and the contrast of the image decreases. In the past I have deliberately used an uncoated lens to help reduce contrast, but pre-exposure is a much more controllable recourse. In addition, with color photography, flare conveys a wash of the dominant colors of the scene—a bluish cast when open sky is in the field of view, green if foliage predominates, and so on. The modern use of multiple lens coatings has virtually eliminated such problems.

Even with a coated lens, however, flare is likely to appear whenever there is a bright light source within, or just outside, the picture area, especially if the lens surface has dust, fingerprints, or mist on it. If the light source is actually in the picture area, there is little we can do about it. Some flare will be present, though far less with a clean, coated lens than with an uncoated or dirty one.

Flare from a light source just outside the picture area can usually be controlled by using an appropriate lens shade. One of the exasperating design failures in photography is the conventional round lens shade. A lens shade of the same proportions as the film, and of the optimum length just to avoid vignetting (i.e., cutting off the corners and edges of the image) provides the best shielding effect for fixed-lens cameras. Leitz makes rectangular lens shades for some lenses, and Hasselblad (and others) has an adjustable bellows lens shade which may be extended for maximum effect with lenses of 50mm to 250mm focal length.

In an emergency, a card or even the hand can be used to shield the lens from the sun. It is not as efficient as a full-surround lens shade, but can be invaluable when working into the sun without a lens shade. It can be difficult to judge the position for such a hand-held lens shade; it must be close enough to the lens field to be

effective without intruding on the picture area. A rule of thumb will help: If the image of the sun does not appear in the image area (but is not far outside the borders), you can hold the shield level with the top edge of the negative, so that its shadow just covers the area of the lens diaphragm. By keeping the sun off the aperture blades, you will avoid "flare spots," although you may not succeed in eliminating all of the flare.

The use of uncoated filters and polarizers adds to the problem of flare. There will inevitably be a light loss due to reflection from the front filter surface, and flare may be caused by reflections between the front lens surface and the rear surface of the filter. Two gel filters should not be used loosely together because of reflections between the two filters. It is better to place one filter behind the lens and the other in front of it, wherever possible, so each faces a coated lens surface.

For a view camera, a bellows lens shade is very useful but hazardous. Adjustments of the camera that move the lens axis away from the center of the field may introduce severe vignetting unless the shade is adjusted to compensate. Shades like the one for the Arca Swiss move with the front assembly of the camera, and include auxiliary sliding blinds to help control the area of the shade.

Figure 5–23. *Hulls, San Franciso.* An example of flare from a light source just outside the picture area. I made this photograph with an uncoated Goerz Dagor lens (manufactured before 1900), using 8x10 film. The sky just outside the picture area behind the background building caused a central flare area that reduces the contrast. I did not use a lens shade, which might have reduced or eliminated the flare. In making a fine print from this negative, some careful "burning in" of the flare area is required.

Great care must be taken when examining the view-camera image for vignetting. We focus with the lens set at maximum aperture, but some vignetting may not be visible until the lens is stopped down. Thus we must check the ground-glass image at the lens stop used for exposure (the same applies with single-lens reflex cameras, where the depth of field preview button allows us to check at the aperture used for exposure). One way to check for vignetting is to look along the edge of the lens shade through the lens, to see if the corners of the ground glass are visible. Or, if the ground glass has cut-off corners, we can look through them through the lens to see if the edges of the shade intrude on the picture area. If a mounted filter is added between the lens and lens shade, be sure to check for vignetting with the filter in place, since its mount may extend the shade far enough to cut off the image corners.

RESOLUTION AND "SHARPNESS"

Some photographic issues seem to defy precise explanation. Visual impressions are difficult to assess in verbal form, and we grope for words that encompass the qualities of the medium. One such elusive concept is *sharpness*. It is worthwhile in this volume to consider sharpness and related concepts in physical terms, but in discussing mechanical or optical issues we must not lose sight of the much greater importance of image *content*—emotional, aesthetic, or literal. I believe there is nothing more disturbing than a sharp image of a fuzzy concept!

The impression of sharpness of an image is a function of many separate factors relating to both the lens and the negative and print materials. The term *resolution* is frequently used to describe a lens's ability to produce an image that appears "sharp," but other considerations besides actual resolving power are involved. True resolving power is the ability of a lens (or a film) to render separate, fine detail distinguishably. Closely spaced lines on a test chart are photographed with the lens to measure its ability to record these lines and spaces as they become narrower. The groups of line pairs are arranged both horizontally and vertically, as an indication of the presence of astigmatism.◁

Acutance refers to the rendering of a sharp edge in the subject as a sharp edge in the photograph. An image may have high acutance without necessarily having high resolution, and vice versa. Another

See page 77

factor is the contrast of the lens; a lens with high contrast will give a greater impression of sharpness than one of lower contrast (the contrast of a lens, in turn, relates to its freedom from flare).

Since there is no one practical measure of the ability of a lens to produce a sharp image, the photographer can best evaluate a lens by comparing it with another lens. There has been a marked improvement in lens quality over the years, to the point where nearly all lenses provide satisfactory image sharpness and detail. In fact, if the expected image quality is lacking, I would first look elsewhere for the cause: poor shutter mounting, optical accessories, filters, dirt, excessive internal camera flare, misalignments of the lens or focal plane—all are likely causes of image degradation.

Diffraction

See page 44

Light passing a sharp edge (such as the aperture blades in a lens) has the property of "bending" slightly around the edge, an effect known as *diffraction* (not to be confused with refraction◁). In practical photography, this effect is significant only at the smallest apertures; the light passing the aperture blades is slightly spread and diffused, causing a reduction in image sharpness. Since at small apertures there is a higher proportion of diffracted light to the total light forming the image, diffraction accounts for the slight loss of image quality at the smallest stops. It is for this reason that many small-camera lenses do not stop down beyond f/16 or f/22. The photographer should be aware of this effect because, with diffraction causing some loss of sharpness at small apertures, and certain aberrations (see below) degrading image quality at large stops, a lens usually gives its best image quality somewhere near the middle of its aperture range. If necessary, test photographs can be made to determine the aperture that gives optimum quality.

LENS ABERRATIONS

Designing a modern lens involves a complex series of compromises that vary depending on the conditions it is to meet. No lens can be perfect, since it is impossible to fully correct all its aberrations. The designer's problem is to find the best compromise possible, taking into account the intended use of the lens and the limits of accept-

able cost. There are a total of seven lens aberrations to contend with; while there is little the photographer can do about their presence in a lens (except to avoid large apertures), it is helpful to be aware of them.

Spherical aberration (Figure 5–24). Light passing through the edges of a lens is actually focused closer to the lens than the light passing through the central area, resulting in a soft image lacking contrast. Some portrait and soft-focus lenses make use of uncorrected spherical aberration to deliberately reduce image sharpness, but in most lenses it is undesirable. It may be reduced by stopping down the lens, but a focus shift◁ usually results. A lens known to have spherical aberration must be refocused at the working aperture.

See page 52

Figure 5–24. *Spherical aberration.*

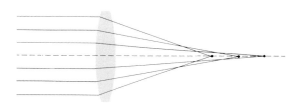

Chromatic aberration (Figure 5–25). There are two varieties of chromatic, or color, aberration, both resulting from the fact that light of different wavelengths (i.e., different colors) undergoes different degrees of refraction as it passes through a lens. Thus an uncorrected lens is not able to bring light of different colors into focus at the same point, or it produces images of slightly different size depending on the color of the light. The result can be color fringes around objects photographed in color, or a loss of sharpness in black-and-white. The terms *achromat* and *apochromat* are sometimes applied to lenses corrected for two and three different wavelengths, respectively; modern lenses are usually well corrected, and these terms are not always used. The variety of chromatic aber-

Figure 5–25. *Chromatic aberration.*
(A) Longitudinal. (B) Lateral.

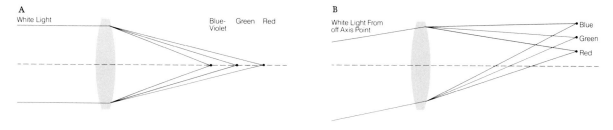

ration that affects image points on the lens axis (longitudinal chromatic aberration) is improved by stopping down the lens, but the off-axis (lateral) variety—the one that produces color fringes—is not.

In black-and-white photography we can improve an image that is unsharp because of chromatic aberration by using monochromatic color filters (filters that transmit the chief broad divisions of the spectrum—red, green, and blue). The usual choices are Wratten #47, blue; Wratten #58, green; and Wratten #25A, red. The green filter is perhaps best because it least disturbs the color interpretations of black-and-white films. With both color and black-and-white films, a UV (ultraviolet) filter can remove a possible cause of unsharpness by eliminating invisible wavelengths that affect the negative.

Coma (Figure 5–26). Coma refers to the inability of a lens to produce a sharp point image of a subject point that is away from the lens axis. The image of such a point is frequently shaped like a comet, hence the name. This fault is similar to spherical aberration in that the edge portions of the lens will focus the light at a different location than the central area. Consequently, stopping down the lens will reduce coma, although it is usually well corrected in modern lenses.

Curvature of field (Figure 5–27). A lens that cannot produce a flat image of a flat subject is said to exhibit curvature of field. A slight degree of field curvature is not a problem in landscape or portrait photography, but subjects made up of flat planes, such as architectural, engineering, or copy subjects, demand flat-field lenses. Process and enlarging lenses require a flat field, plus sharp focus of all colors. Stopping down the lens generally helps correct field curvature.

Figure 5–26. (Left) *Coma.*

Figure 5–27. (Right) *Curvature of field.*

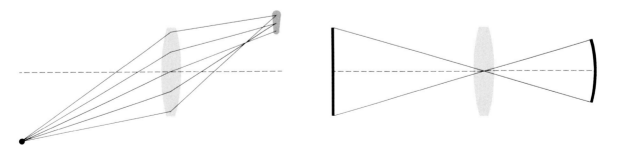

Astigmatism (Figure 5–28). With an astigmatic lens, an off-axis subject point will be imaged as a short line at one focus distance, a short line perpendicular to the first at another focus distance, and a small disc in between. It is very difficult to fully correct astigmatism over the entire field, so the lens designer works for an acceptable compromise. Astigmatism will be seen as the inability to focus sharply both horizontal and vertical lines near the edge of the film. Stopping down the lens will reduce the effect of astigmatism.

Distortion (Figure 5–29). A simple (single-element) lens will produce distorted image shapes depending on whether it is ahead of or behind the aperture. With the lens behind the stop, "barrel" distortion is introduced, and with the lens ahead of the stop, "pincushion" distortion results. It is corrected in lens design by ensuring that the distortion introduced by the lens elements behind the aperture offsets that of the elements ahead of the aperture. If present in a lens, stopping down will not help. It will be present to some degree when the single elements of convertible or symmetrical lenses are used.

Figure 5–28. *Astigmatism.*

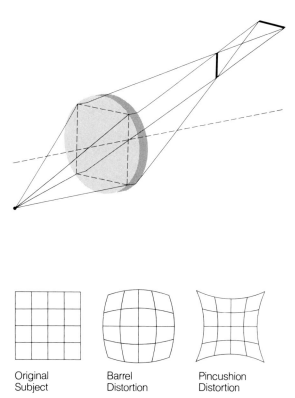

Figure 5–29. *Distortion.*

Original
Subject

Barrel
Distortion

Pincushion
Distortion

Chapter 6 **Shutters**

The shutter controls the time interval during which light is allowed to pass through the lens to the film. I can recall the time, in the early 1920s, when my means of regulating exposure times was to remove and replace the lens cap. I had a few lenses without shutters, and exposure times were usually one second or longer because of the slow speed of the plates and films (about equivalent to an ASA value of 12 to 25) and my preference for small apertures and, sometimes, a filter. With practice, I found I could manage an exposure of about 1/4 second with reasonable consistency.

The lens cap technique was replaced by mechanical shutters beginning in the latter part of the nineteenth century. The early shutters had only a "bulb" or "time" setting, for manually timed exposures, plus perhaps a setting marked "instantaneous," for exposures of about 1/25 second. These early "guillotine" systems evolved into the modern leaf and focal-plane shutter, very complex and precise mechanisms that provide the accurate timing of small fractions of a second required by contemporary fast films and lenses.

Figure 6–1. *Old Faithful Geyser, Yellowstone National Park.* A relatively short exposure, and different parts of the image show the water moving at different speeds. This sense of the motion of the water is more satisfying than the "frozen" appearance that would have resulted from further reducing the exposure time.

EXPOSURE

The total exposure of the film is a function of both the *time* the light strikes the film, controlled by the shutter, and the *intensity* of the light, determined by the aperture setting and the subject luminances (brightnesses).

The "correct" exposure for any film is always about the same total amount of absorbed light energy. Films have different sensitivity to light, indicated by their ASA index numbers. We measure the subject luminances, and then use the aperture and shutter speed settings to control the amount of light from the subject that reaches the film, so the total "exposure" is the same whether our subject is very bright or dim. The formula expressing this exposure relationship is:

$$\text{Exposure} = \text{Intensity} \times \text{Time}, \quad \text{or} \quad E = It.$$

In this formula, intensity refers to the light that reaches the film, not just the subject luminances, and therefore depends partly on the aperture setting. Relating the subject luminances with the film's sensitivity, and indicating the aperture and shutter speed that will provide optimum exposure is the function of the exposure meter (with an additional large measure of human judgment; see Book 2).

Once the desired exposure is known, the formula above shows that, if the intensity is reduced, the time must be increased to obtain the same total exposure. To facilitate such adjustments the modern series of shutter speed settings are in geometric progression, related by a 1:2 ratio, so that each shutter speed is one half or twice the adjacent value: one second, 1/2, 1/4, 1/8, 1/15, 1/30, 1/60, and so on. The rounded values—1/15 instead of 1/16, 1/60 instead of 1/64—are well within acceptable tolerance limits.*

Since this 1:2 relationship exists with both the shutter speeds and the apertures, there are always a number of different f-stop/shutter-speed combinations that will give the same total exposure to the film. For example, if an exposure of 1/2 second at f/22 is correct, then any of these other combinations would also be correct: 1/4 second at f/16, 1/8 at f/11, 1/15 at f/8, 1/30 at f/5.6, and so on. In each case the shutter speed is one half the previous value, but the aperture is opened one stop to admit twice as much light.

Most shutters have one or two additional settings for long exposures: *B* stands for bulb, which keeps the shutter open for as long as the shutter release is depressed, and *T* for time, which opens the shutter the first time the release is pressed and closes it the second time, or through a separate action such as turning the shutter speed dial. The *B* setting is usually convenient for exposures of one-half to several seconds, and *T* is useful for very long exposures. On cameras that have only the *B* setting, the use of a locking cable

*The accepted early shutter speed sequence was 1, 1/2, 1/5, 1/10, 1/25, 1/50, 1/100, 1/250—hardly a consistent progression!

release will help in making very long exposures. A stopwatch will permit accurately timed exposures.

Given a range of f-stop and shutter speed combinations that provide equivalent exposure, the photographer must consider his creative purpose and the conditions that prevail when deciding which combination to use. If movement of either the subject or camera is anticipated, a fast shutter speed will be required to prevent blurred movement of the subject on the film.◁ The use of long lenses with hand-held cameras also dictates very fast shutter speeds, since slight tremors of the camera will produce a noticeable loss of image sharpness or even a blurred image. On the other hand, if the camera is mounted on a tripod and the subject is stationary, very long exposures become practical. The photographer should be aware, however, that exposures longer than about one second may require correction for the reciprocity effect.◁

The choice of shutter speed must also be made with consideration for the aperture that will apply, as faster shutter speeds will require the use of larger apertures, with resulting loss of depth of field. There are many occasions when we must compromise between the demands for short exposure times and depth of field. In situations where these two requirements arise frequently, such as photographing news or sports events, photographers prefer a high-speed film. Such films, because of their greater sensitivity to light, permit both fast shutter speeds and small or moderate apertures when used under normal daytime lighting. Unfortunately, using high-speed film involves some sacrifice of image quality compared with slower films (film speed and related issues are discussed fully in Book 2; I will make some recommendations regarding choice of shutter speed in Chapter 8). Note that terms relating to "speed" are used in several senses in photography, and they should not be

See page 117

See page 136

Figure 6–2. *Cascade.*

(A) At a shutter speed of 1/250 second, the water is "frozen," and has a glassy appearance.

(B) At a 1/4-second exposure, the water shows movement. This may be more nearly what we see with our eyes, but the aesthetic issue of which representation is preferable differs from one photograph to another, depending on the photographer's intention.

(C) An enlargement of a section of B. The movement of the water is most clearly revealed by the trails of the scintillations. A static object, such as a rock, establishes a point of reference.

B

C

confused. Both films and shutters have speeds, the former expressed as an index number on the ASA or other scale, and the latter as fractions of a second. Lenses, too, are described as fast or slow depending on their largest relative aperture.

SHUTTER TYPES

Leaf Shutters

The leaf shutter consists of a series of blades that, when the shutter is closed, overlap to keep out light; a rotating ring opens and closes the blades during exposure. The leaf shutter is located within the lens near the diaphragm.

A timing mechanism controls the opening and closing of the blades. In some earlier shutters, the timing was controlled by an air piston and cylinder, and this system often proved extremely reliable. I have an early Compur shutter of this type in a large

Figure 6–3. *The leaf shutter.* The series of photographs shows the opening sequence of a leaf shutter. The blades open and close extremely fast, but it is impossible to construct a "perfect" shutter, i.e., one that opens and closes instantaneously.

Protar lens, and after forty years it still performs with gratifying accuracy.

Most shutters today use a mechanical gear train, similar to a watch mechanism, to control timing, or this function is performed electronically. The new electronic shutters introduced in the 1970s are marvels of design and accuracy. The practical upper limit of exposure times with leaf shutters is not generally faster than 1/500 second, since the shutter blades must complete a cycle that involves moving to the fully open position and then reversing direction to close. A leaf shutter for view camera use will also usually have a manual setting to open the shutter for viewing, although with some the time or bulb settings are used. Having a separate control lever on the shutter is best, as it eliminates the need to reset the shutter speed between viewing and photographing. Some current electronic shutters have very precise long exposure times, up to about 30 seconds, in addition to the standard fast speeds.

View camera lens are usually mounted in shutters, so that the entire ensemble is replaced when lenses are interchanged. A few shutters, however, are made for use behind or in front of a view-camera lens, and thus can be used with a variety of lenses, especially the process type. The current Packard shutter, first introduced in 1897, functions at time, bulb, and relatively slow speeds, and thus can be used for studio and field work where short exposures are not required (about 90 percent of my view-camera exposures are ¼ second or longer). Sinar also makes an excellent shutter for its view camera with a wider range of speeds.

Focal-Plane Shutters

A focal-plane shutter, as its name implies, is mounted near the film plane rather than at the lens. Early focal-plane shutters were made

Figure 6–4. *Focal-plane shutter.*
(A) The focal-plane curtain of the Nikon F moves from right to left. The slit shown, traveling very fast across the film, produces an exposure of 1/500 second.

(B) This wider curtain slit corresponds to an exposure of 1/250 second. The width of the opening increases further at a setting of 1/125 second. At exposures of 1/60 second or longer, the first curtain fully uncovers the film before the second begins moving to terminate exposure. The object of any good focal-plane shutter is to assure consistent speed and equal illumination over the entire area of the film.

These pictures were made with an electronic flash of about 1/10,000-second duration.

A

B

Figure 6–5. *Image motion and focal plane shutter*. Distortion is caused by the motion of the image at the film plane in relation to the direction the focal plane curtain moves. A fast shutter speed exposes the film through a narrow curtain slit, so that one edge of the image is exposed at a slightly different moment than the other.

 The figure at the lower left is compressed as it would be if the shutter curtain moved in the opposite direction of the image on the film. The lower right figure is elongated, indicating the shutter curtain and the image moved in the same direction.

See Figure 6–4

up of a curtain with slits of different widths and, in some cases, adjustable spring tensions to alter the speed at which the curtain traveled. One of the slits passed across the film surface to make the exposure, and different exposure times were selected by changing slit widths and curtain speed. Current focal-plane shutters usually consist of two separate curtains. As the first one travels across the focal plane it uncovers the film to begin the exposure, and the second curtain follows after a controlled interval to terminate the exposure.◁

 At longer exposures the first curtain will open completely, and, after the measured delay, the second curtain then closes. As the shutter speeds become faster, however, the second curtain begins closing before the first has fully uncovered the film, thus following the first curtain across the film. The exposure is made through the slit formed by the two curtains, and very fast shutter times are possible. Many recent cameras have shutters like the Copal-Square, using sets of metal blades that overlap like a venetian blind instead of a curtain. Since the curtains or metal blades for 35mm cameras travel at a high rate and form a very narrow slit, shutter speeds of 1/1000 second or faster are possible.

 One difficulty in designing focal-plane shutters is that, because of inertia, they tend to accelerate as they cross the film plane. Modern focal-plane shutters are corrected to ensure uniform ex-

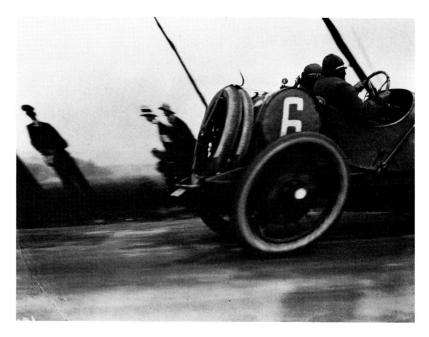

Figure 6–6. Jacques Henri Lartigue, *Grand Prix of the Automobile Club of France, 1912.* This classic photograph provides an exaggerated example of the distortion that can be caused by a focal-plane shutter. The oval shape of the automobile tire is caused by the motion of the car between the time the bottom of the tire was exposed and the top. (Remember–the image is upside-down on the negative.) The same principle caused the leaning appearance of the spectators. Lartigue turned the camera to follow the automobile (panning), and thus the image of the spectators moved at the film plane during the exposure. (Courtesy International Museum of Photography at George Eastman House.)

posures, but it is worthwhile to test by photographing an evenly lighted surface exposed on about Zone VI (see Book 2). Variation of curtain speed or slit width that is not corrected will show as a change in film density at one edge of the negative, parallel to the edge of the shutter curtains. This uneven density is especially apparent when photographing architecture, paintings, or other subjects with a continous-value area across the film. In complex subjects, such as foliage, the effect is hardly seen.

SHUTTER CHARACTERISTICS

An important difference between focal-plane shutters and leaf shutters is that the latter always expose the entire film area at the same time, while the focal-plane shutter, when set at faster speeds, exposes a continuously overlapping series of strips. Each of these approaches has its drawbacks. A focal-plane shutter can cause distortion if the subject moves during the exposure period, since the subject may be in a slightly different location when the last strip of the film is exposed than it was at the beginning of the exposure.

See Figure 6–5

For example, assuming a stationary camera and a focal-plane shutter that moves horizontally, the front edge of a moving vehicle will be recorded at a different moment than the rear edge, and the image will have moved between the times these two areas are exposed.◁ The result is that the image will be either stretched or compressed, depending on the direction the image moves at the film plane in relation to the direction of shutter curtain travel. This effect is often most clearly seen in the wheels of a moving vehicle, which become oval instead of round. If the shutter operates horizontally, the wheel will be compressed when the shutter and the image move in opposite directions, and widened when they move in the same direction. With a curtain that operates vertically, the bottom of the image will be recorded at a slightly earlier instant than the top, so the wheel would appear elongated, leaning forward. When both the camera and the subject are in motion, the effect can be quite bizarre.◁ Since a leaf shutter exposes the entire film area at the same instant, this distortion will not occur, although a wheel may show movement blur, both rotational and directional.

See Figure 6–6

Synchronization with Flash

Synchronizing a shutter with a flash source requires precise timing to ensure that the light from the flash is efficiently used to make the exposure. The different types of shutter synchronization each relate to a specific kind of flash source, whether electronic flash (X synchronization) or the various flashbulbs available (M, S, FP, and others).

See Figure 6–7A

With electronic flash the pulse of light is very brief, in the range of 1/500 to as little as 1/50,000 second, so the flash must be triggered at the moment the shutter is fully open.◁ This requirement presents no problem with a leaf shutter, since there is always a moment when the shutter is fully open, even at the fastest speeds. With a focal-plane shutter, however, the maximum speed that can be synchronized with electronic flash is the fastest at which the entire film surface is exposed at the same moment, usually 1/60 to 1/90 second with the curtain-type shutter and 1/125 second with the metal blade–type. Using electronic flash with a higher speed

means that part of the film will be covered by one or both curtains when the flash fires, and only a section of the film will be exposed.

When using electronic flash, the effective exposure time is usually only the duration of the flash pulse, even though the shutter is open longer. If the flash lasts only 1/1000 second, for example, the basic exposure of the film is virtually completed in that 1/1000 second. During the total open-shutter period, the film is exposed to ambient light (available light), but that exposure is generally so much weaker than the exposure from the flash that it can be disregarded. Electronic flash is thus very useful for photographing moving subjects, since the exposure time is very brief.

There are occasions, however, when the ambient light level is high enough to provide additional exposure of the film during the time the shutter is open. If a slow shutter speed has been used with the electronic flash, the result can be a sharp image produced by the flash surrounded by a fainter "ghost" image from the available light, especially from areas of specular reflection. It is for this reason that the ability to synchronize the flash with fast shutter speeds

Figure 6–7. *Flash synchronization.*
(A) Electronic flash gives an extremely brief pulse of light, represented by the sharply peaked curve. The shutter (the straight lines on the graph) must be fully open when the flash is triggered to ensure efficient use of the light.
(B) Flashbulbs require a certain amount of time to reach full output. As a result, the shutter must be delayed so that its fully open interval occurs at the peak of illumination from the flashbulb.
Comparison of the two graphs should make it clear that a slower shutter speed setting will not increase the exposure from the electronic flash, since its entire light output already occurs during the time the shutter is open. With the flashbulb, on the other hand, a longer exposure time will produce an increase in exposure because of the bulb's longer burning time.

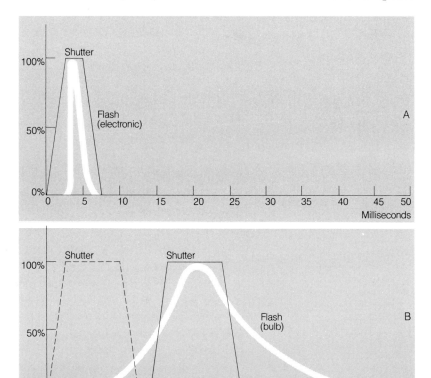

is important; the faster shutter speed reduces the exposure to ambient light, but is still long enough to admit the entire light output of the flash. In these cases, leaf shutters have the advantage over focal-plane shutters, since leaf shutters can be synchronized at their fastest speeds. Studio and commercial photographers who frequently use electronic flash may prefer a camera with leaf shutter for this reason.

See Figure 6–7B

Conventional flashbulbs present a different synchronization problem. The flashbulb requires a certain amount of time to reach its peak output after being triggered,◁ so release of the shutter must be effectively delayed. Without this delay, the shutter would open and close before the bulb reaches full output, at least at the faster shutter speeds. The most common flashbulb synchronization is *M*, which refers to medium-speed flashbulbs. In addition, the *FP* class is designed for use with focal-plane shutters, primarily the older types which require a relatively long peak output to provide even illumination during the time the curtain slit crosses the film.

The essential point is to be sure the synchronization setting on the camera or shutter matches the flash source in use. Most cameras have at least *M* for flashbulbs and *X* for electronic flash. When using electronic flash with a focal-plane shutter, remember not to exceed the maximum speed allowed by the shutter design (usually 1/60 to 1/125—consult the manufacturer's instructions).

Shutter Efficiency

Ideally, a shutter should open instantly, remain open for exactly the time interval of the shutter speed setting, and then close instantly. In fact, this is impossible, since the shutter's mechanical components take a certain amount of time to make their opening and closing movements. With long exposures the opening and closing times are inconsequential in relation to the total exposure, but they are quite significant at fast speeds. The term *efficiency* refers to a shutter's actual performance compared with a theoretical, perfect shutter that opens and closes instantly.

Figure 6–8 graphs the performance of a typical leaf shutter, compared with the ideal. The rectangular area on the graph represents an ideal shutter; the left vertical line represents the shutter opening instantly, the horizontal line shows the shutter fully open for precisely the total interval of the shutter speed, and the right vertical line shows the instantaneous closing. A real leaf shutter takes a

measurable amount of time to open (left sloping line) and close (right sloping line), and thus forms the trapezoid shape on the graph, which suggests the total amount of light reaching the film. This shape will vary from one shutter to another, depending on the speed of movement of the blades to the fully open and fully closed positions. (The time required for the movement of the blades should not be confused with effective shutter speed, which relates to the amount of light admitted to the film at a given f-stop.) The faster the blades move to open and close, the more closely the graph of the actual shutter would match the ideal. The ratio of the two areas, representing the real shutter and the ideal, is the *efficiency*. The efficiency of a typical leaf shutter is usually in the range of about 60 to 90 percent.

The actual efficiency will vary depending on several circumstances. First, note that as exposure times become longer efficiency increases,◁ since the difference between the actual and the ideal is proportionately smaller. Leaf shutters are obviously more efficient

See Figure 6–8

Figure 6–8. *Shutter efficiency.* These graphs of a hypothetical leaf shutter show actual shutter performance (trapezoid) compared with an "ideal" shutter (rectangle). At longer exposures (bottom) the time required for the shutter to open and close is relatively insignificant and efficiency is high. Short exposure times, however, are affected to a greater degree by the time required for the shutter to open and close, resulting in lower efficiency.

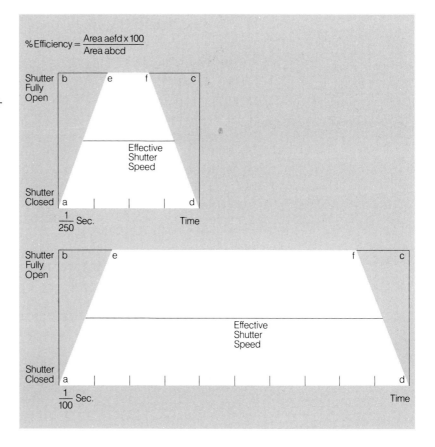

at slower speeds; at one or ½ second, the efficiency should be over 95 percent.

See Figure 6–9

In addition, the aperture selected alters the actual exposure time for a given leaf shutter setting,◁ since the blades uncover a small aperture more quickly than a large one. Thus the shutter's efficiency increases at small apertures. Its *accuracy*, however, may be greatest at large apertures if the shutter, as is usually the case, has been calibrated for full aperture. In measuring the effective "speed" of leaf shutter settings for view-camera lenses, I select f/16 as the pivotal lens stop. Evaluations made at this stop are usually within about 10 percent, the equivalent of 1/7 f-stop, a very acceptable degree of accuracy.

With a focal-plane shutter, the efficiency and accuracy are not affected by aperture. Efficiency is, however, related to the distance of the shutter curtains from the film plane, and to the speed of travel of the curtains. An ideal focal-plane shutter would have the curtains exactly at the film plane. The modern focal-plane shutter

Figure 6–9. *Shutter efficiency.* When the lens is set at a small aperture shutter efficiency is high, since the aperture is uncovered relatively quickly. Compare this sequence with Figure 6–3, where the shutter must uncover the full lens aperture and efficiency is correspondingly lower.

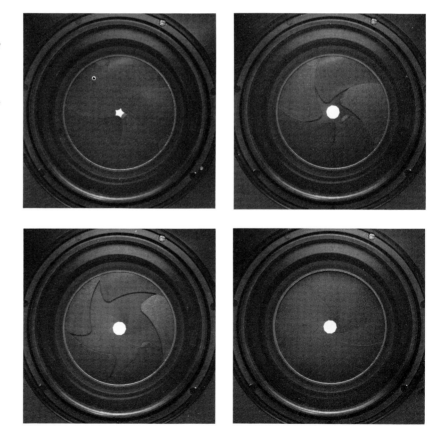

is capable of very high accuracy and efficiency. A graph of its performance would be somewhat similar in shape to that of a leaf shutter, with the efficiency increasing as the curtain-to-film distance decreases, and as the curtain speed increases. Like the leaf shutter, the focal-plane shutter has highest efficiency at slower speeds.

OPERATING THE SHUTTER

The way the shutter is released can affect the definition of the final image, since any movement of the camera during exposure reduces the sharpness. It is important never to jab or poke the shutter release button. Give it steady pressure with the ball of the finger, squeezing until the shutter trips. Many recent cameras have a ring or cup surrounding the release button, a help in applying steady pressure. Whenever possible, the thumb should rest against the bottom or rear of the camera, so the thumb and forefinger can act in a "pinching" manner, exerting opposing pressures that equalize each other. Failure to use a smooth, steady pressure can have dire consequences for image sharpness.

Cable release. The flexible cable release greatly reduces the risk of jarring the camera during shutter release. It consists of a cable within a tube, which screws into a socket in the camera. Since the release pressure is entirely equalized at the camera, the risk of disturbing the camera during exposure is greatly reduced. The cable release must be as flexible as possible, since vibrations can be transmitted through the cable itself, and must be held in a relaxed loop without tension. Cameras that use an electric cable release rather than a mechanical one are much better isolated from vibration. Most mechanical cable releases also include a lock or clamp, which can be used to keep the shutter open for time exposures using the *B* setting if no time setting is provided in the shutter (if this lock is not tightly secured, the shutter can malfunction, ruining the exposure).

Bulb and air hose. This is a very dependable way of operating the shutter. A gentle squeeze of the air bulb provides vibrationless

action, and the air hose can be of any reasonable length. Although not as precise as a cable release—building up air pressure gives a *slight* lag to the shutter action—there is almost no risk of transmitting vibration to the camera, provided the air hose is not under tension.

Self-timer. The self-timer, designed to trip the shutter after a measured interval, can be effective for making exposures with minimum risk of jarring the camera when no cable or air bulb release is available. The time delay can be as long as 10 seconds; during that time any vibrations from touching the camera will die down. However, since the precise moment of exposure is not known, this method is useful only with stationary subjects.

Remote controls. In addition to the air bulb, which can be used with a very long hose if necessary, there are various means of making exposures through electronic remote controls. Cameras for use with such systems must include a motor drive for advancing the film and resetting the shutter if more than one exposure is to be made.

CALIBRATION OF SHUTTERS

A shutter may be of good design, but, because of age, wear, or improper calibration, still inaccurate. It is important to know what the *true* shutter speeds are. They will usually be quite accurate as marked in the middle of the speed range, but may be considerably off at the slowest and fastest speeds. If a shutter set at 1/125 second actually gives a 1/100-second exposure, you are safe using 1/100 second in exposure calculations, provided the error is consistent. If erratic readings are found when a shutter is tested, however, the unit must be overhauled or replaced.

Electronic shutter testers, such as the Bogen and Sig-Tec, are available at moderate cost, but these may not be accurate with focal-plane shutters at fast speeds. A professional photographer may find it worthwhile to have such an instrument, since it will permit frequent checking of shutter performance. A camera technician can evaluate and calibrate a shutter with great accuracy.

CARE OF SHUTTERS

There is little a photographer can do in the way of shutter maintenance beyond the preventive level. Always protect the shutter from dust and dirt, and never put the camera on the ground. With roll-film cameras, be careful that foreign objects or bits of film or paper from the rolls do not fall into the camera when loading film or exchanging magazines. Be very careful to avoid mist, rain, and especially salt spray when the camera is open.

A *gentle* stream of air, or better, a very mild vacuum can be used to remove dust from a focal-plane shutter when the camera back is opened, or from a leaf shutter with the lenses removed (the latter applies to large-camera shutters, where the lenses are designed to be easily removable; do not attempt to remove the lenses unless the camera design specifically permits it). Be extremely careful, since shutter and aperture components can be injured by the use of a forceful air blower or suction.

Focal-plane shutters are exposed when the camera back is opened or removed for loading film, and are very vulnerable to impact damage. A 35mm shutter is small and less likely to be harmed, but the focal-plane shutter of a medium-format camera, like the Hasselblad 2000 FC, is large, and can easily be damaged by fingers or the corners of a film magazine if care is not taken.

Do not store the camera with the shutter tensioned unless the camera's instructions specifically state otherwise. *Never* attempt to lubricate a shutter (or aperture blades); special lubricants are used, and applying lubricant in the wrong place can cause an accumulation of dirt, which will interfere with the shutter's performance. Shutters should be cleaned and lubricated by a qualified repair technician. In addition, if photographing under severe conditions of cold, heat, or dust, consult a repair expert about special lubrication. I advise you to have a qualified technician care for your equipment; I have encountered serious trouble attempting repairs or adjustments when I did not understand important details.

Chapter 7

Basic Image Management

The process of visualization, as discussed in Chapter 1, requires learning to see as the camera sees. We accomplish this by understanding how the camera-film-development sequence modifies the subject as it records it. Once these processes are understood, we can anticipate as we view the subject the transformations that occur in each stage of the sequence.

The term *image management* refers to those controls we employ to alter the image formed by the lens and projected on the film.* By understanding these controls, we can visualize the different possible renderings of a subject at the film plane, and manage the image in such a way as to achieve the desired photographic interpretation.

To do so, we must understand the differences between the image seen by the human eye and the one seen by the camera. The photographic image, for example, is flat and two-dimensional. It has borders that define what is included and what is not; its focus, content, and point of view are fixed at the moment of exposure. These characteristics are very different from what we are accustomed to, and take for granted, in our visual contact with the world. Whether we realize it or not, we observe the world from many points of view, not just one, by means of our binocular vision (using our two eyes), and through continuous movements of the eyes, head, and body. The brain synthesizes this continuous exploration into a unified experience.

Figure 7–1. *Church and Road, Bodega, California.* In this photograph the camera position was critical. I used a 5-inch lens (Ross Express Wide Angle) and 4x5 camera on the platform on top of my car. The high position, about 10$^{1}/_{2}$ feet above the ground, made possible the long foreground area of the road. In addition, from a lower position the road would have obstructed the lower portion of the doorway. The upper part of the church was near the edge of the lens field because of the use of camera adjustments; this area is thus slightly elongated, accentuating the impression of "lift."

*The second phase of visualization, control of image values, relates to exposure and development of the negative and the making of the print, the subjects of Books 2 and 3 of this series.

The novice photographer usually learns about the differences between camera and human vision through a series of disappointments (which can be called failures of visualization). Examining a developed photograph, he "discovers" a bit of trash or a telephone pole, or he finds that the object that filled his attention when photographing appears small and insignificant in the picture, lost in its surroundings. In either case, the result is not what the photographer believes he saw when he made the exposure, and the effect he recalls is absent or spoiled by intrusions. Such disappointments usually provide the first impetus toward conscious visualization.

Once we understand the way the camera sees, there are many controls available for managing the image. The simplest involves the decision of where to place the camera in relation to the subject. We proceed to considerations of lens focal length, f-stop, and shutter speed (in relation to the optical image rather than exposure), and the use of lens and film plane adjustments, if any. Many of these decisions become intuitive with experience, but it is best to be methodical and analytical about each step of the process while learning photography; thus these image management considerations will be the subject of the next four chapters.

EXPLORING THE SUBJECT

The first important image management decisions can be made partly by eye alone as we first approach the subject. Careful consideration must be given to the placement of the camera, elementary though that may sound. Subtle changes in camera position can do much to enhance a photograph, and an oversight can ruin it.

It is important that we examine the subject with the utmost care at the outset, to see that all shapes are clearly defined and mergers of line or tonality are avoided. We may find that one part of the subject in the foreground obscures or interferes with a background area, or that a tree branch, utility lines, or other intrusions appear. I do not want to give the impression that every photograph involves arduous examination, but by practicing careful and intense seeing at this early stage, we will be able to arrive at a definitive response to the subject rapidly and intuitively.

Distant subjects are least sensitive to changes of camera position. When photographing a distant building or tree, for example, we can move the camera slightly with no apparent change in the subject's

appearance or placement in space. With a closer subject, however, the same amount of movement will have a much more pronounced effect. If we choose a single small object, such as a plant or flower, slight movement to either side may cause dramatic changes, revealing some aspects of the subject and concealing others. Gross movement about the subject may also change the character of the lighting from flat frontal light to more emphatic side- or back-lighting, separating or blending tonal values, as the case may be.

The choice of camera position becomes most important when we consider changes of the line of sight—the visual relation of near objects to more distant ones. As we move our eyes and camera to the left, the closer objects appear to move to the *right* in relation to more distant ones. Situations where foreground objects are much closer to the camera than distant ones are very sensitive to such changes. Where the difference in near-far distance is smaller, a greater shift of camera position will be required for noticeable change. Such lateral changes in position, whether vertical or horizontal, can be seen by eye as one of the first steps in visualizing the image.

Subject Distance

As we establish the line of sight to the subject, we also choose the best position along this line, that is, the distance to the subject that gives the desired spatial and visual relationships. The camera-to-

Figure 7–2. *Mariposa Courthouse, California.*

(A) I used a 12-inch lens on 8x10 film from a relatively close position. Although I used adjustments to reduce the convergence of the tower, note that the perspective—the sense of "looking up" at the tower—is still rather severe.

(B) I returned another day and, from a greater distance than A, I used a 19-inch lens to make this photograph. The foreshortening is practically non-existent compared with A.

(C) I then made this image from about the same distance as B, using a 10-inch lens with the camera on the platform of my car. Note that cropping to show only the clock tower gives the same perspective as in B.

A

B

C

subject distance is of great importance because of its effect on the *perspective* of the photograph.

We are all aware that a subject close to us appears larger than it will at greater distance, and by moving closer to a subject, we can make its image larger within our picture format. We should also understand that moving closer to or farther from a scene will have a different effect on those parts of the subject that are different distances from us. The apparent size of subject areas close to the camera will increase or decrease *more* than distant ones as we change the camera-to-subject distance.

When photographing a distant landscape, for example, we can alter the importance of a foreground tree by changing our distance from it, with little change in the appearance of the distant scene. From a position close to the tree, it becomes large and important, with the landscape as background; from a more distant viewpoint, the tree may merge with the landscape into a unified scene. In both cases, the landscape itself may change only slightly, while the closer object is radically altered by the different viewpoints. We consider such issues as mass, balance, and visual and emotional significance in evaluating the scale of foreground areas compared with more distant ones, and we can alter these relationships by changing the camera-to-subject distance.

We become aware of true perspective when considering a known geometric shape, such as a rectangular building. When seen from an angle, such a shape involves converging lines, even though we know these lines are parallel in the building. This convergence is an inevitable result of the angle at which we view the building and our distance from it, and we rely on convergence for visual clues regarding the depth and shape of the subject. Since convergence is governed by camera position, we can alter this effect at will by moving the camera laterally, to change the angle at which we view the building. We can also move closer or farther from the building. If we stand close to one corner of the building, the horizontal lines converge dramatically; when seen from a more distant viewpoint, the convergence is reduced. Thus, to repeat, *perspective is a function of camera-to-subject distance.*

With practice, we can rapidly assess visual relationships and choose an appropriate camera position for any subject. For example, imagine that I am sitting in my living room talking with a friend. My friend sits in an old chair with a delicately carved back, and on a table nearby is a spray of flowers in a tall cut-glass vase. The subject combinations are very agreeable, but as I become aware that a

Figure 7–3. *Sentinel Rock and Pine Tree, Yosemite Valley.* These two photographs show the effect of moving the camera. Both were made with the Hasselblad 500C and 50mm Zeiss Distagon lens.

(A) The considerable angle of view of the lens is apparent, and the effect is almost two-dimensional and rather dull.

(B) Moving the camera close to the tree gives a very strong sense of scale. Note that the distant mountain is about the same size as in A (it is slightly larger because the lens was focused on a closer distance), but the tree in the foreground is obviously enlarged, and a much greater sense of depth prevails. I used the depth of field scale on the lens to determine the focus setting.

A

B

possible photograph awaits attention, I begin to observe the problems of visualization. I note that, from my present point of view, my friend's face is visually confused with the lines of the chair back, and the flowers conflict with the wall paneling. If I move about two feet to the right, the face is now nicely placed with the chair back. The flowers too have moved into a better position, but they now intrude upon a horizontal shelf. I raise my head about one foot (or imagine that I do), and the flowers are now seen against a clean space. I might decide that moving away from my friend by a foot or two would further clarify the relationships of all elements.

I do not necessarily make the photograph—it may be simply an exercise in visualizing the image possibilities. The important point is the process of visualizing the photograph from different viewpoints and arriving at one that is far more satisfactory than the first glance. Experienced photographers follow similar thought sequences in making most photographs, perhaps continuing the process through more refinement with a complex and challenging subject, or reducing it to a few instantaneous decisions with a fast-moving subject.

The Viewfinder

It should be apparent that the image we see in a viewfinder or ground glass is different physically and psychologically from the eye's view. As we move with the camera, the finder image moves, but the visual experience is not the same as we have by eye alone. The finder's optical system takes us a step toward what the negative will "see," compared with the visual experience of the subject. If this fact is understood, the viewfinder image can be an important aid in visualizing the subject as seen by the camera.

See page 13

Remember that any camera that uses a separate lens system for the viewfinder is subject to the parallax effect.◁ Included in this group are all viewfinder/rangefinder cameras and twin-lens reflex models. Only with single-lens reflex or direct ground-glass viewing is parallax totally avoided. In practice, this means that any picture situation where near-far relationships are very precise and important requires careful positioning of the camera lens, before exposure, in the position occupied by the viewfinder lens during composition. Some viewfinders have provision for reframing the subject as the lens is focused, so the subject is correctly *centered* in the viewing area at close focusing distances. However, this does *not* correct

See Figure 2–5

the parallax effect, which involves the precise alignment of a near subject against a distant one.◁

INTERCHANGING LENSES

As discussed in Chapter 5, the effect of changing to a lens of longer focal length is to increase the size of the image of any part of the subject. Beginning photographers therefore often assume that the effect of changing to a longer focal length lens is equivalent to moving closer to the subject. In fact there are important differences. Since photographers often do both at the same time—change lenses and subject distance simultaneously—the effects of these two acts are often confused.

We have discussed the effect of a change in distance along the line of sight; moving closer to the subject causes nearby objects to grow in apparent size more rapidly than distant ones, so their relative sizes change. In contrast, changing the lens focal length without moving the camera does *not* alter the relative sizes of different parts of the subject. If a nearby object doubles in size because of a lens change, then all distant objects also double in size; all parts of the subject are affected equally. As a result, two photographs made from the same position with different lenses will be identical in scale and perspective; only the *subject area* revealed in each will change. If each were enlarged to yield the same size image of the same subject area and then superimposed, the two prints would match exactly.

It is worthwhile repeating that if we double the focal length of the lens, the image size of each part of the subject will double; if we halve the focal length, the image size will be reduced by one half. This fact enables us to predict the effect of a lens change. If a certain subject fills half the frame (either vertically or horizontally) with a 50mm lens, it will completely fill the frame with a 100mm lens.

Changing to a lens of longer focal length *reduces* the subject *area* covered (the angle of view). It may be useful to think of a change in focal length as having the effect of cropping the image, that is, simply bringing the borders of the image in to frame the subject more tightly with a longer lens, or expanding them if we change to a shorter lens.◁ This effect can be most directly seen by viewing a subject through a zoom lens. As the lens is zoomed the image

See Figure 7–5

A

Figure 7–4. *Buckthorn Mountain, Tonquin Valley, Canada.* (A) I used a 10-inch Dagor lens on 6¹/₂x 8¹/₂ film for this photograph.

(B) At about the same distance from the mountains, but a half mile south of the camera position for A, I used the same 10-lens and added a Ross tele-converter, giving the equivalent of about a 50-inch focal length. Note that the perspective of the mountain, and its relation to the trees in front of it, is roughly the same as would be obtained by cropping A, since the distance from which the picture was made is the same.

B

cropping changes, and each part of the subject becomes larger or smaller within the frame. But the *relative* sizes and positions of closer objects compared with more distant ones do not change, and the perspective is identical.

If we want to enlarge our primary subject within the film area—to fill most of the frame with a portrait subject's head, for example—we have two possible approaches. If we change to a lens of longer focal length, all objects within the field will be enlarged equally, without changing the size of the head in relation to the background. If, however, we keep the original lens and move the camera closer, the nearby head will be enlarged to a greater extent than the background. Understanding the difference between these two procedures will provide considerable flexibility in image management.

The most efficient procedure is first to choose the appropriate subject distance, examining the subject by eye alone, to establish the desired visual relationships of closer objects with more distant ones. From this position, we then choose a lens that records the appropriate subject area on the film, in effect "cropping" the image.

I advise much practice and experimentation with these concepts.

Figure 7–5. *Custom House Plaza, Monterey.* The effect of changing lens focal length *only* can be seen from these two photographs.

(A) For this photograph I used a 40mm Zeiss Distagon lens on the Hasselblad.

(B) From the same camera position, I used the Zeiss Sonnar 250mm lens. The visual relationships are exactly the same as in A, since the camera has not moved. The size of the fountain in relation to the building behind it is identical in both photographs. Compare these photographs with Figure 7–6.

A

B

A B

Figure 7–6. *Custom House Plaza, Monterey, California.* These two photographs show the result of changing camera distance.

(A) I used the Zeiss 40mm lens from a position close enough so that the fountain basin filled the frame.

(B) Using the Sonnar 150mm lens, I moved back until the basin again filled the frame. Note the difference in the apparent size of the fountain in relation to the building, and the altered angle of view into the fountain.

See Figure 7–7

Visualizing photographs often, with or without a camera, can help in developing the ability to respond rapidly to subjects and make appropriate image management decisions. You can learn to frame the subject approximately as the lens will see it by holding out your hands at arm's length and determining the number of finger widths needed to cover the subject area seen by the lens (one or both hands may be needed, held at varying distances from the eye, or you can use your hands to form a frame of the image area).

This procedure can be carried a step further by using a black cut-out card to aid visualization.◁ The frame is cut to the proportions of the film format and held at the appropriate distance from the eye to approximate the image area. Moving the frame closer to the eye will suggest the wider angle of view of a short focal length lens, and moving it away from the eye gives the visual effect of a longer lens. The card helps in isolating and seeing more acutely the relationships of subject elements, and observing the importance of the borders of the image. The *relative* sizes of subject elements remain the same unless we change the distance. It is seldom possible to duplicate exactly with the lens the viewing position and framing found with such a card. Instead we approximate the visual effect seen with the card using the equipment at our disposal. We can decide on further cropping of the image if we desire proportions different from those of the film format.

A

B

Figure 7–7. *Use of the cut-out card.*
The cut-out card, with an opening
in the proportions of the film
format, can be used to suggest pos-
sible images within the surrounding
areas. Composition of the final
image will depend on choice of
lens, camera position, etc., and
thus cannot be worked out with
great precision with the card.

(A) An area of interest is viewed
through the card.

(B) A trial image is stimulated by
exploration and visualization using
the card as in (A).

(C) Further use of the card helps
to clarify new formal and spatial
relationships. The camera was
moved slightly, and a lens of
appropriate focal length was chosen,
in this case an 8-inch Ektar on a
4x5 camera, with a small lens stop.

C

Subjective Properties of Lenses

See page 97

It should be clear that "wide-angle perspective" and "telephoto perspective" are imprecise terms, since perspective relates only indirectly to the actual lens focal length. True perspective depends only upon the camera-to-subject distance.◁ We have all seen photographs that obviously were made with a wide-angle lens. The parallel lines of a building or other rectangular shape converge dramatically, and there is often a great feeling of depth in the photograph. The foreground seems tangibly close to the viewer, and the space encompassed from border to border seems very large and open. In a portrait, the features are usually rounded, and may even be distorted so that a hand extending toward the viewer is larger than the head, or the nose projects prominently.

These characteristics are caused by the short camera-to-subject distances that are usual with short lenses. If photographing a building, the camera is usually close to it so the structure fills the frame, with the result that the parallel lines of the building show exaggerated convergence. If making a portrait, we are likely to move in to fill the frame with the subject, creating a feeling of closeness but also perhaps causing a distortion of the features.

See Figure 7–4B

We recognize images made with long lenses by the apparent "flatness" of the subject. The feeling of space and depth is compressed, and the borders of the image seem more abrupt. The flatness of space is again caused by camera position (distance) rather than focal length. The subject area is located farther from the lens, so the differences in distance of various subject elements become relatively insignificant.◁ With a long lens and greater distance to the subject, a portrait face may have a rather flat appearance.

See page 143

We can use these properties to enhance the subjective qualities of a photograph. In architecture, a sleek modern building might suggest a dramatic approach, using a short lens and moving close to the building to enhance its angular nature and to obtain a feeling of its "presence." Camera adjustments might be used to correct the vertical convergence,◁ but even so the photograph would have a certain dramatic nature. An older, stately building might suggest a more classical approach, using a longer lens from a greater distance. The building would then appear more geometrically natural with emphasis on its proportions and solidity. All such impressions are partly subjective, and there are no rules that must be followed. We should follow instead the dictates of our visualization.

Similar choices arise in portraiture, where it is usual to employ a

lens of about twice "normal" focal length to obtain approximately the natural visual rendering of features—neither distorted nor too flat—at a comfortable working distance. Departures from this standard focal length may be used for emotional and aesthetic effect.

There are other visual effects that relate to lens focal length. As discussed in Chapter 5, short-focus lenses give great depth of field. When photographing with a hand-held camera under low available light conditions, a short lens offers distinct advantages. At full aperture it will still have adequate depth of field for many situations, and it can be hand-held at slower shutter speeds than a longer lens without blurring. A long lens, on the other hand, can be used when minimum depth of field is desired for selective focus.

It is worthwhile to practice "seeing" and image visualization at every opportunity. You can start by making an effort to observe the countless significant relationships of things in the world around you. Much facility in photography can be gained by seeking related shapes and value progressions that are otherwise taken for granted, and by shifting viewpoints to see the effect in clarifying obvious confusions.

"Dry shooting" is my term covering practice in visualization with and without a camera. Pictures can be organized, tonal qualities visualized, notations made—without actually making an image. It is a process that greatly enhances command of the medium.

I recommend that the beginner start photographing with one lens, to minimize the complexity of the process, and add lenses judiciously, becoming familiar with one before acquiring others. There is also much to be learned by studying published photographs to determine the image management procedures involved; in a sense, visualizing in reverse to "see" the original subject. We have no assurance that changes of camera position would actually be possible because of environmental considerations, but such issues need not affect our imagined alterations. We might think of lowering the camera, or moving it to one side to avoid mergers and separate foreground objects from distant ones. Or perhaps moving the camera closer to the subject would "open" the spaces. By continually practicing observation, we can learn to visualize the image possibilities of any subject quite readily.

Chapter 8 Hand-Held Cameras

Mobility is a great virtue of the hand-held camera, and it should be fully appreciated and enjoyed. By using a hand-held camera, we can relate to the non-static aspects of the world—objects and people in motion, singly and in groups. The masters of the small camera, such as Henri Cartier-Bresson and W. Eugene Smith, learned through practice and experience to seek what Cartier-Bresson calls the "decisive moment." When our subject is fleeting relationships and expressions, we must make decisions about viewpoint, framing, and the decisive moment to expose almost instantly, in contrast to the more contemplative approach of stationary subjects with static, tripod-mounted cameras.

Recording these brief moments introduces a new factor in image management called *anticipation*. Through practice, we learn to anticipate instants of high intensity, the *visual* peaks of activity. We must also take into account the slight delay between the mental impulse to expose and the actual instant of exposure, a psycho-physical lag caused by the complex chain of human and mechanical actions involved in operating the shutter.

Anticipation becomes intuitive in successful small-camera photographers, although some learn it more quickly, and employ it with greater facility, than others. Cartier-Bresson, for example, is so "tuned" that he responds to the movements of several individuals at the same time. In the introduction to his classic *The Decisive Moment*, Cartier-Bresson expressed the challenge to the photographer:

Figure 8–1. Henri Cartier-Bresson, *Children Playing in the Ruins.* Cartier-Bresson is a master of the small camera, making photographs such as this at precisely the "decisive moment" when the various moving elements come together in a unified composition. (Courtesy Magnum.)

> To me, photography is the simultaneous recognition, in a fraction of a second, of the significance of an event as well as of a precise organization of forms which give that event its proper expression.
>
> I believe that, through the act of living, the discovery of oneself is made concurrently with the discovery of the world around us which can mold us, but which can also be affected by us. A balance must be established between these two worlds—the one inside us and the one outside us. As the result of a constant reciprocal process, both these worlds come to form a single one. And it is this world that we must communicate.
>
> But this takes care only of the content of the picture. For me, content cannot be separated from form. By form, I mean a rigorous organization of the interplay of surfaces, lines and values. It is in this organization alone that our conceptions and emotions become concrete and communicable. In photography, visual organization can stem only from a developed instinct.

The same principle applies to various subjects, such as facial features during a portrait session. The face is usually in constant motion, passing rapidly from one expression to another, showing both appropriate expressions that represent the personality of the subject and atypical expressions that do not. We frequently see the latter in the unfortunate caricatures of public figures so often published by the news media. A good portrait photographer learns to develop understanding and rapport with his subject quickly, and to photograph the moments that reveal the genuine personality.

It is tempting with small cameras and roll films to make a great number of exposures to be "safe." True, there will always be *one* that is better than the others, but that does not mean it is a good photograph! The best 35mm photographers I know are efficient and make relatively few exposures. They know what they want to do, and do not rely on the "scattered" approach.

This is not to deny the validity of exploring with the small camera. The pictures, in a sense, can be constructed and refined as a sequence, almost a cinematic experience. The fact that this approach is relatively wasteful of exposures is of little concern if justified by the results. I wish to reaffirm that, while I believe in the basic, "classic" approach to photography as the most rewarding, at least while learning, there is no limit to the personal scope of the medium. Photography is, indeed, an inclusive language.

HOLDING THE CAMERA

Secure support of the camera during exposure is important, and the supporting structure we are discussing here—the human body—is relatively unsteady. Slight movement during exposure is often the

cause of serious degradation of image quality, although photographers often seem to prefer to blame their equipment, usually criticizing the lens quality!

It is, first of all, important that the photographer stand in a comfortable and relaxed position. A position that requires a half-crouch or leaning posture invites unsteadiness and, if necessary, is best attempted with additional support. After strenuous exertion, it is best to rest a few minutes before photographing, since muscular tremors and heavy breathing can interfere with steady camera support.

The position of the hands gripping the camera is partly determined by the location and means of operating the camera controls, and partly a matter of personal preference. With 35mm cameras, most photographers use their left hand as the primary support, forming a cradle for the camera with the hand and bracing the arm against the body. The left hand can then also operate the focus and aperture controls if they are conveniently placed. The right hand provides additional bracing, and controls the shutter release and film advance. With most medium-format cameras, the left hand acts as a camera platform, and the right hand operates all controls.

Remember to brace both arms against the body without straining, if possible, and above all handle the camera in a *relaxed* manner. The grip should be firm but not too tight, since squeezing the camera will cause muscular tension, and tremors will be transmitted to the camera. The positioning of the hands will change if the camera is used vertically, but the same concerns are paramount: firm support and access to controls. It is worthwhile to experiment with different postures and grips, to find the one that gives you the best support and access to controls. Once you have found the best position, practice it until it becomes automatic.

Heavier cameras, such as medium-format models, offer both advantages and drawbacks when hand-held. Their primary advantage is that their greater inertia tends to minimize the effect of small vibrations, such as those caused by the mirror of single-lens reflex cameras. However, such a camera will cause muscular fatigue more quickly than a smaller, lighter unit.

See page 116

These considerations and others will indicate a certain minimum shutter speed you can confidently use with hand-held cameras.◁ Whenever conditions require a slower speed, I strongly recommend additional support for the camera. Rest it or your body against a door frame, tree, or fence post; support your elbows on a table, automobile hood or, when sitting on the ground, your knees. Consider whether a monopod, tripod, or chest support can be used.

Any additional support will help ensure sharp images. When unsharp images occur because of camera movement, the direction of motion can be detected by noting which lines or edges in the image are sharpest, since these will be parallel to the direction of camera motion. Lines perpendicular to the direction of motion will be least sharp.

If you observe people using an eye-level viewfinder or single-lens reflex camera, you will note that they often hold the camera in a tilted position, obviously causing tilt of the image. The cause is often a common vision defect known as *extraocular imbalance,* which results in an unequal level of the eye axes when the muscles are in repose. When using one eye to look into the finder, the photographer with this imbalance unconsciously tilts the camera.

Those who have this eye condition should consult their doctor. Prescription lenses can be obtained to correct this effect, either in eyeglasses or in lenses that can be incorporated in the eyepiece of the viewfinder. The problem can also be controlled if the viewfinder contains horizontal or vertical reference lines. Some people with this condition also have difficulty viewing stereoscopic pictures. The images "float" together, with one uncontrollably higher than the other.

A simple visual test for extraocular imbalance is to focus on some near object and then bring a finger about one or two feet in front of the eye. Do not focus on the finger. You will see two out-of-focus images of the finger between you and the object focused upon. With correct eyesight the two images will appear to be at the same height, but if extraocular imbalance is present, one image will be lower than the other.

CAMERA POSITION AND VIEWPOINT

Figure 8–2. *Brassai, Yosemite Valley, 1973.* Using an 80mm lens on the Hasselblad, I moved fairly close to the subject to stress his personal intensity, yet not close enough to produce distortion. I focused on his eyes, a dominant feature of this remarkable photographer, and used a small stop to secure optimum depth of field. The image is cropped slightly from the full negative.

We discussed in the last chapter the issues involved in selecting camera position. With the mobility of the hand-held camera, there is little excuse for failing to explore fully different camera positions to find one that suits your interpretation of the subject.

Approaching the subject should be a process of continuous motion and exploration of visual relationships. Attention must be directed not only to the subject, but to the background and foreground, the position of the borders, the direction of light, and so on. As discussed, a very small change in camera position can make

a great difference in the visual relationships within the photograph.

Remember too that you need not view the world only from a full standing position. It may be that moving the camera lower, to waist level or even to the ground, will bring an improvement in organization to the photograph. Some single-lens reflex cameras have provision for removing the pentaprism so the photographer can view down onto the focusing screen with the camera held in a low position.

A high vantage point can also dramatically alter the organization of a photograph, expanding the view of the foreground and giving more sense of depth. Try standing on any available secure support, such as a chair, stairway, or natural object such as a boulder. For years I have had a car-top platform capable of supporting me and my largest cameras, because of the potential advantages of a viewpoint elevated by 5 to 6 feet above normal.

You may have seen photojournalists achieving a high viewpoint by holding their cameras overhead, usually when trying to photograph over a crowd. This approach is not entirely haphazard: by using a wide-angle lens the photographer ensures that the subject is framed accurately enough (for journalistic purposes, at least) with room for cropping, and that the depth of field will be adequate. He focuses in advance and then watches the subject closely to choose the best moments for exposure, usually assisted by a motor drive on the camera. The crowd, which obstructs his own view of the subject, simply becomes part of the foreground from the elevated camera position. Clearly, this procedure should be reserved for emergencies.

FOCUSING

There are a number of techniques that are helpful when photographing moving subjects, and all involve the element of anticipation, being fully prepared to make a photograph. In addition to presetting the exposure controls, there are steps you can take to ensure that a minimum of time is spent in focusing.

Most small cameras today incorporate focusing systems that can be operated very rapidly. In choosing a camera, it is wise to investigate the focusing system and viewing screens or rangefinder, to be certain these operate efficiently with all lenses to be used. This is partly a matter of personal preference, and some experi-

mentation may be required. Eyeglass wearers should be especially careful to find a camera they can use conveniently when focusing and viewing. Some cameras provide better visibility of the viewfinder image than others for people wearing glasses, and many permit the addition of prescription lenses at the eyepiece so the camera can be used without glasses.

I suggest also that you practice estimating the distance of subjects before focusing, when time permits, and then check your estimate with the scale on the lens. When proficient, you will find that you can pre-focus the lens as you approach a subject. More precise pre-focusing is sometimes possible with a moving subject. You may be able to anticipate that it will be in a certain location, and then focus on the *location*. When the subject arrives at that place, you need only release the shutter. Situations where pre-focusing can often be helpful include sports (for a high jumper, you can focus on the bar, since he will be directly above it at the peak of his jump) or news events (if an important person will be passing through a doorway, focus on the doorway or just in front of it).

A related technique is *zone focusing* (not to be confused with the Zone System, which relates to exposure and is fully discussed in Book 2). This involves pre-focusing so that all subjects in a certain range of distances (zone) are within acceptable depth of field limits.

See page 52

Using the hyperfocal distance principle,◁ for example, you may be able to set your camera so that everything from 10 feet to infinity is in the region of acceptable depth of field, and can be photographed without changing the focus setting. (The hyperfocal distance rule tells you that to obtain depth of field from any distance to infinity, focus at *twice* the desired near limit of depth of field and stop down as needed.)

You can also focus in advance on a zone that extends from, say, 5 to 16 feet by using the depth of field scale engraved on the lens barrel. If you are photographing at a social or sports event, for example, you may be able to predict that your subjects will be within these limits, and photograph them without specific refocusing for each subject.

I advise caution, however, when using depth of field in this way. If your principal subject is near the limit of the focusing zone you may not consider the resulting sharpness acceptable. You may want to be on the safe side by working within the f/8 marks on the focusing scale while the camera is set at f/11, for example. Remember also that these techniques will work when using a normal or short focal length lens; with a longer lens the depth of field is usually inadequate for accurate prefocusing.

SHUTTER SPEED

The choice of shutter speed must be made with consideration for the subject, whether moving or stationary, and also for the loss of image sharpness caused by slight camera movements during exposure. The general rule to observe whenever the camera is hand-held is to *use as fast a shutter speed as you can*, consistent with the requirements of exposure and depth of field. Tests I conducted some years ago, photographing distant leafless trees against the sky, indicated that, using a normal lens with a hand-held camera, the *slowest* shutter speed that ensured maximum sharpness was 1/250 second. I found that even with firm body support image sharpness was noticeably degraded at 1/125 second, a speed that many photographers consider safe for hand-holding a camera with normal lens. With a lens of longer than normal focal length, even shorter exposure times will be required: 1/500 second with a 100mm lens and 1/1000 second with longer lenses, as a guide. Situations occur where these speeds are not possible because of other requirements, but remember that using a slower shutter speed will probably cause a loss of sharpness unless additional support is used.

Moving Subjects

Motion of the subject introduces image management considerations not present with stationary subjects. The problem of visualization becomes more complicated because the camera can see a moving subject in ways the eye cannot—freezing motion in a small fraction of a second, or allowing the effect of movement to accumulate over time in a single image, unlike anything we experience with our eyes. However, it is possible to learn to anticipate the effect of certain shutter settings and subject situations, and to visualize at least approximately the final image.

Several factors will affect the amount of blurring that occurs with a moving subject at a given shutter speed. One is the subject's distance from the camera. A jet airplane, traveling at hundreds of miles an hour high overhead might be photographed at 1/250 second with no apparent blur, but the same shutter speed might not fully arrest the movement of a bicyclist who passes very close to the camera. The critical difference is the distance to the subject; simply moving back from the bicyclist would allow us, at some point, to photograph him without blur.

The important element in determining how much blur will occur is not the actual speed of the moving subject, but the speed of its image *across the film plane.* By moving farther away from the subject, we reduce its speed of movement on the film to the point where, for all practical purposes, the image is stationary during a given time of exposure, and no blur shows. Similarly, a lens of shorter focal length reduces the amount of movement of a given subject at the film plane, and enables us to photograph it successfully at a somewhat slower shutter speed than with a longer lens. We must also consider the degree of enlargement anticipated. An image may look acceptably sharp in the negative size, but reveal disturbing effects of motion in an enlargement of 4X or 8X.

The direction the subject is traveling is also important. In the case of the bicyclist, a faster shutter speed will be required if he is traveling directly across our field of vision than if he is moving toward or away from the camera. An object that moves toward or away from the camera only appears to grow larger or smaller, but does not race through the picture area as it does when moving across the field of view; thus its movement at the film plane is relatively small. An object traveling at an intermediate angle will require a faster shutter speed than one traveling directly toward or away from us, but a slower shutter speed than one moving across the field.

Thus the factors affecting the choice of shutter speed with a moving subject are (1) the speed and direction of motion, (2) the distance from the camera, and (3) the focal length of the lens. Understanding the way each of these affects the motion of the *image* at the film plane will help you to make intelligent decisions about shutter speed when confronted with a situation involving subject motion.

Moving subjects and changing conditions also invite the use of zoom lenses, and the best of these have improved in quality to the point where there is relatively little penalty in optical sharpness. However, you must be sure to use a shutter speed fast enough to arrest the movement of the camera and the subject at the longest focal length of the lens (the largest image) if you use that focal length frequently.

See Figure 8–3

For some subjects, you may not wish to freeze the motion, since partial or total blurring can sometimes be effective in communicating a sense of speed or activity.◁ It is difficult to make specific recommendations regarding appropriate shutter speeds for such situations, since different degrees of blurring may be acceptable with different subjects. As a starting point, try shutter speeds in

the range of 1/15 to 1/60 second, which should be fast enough to provide moderate sharpness of the stationary parts of the subject, while permitting some blurring of moving objects. Slow shutter speeds, of course, may require the use of a tripod. If you are using a camera that accepts a Polaroid back, a few test prints can be made to examine the effects of subject motion, if time permits.

A related technique is known as *panning* the camera. This term means simply moving the camera to follow the subject. If correctly done, the image of the moving subject will be relatively stationary on the film because of the camera's complementary motion. The background, on the other hand, moves rapidly through the image

Figure 8–3. *Train, near Salinas, California.* This photograph of a rapidly moving freight train demonstrates that blur due to motion is related to distance. At an exposure time of 1/250 second, the near freight car shows movement, while the more distant cars are sharp.

area and is recorded as a blur. This approach is frequently used at sports events and races, since it simulates our visual impression. We tend to follow the primary subject with our eyes, and the background is an indistinct blur if we are aware of it at all. You may want to experiment, starting with shutter speeds of about 1/30 second with a normal lens. Again, Polaroid test prints, if possible, will be very helpful.

Operating the Shutter

The way the shutter is released can affect the sharpness of the final image if it induces any movement in the camera. Remember not to jab or poke the shutter release button; give it steady pressure with the ball of the finger and squeeze, so that the pressure of the finger is offset by pressure of the hand at the base or side of the camera. Be certain to hold the camera securely, resting the arms against the body if possible, and relax to reduce muscular tremors. Cold weather or exertion can cause shivering; when photographing you should wait until the trembling has passed, or use a tripod.

It should also be noted that some causes of camera vibration are internal, and thus beyond the direct control of the photographer. The movement of the mirror in a single-lens reflex camera causes definite vibrations, although modern cameras have built-in dampers or a slight electronic delay to allow the vibrations to die down. For critical applications, some cameras permit the mirror to be locked in the up position before making the exposure, but this procedure will require the use of a tripod.

EQUIPMENT AND OTHER CONSIDERATIONS

A photographer who knows he will frequently be photographing moving subjects can make his equipment decisions accordingly. Fast and convenient operation of controls becomes a major consideration in selecting a camera, and a built-in meter system can prove of great value, provided its operation is fully understood.

Some photographers who must be ready to photograph instantly prefer to leave the lens cap off at all times. Since this involves obvious risk to the lens from dirt and abrasion, I suggest placing a

clear glass optical flat, or an ultraviolet or skylight filter, over the lens. If damaged, the filter can be replaced at little expense compared with the cost of the lens. However, there is no point in using such a filter if the lens cap is ordinarily in place over the lens, since an inferior filter may cause some loss of image sharpness.

There is a definite trend in 35mm cameras to the use of a motor drive or auto-winder, the latter being a lighter-duty version of the motor drive. In general, I would recommend using such a unit only if you find you miss photographs because you cannot advance the film quickly enough with the hand lever. Otherwise, it only adds to equipment weight and expense, and promotes a "shotgun" approach to photographing, which some photographers substitute for active use of the eye and brain.

It should be clear that a number of interrelated elements contribute to success or failure in using hand-held cameras. Probably foremost among these is the element of *anticipation*. A photographer who is aware of the developing potential for a photograph in advance is in a position to make appropriate decisions regarding camera location, lens focal length, shutter speed, and aperture before the "decisive moment" arrives.

Anticipation comes into play even earlier, in making the choice of camera and lenses, and which film to use. Although films are primarily the subject of Book 2, it should be noted that a film's speed (i.e., its sensitivity to light) is a major factor in determining the range of f-stop and shutter speed settings that will be possible under given light conditions. Not only can a high-speed film provide the sensitivity required in low-light situations, but it also permits the use of small apertures and fast shutter speeds for brightly lighted subjects. Thus film speed can be an important consideration if you intend to photograph rapidly moving subjects, especially if you will be using long lenses. The combination of long focal length and subject motion will dictate very fast shutter speeds, and the lens will have very little depth of field unless stopped down. Such combinations of aperture and shutter speed become possible only when a high-speed film is used, even though such films have more grain than slower films. Perhaps your general guideline should be to use the fastest film that gives you acceptable quality.

Ultimately, it is the eye and mind of the photographer that determines the quality of images produced. The factors discussed here, primarily technical and mechanical in nature, can help you

be prepared for situations you may encounter, and ensure that you have adequate information for the essential decisions. Beyond that, continual practice in visualizing and photographing will be of greatest help.

| Chapter 9 | # Cameras on Tripods |

With the camera mounted on a tripod, the photographer adopts a more contemplative and precise attitude toward his subjects than is usual with the camera hand-held, and the subjects chosen tend to be more static. The basic image management considerations remain the same, but using a tripod permits fine adjustments of camera position, more precise location of the borders, and better control of visual relationships. It also opens up all the visual possibilities of time exposures, whether simply for greater depth of field via small apertures, or for the sometimes surreal effects of long exposures with moving subjects.

THE TRIPOD

Figure 9–1. *Mission San Xavier del Bac, Tucson.* Because of the complex planes of the subject, I had to rely chiefly on a small aperture to secure depth of field, though I did swing the camera back slightly to bring the left-hand wall into better focus. With the middle pillar sharply focused, I used a small stop to bring the more distant surfaces into focus, while keeping the camera back precisely vertical. I used Polaroid Type 55 P/N Land film with a Schneider 90mm Super Angulon lens.

The tripod is essentially a simple device, but if poorly designed or constructed, it can cause inferior image quality and endless frustration. I have lost a number of potentially important photographs because of tripod misbehavior or failure. Therefore I recommend that, when considering the purchase of a tripod, you inspect it carefully for rigidity, adequate height and adjustments, and ease of operation. Tripod legs that slip or bind, and tilting parts that do not lock securely, can be most exasperating. Selecting an appropriate tripod is usually a matter of compromise between weight and bulk, versus strength, extension, and versatility. The obvious defects will appear on careful examination, but others become evident only after continued use. You should certainly seek the

advice of serious photographers and honest dealers in this important matter.

The tripod is made up of extendable legs, secured and pivoted in a yoke. To the yoke is attached either an adjustable center post carrying the tripod head, or, in a few cases, the head itself. Nearly all tripod heads permit rotation and tilting of the camera, horizontally and vertically.

Tripod legs. These can be single or multiple elements, usually metal rods or tubes, but occasionally still available in wood. Of the metal units, most are tubular or U-shaped in cross section, to provide maximum strength with minimum weight, and are often made of aluminum or other light alloy. Various locking mechanisms are employed to secure the leg extension, including some quick-release designs that may prove convenient. The locks should be examined for their security and ability to withstand wear. Brass bushings are far less likely to jam than plastic ones.

The legs terminate with fixed or retractable spikes for outdoor use, or rubber or plastic tips to provide firm contact without damage to floors. The spikes are preferable outdoors, since they provide firm, inelastic contact with the ground; with larger tripods a "step" may be provided for pressing the spikes into the ground with the foot. The rubber tips for indoor use must be of a hard rubber or plastic, to avoid vibration and slight "bounce" of the camera.

Tripod legs are usually stopped, that is, limited in their spread by the configuration of the yoke. This feaure adds security when working on a smooth floor. If stops are not provided, you may want to place the tripod on a dolly for added stability when working indoors. The dolly also allows the camera to be wheeled about easily, or moved on nylon slides.

Outdoors, however, leg stops limit the tripod's ability to adjust to rough terrain. If most of your photography involves outdoor locations, you can have a skilled camera technician remove or reduce stops, but there must be no weakening of the leg/yoke assembly, and secure locking of the leg position must be ensured. Some tripods have adjustable stops allowing for different angles of the tripod legs, very convenient on rough terrain.

Additional rigidity is provided by braces that attach the legs to the center column. This design can be helpful with a lightweight tripod, which otherwise may be quite flimsy, but such construction, again, is best for studio use or on level ground. On uneven

terrain, the ability to adjust the angle of each leg separately is important. The tripod position can then be adjusted by changing the angle as well as the length of each leg independently.

The tripod legs are hinged at the yoke. It is important that the legs be attached in wide sockets with substantial bearings and axles to ensure maximum resistance to torque, or twisting of the tripod head and yoke.

The center post. Nearly all tripods today have an extendable center post. Those that did not in the past could be adjusted lower to the ground by shortening or spreading the legs, but the convenience of the center post elevation control is usually preferable. Some tripods permit low-level camera positions by using a separate arm (the Majestic tripod) or by removing the center post and inserting it upside down (the Quick-Set and Tilt-All).

The center post slides up and down through friction clamps, or it may be controlled by a crank-and-gear system. The crank design is generally preferable *if* it is strong enough to withstand wear without stripping the gear threads. With some lighter tripods, the clamp system is adequately secure and less subject to wear and

Figure 9–2. *Tripod with side arm.* The Majestic tripod permits attachment of a side arm for low camera positions. The center post elevation is used to adjust height. For lower positioning, the camera can be tilted on its side. Some tripods permit attaching the camera at the bottom of the center post for low viewpoints, although the resulting camera position between the legs can be awkward. Using the side arm assembly as shown increases the possibility of vibration, and direct support of the arm may be necessary.

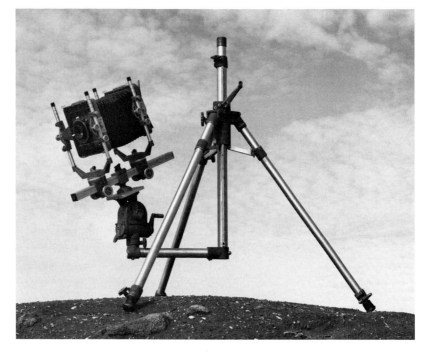

damage. There is also one Linhof tripod design that allows the cen-
ter post to rotate in a socket in the yoke, offering adjustment of
lateral position. The tilt controls in the tripod head are then used to
maintain the level positioning of the camera.

Tripod head. The head or top of the tripod adjusts to permit various
vertical, horizontal, and rotational camera positions, depending
on the design. Some units permit no side tilt of the camera, so that
leg adjustments must be used to level the camera on uneven sur-
faces; others tilt fully to left or right. The camera platform should
be as large as possible for the camera(s) used, and should include a
non-slip surface.

The security of the locks on the tripod head is of utmost impor-
tance. All pivots and bearings should be as large as possible, and
locks should operate on a large surface area. There is a simple test
for the stability of the head and other components: set up the tri-
pod on a firm surface, and, while bearing down on the top, try to
twist it. If it yields under moderate or strong pressure, the tripod
is certainly inadequate for a view camera. You should also test the
tripod with the camera attached; exert pressure and torque to the
camera bed or rail. If the camera deflects under such pressure, it
should immediately rebound firmly to the original position when
the pressure is removed. These tests will be most informative if
several tripods are compared at the same time. You should also test
See page 131 for resonant vibration of the camera and tripod.◁

The tripod head may also include engraved degree marks indi-
cating rotational position. This feature can be very helpful when
working in a restricted area, where there is limited access to the
front of the camera for setting the shutter and aperture. After com-
posing the picture, note the degree indication and rotate the cam-
era to adjust the settings; then return the camera to the indicated
position. (A small industrial mirror is also helpful under tight
operating conditions.) This degree scale is also helpful when mak-
See page 184 ing panoramic photographs.◁

There is no avoiding the fact that a heavy camera requires a
rigid, and therefore heavy, tripod. While tripods for large cameras
may weigh up to 20 pounds or more, some lighter tripods for small
cameras are surprisingly stable, particularly if the legs are securely
braced to the center post. In choosing a tripod you must consider
the cameras to be used, as well as the need for portability versus
strength. For maximum stability when using any tripod, suspend a

weight (such as a camera case) from the bottom of the center post or the yoke to increase its effective mass.

Monopod

The monopod is a frequently overlooked device that deserves mention. A monopod is simply a single rod, usually in extendable sections like the legs of a tripod, that has many valuable uses with small cameras when extra support is needed but a tripod is not practical or not available. To be useful, a monopod should be long enough to permit the photographer to stand comfortably with the camera at viewing level, and a swivel ball head will be convenient if the camera is to be used horizontally and vertically. The inevitable lateral movement of the camera can be controlled somewhat by pressing the monopod against the leg or body, or by bracing it against a camera case or large stone. A tree trunk, railing, or, indoors, a piece of furniture, can provide excellent stability, and the foot can be pressed against the bottom of the monopod to hold it in place. Used carefully, the monopod can provide relatively stable support, and allows longer exposures than you might attempt with the camera hand-held. In an emergency, it can also substitute for a second tripod in situations calling for two tripods. ◁

See page 131

Tripod Accessories

When using a tripod capable of great extension, a stepladder can be a valuable accessory for attaining a high vantage point. Many industrial and architectural photographers have a tripod head attached directly to a strong stepladder. A tripod platform atop an automobile or small truck can also be useful in this regard; be certain the vehicle is not moving or vibrating because of the wind or people moving about inside. Jacks or blocks should be placed under the frame for full stability.

The photographer should also keep one or two extra tripod screws on hand. For some cameras a quick-lock attachment is available. One part clamps to the tripod head and the other to the camera, so that attaching or removing the camera involves only the locking or releasing of a clamp that secures the two elements together. Be certain that such devices are strong enough to hold the camera securely in any position, and that they lock decisively.

Care of Tripods

Tripods should be cleaned periodically to remove dirt from all components, particularly clamps and threaded elements. Lubrication may also be required, but should not be excessive (consult a camera technician on the appropriate lubricants to use for the various materials). Clamps and other threaded parts made of aluminum should be treated with care and *never* over-tightened, since the threads may break down.

USE OF THE TRIPOD

Figure 9–3. *Mormon Temple, Manti, Utah.* Even using camera adjustments, I was required to tilt the camera upward slightly, causing convergence. In this photograph, however, the convergence lends an impression of height, which is augmented by the elongation of shapes near the edge of the field. I was using an 8-inch wide-angle lens on 8x10 film.

Many photographers casually set up the tripod and use the various tilts and adjustments in a haphazard way. It is preferable, however, to be more methodical in setting up the tripod, if time and situation permit, to provide precise positioning of the camera and the greatest possible stability.

Before attaching the camera, the tripod legs should be extended to approximately the desired height. Equal extension of each leg is ensured by making the adjustment while the legs are folded together. The center post elevation should be used as little as possible, and then only to make minor height adjustments. The tripod is far more stable with the legs extended than it is with shorter leg extension and high center post elevation. The leg extension or angle should be adjusted to compensate for uneven ground when necessary, and in such a way that the center post is *vertical*, to keep the weight of the camera evenly distributed among the three legs. Use caution whenever it is necessary to tilt the center post away from the vertical, since the center of gravity shifts and the tripod may become quite unstable. In addition, if the center post is raised or lowered when it is not vertical, the camera will shift position laterally as well as vertically, and may cause image management problems.

Position the tripod, when possible, with one leg pointing toward the subject, parallel to the lens axis. There will then be space between the other two legs for you to stand behind the camera with minimum risk of kicking or tripping over a tripod leg. Once the legs are adjusted so the center post is vertical, the tripod head can be carefully leveled. If both the yoke and the head are level (the yoke

is level if the center post is vertical), the camera can be rotated in any direction without disturbing the level orientation.

You can then attach the camera, securing it firmly with the lock on the tripod screw if one is provided. With the camera on the tripod, check for vibration and instability. If you must tilt the tripod head sideways to make a vertical photograph, be sure that the shift in weight distribution does not make the tripod-camera ensemble unsteady. Similarly, if the camera is tilted severely up or down, the weight distribution will shift, and you should again check the stability. With monorail view cameras the center of gravity can be adjusted by moving both the front and back standards toward the front or rear of the rail. If a sliding rail is provided, it can be used to slide the entire camera forward or back as required. Be sure to tighten the sliding rail carefully in the final position.

Vibrations that will reduce image quality may arise in an otherwise well-matched camera-tripod unit because of resonance. Every object has a resonant frequency, and if the wind or other force sets up vibrations at that frequency, they may persist for 10 seconds or longer. Such vibrations can be reduced by weighting the tripod, by applying solid pressure of the hand (be careful not to move the camera), or by wrapping the tripod legs in heavy tape. If such resonances are persistent, try the tripod with a different camera, or replace it. I have had many annoying experiences of this kind, including one 19-pound tripod of great strength that nevertheless vibrated when used with a small 2¼ x 2¼ camera.

I want to emphasize again that all locks on the tripod legs and head must be securely fastened. Seeing a tripod collapse with the camera because of inadequate tightening of the locks is an unforgettable experience! Even if it does not collapse, an inadequately tightened adjustment can cause the camera or leg to slip gradually out of position before or during exposure.

Once the camera has been set up on the tripod, many photographers carry the unit from one location to another fully assembled, folding the legs together and carrying the whole ensemble over the shoulder. Before doing so, check the locks on the head *again*; even if tight enough to secure the camera with the tripod upright, they may slip when the tripod is tilted for carrying.

When a large camera is poorly balanced because of a heavy lens or long extension of its rail or bed, a second tripod may be needed. The second tripod can be of lighter construction, but it will be most helpful if it has a geared center post. It is placed under the lens or extended camera bed, and the center post elevated until it engages

Figure 9–4. *Wooden Shutters, Columbia Farm, Los Angeles.* Even with the highest elevation of my tripod on the ground, I could not see over the top edges of the shutters to reveal each distinctly. For this photograph, I placed the tripod on the back platform of a pickup truck, achieving the height required to clear each edge. Everything in the *subject* was a bit askew, but the center of the front shutter is vertical, and this establishes a certain orientation.

the camera or lens. Maximum stability will be obtained if the camera is pointed down *slightly* after composing, and the second tripod then used to apply upward pressure to bring it back to its original position (avoid excessive strain, of course). With a view camera I start with the rising front slightly elevated, and then lower it if necessary to correct the image framing. The second tripod may also be needed in a strong wind, although the camera or bellows should still be shielded as much as possible with the body to prevent vibrations. If a second tripod is not available, a monopod will prove helpful.◁

See page 127

CAMERA SETTINGS

With the camera secured to a tripod, it is no longer essential to use only fast shutter speeds, as different requirements may prevail. Longer exposure times become common, both because smaller apertures are desirable to increase depth of field and because slower films can be used to improve image quality. Long exposures introduce several new considerations.

Subject Motion

Figure 9–5. *Rocks, Alabama Hills, California.* This photograph was an attempt to relate a number of rock shapes in an image of some movement and vigor. About 30 seconds before I made this exposure, there were no clouds to disturb the rock shape on the right. I waited because gusts of wind were moving the shrubs in the foreground, and with an exposure time of ¹/₂ second, they would have been unclear. Unfortunately, the movement of clouds while I waited interrupted the clean edge of the rock at the right. I used a 12-inch lens on my 8x10 camera.

With the camera stationary, only movement of the subject must be dealt with, and some subjects that are essentially static at typical hand-held shutter speeds can exhibit a disturbing degree of motion at longer exposures. The best example is movement caused by the wind: with near- to middle-distance foliage, even a slight breeze can cause enough movement to obliterate fine detail at exposures longer than about 1/30 second. The problem is obviously more severe with stronger winds, when even distant trees move visibly during the exposure time. The factors that determine the seriousness of the problem are the same as with hand-held cameras and moving subjects: distance to the subject, focal length of the lens, speed and direction of motion, and, of course, exposure time. Using fast shutter speeds may be the only solution, even at the expense of depth of field.

In most cases, an acceptable shutter speed and aperture combination can be found. Most modern films are sensitive enough to provide an adequate range of choices, at least in full daylight, but

conflicts can arise. You may be working under low illumination levels, early or late in the day, or you may want to use a very slow emulsion, at the same time desiring to arrest the subject motion and secure great depth of field. Obviously, a compromise is called for, perhaps involving visualizing the photographs with less foreground, and therefore less demand for depth of field. Or if the wind is causing your problem with subject motion, you may simply have to wait for it to subside!

As mentioned in the last chapter, there are also situations when a degree of subject movement during exposure can effectively communicate the sense of motion. A wheat field in which some stalks are blurred can convey a sense of the moving wind. Water in motion is another example; the camera can record moving water in ways the eye never sees, sometimes with great visual effectiveness. A

Figure 9–6. *Rocks, Alabama Hills, California.* The composition has considerable energy, chiefly because of the relative scale of the near and far rocks and the echoing of the rock shapes. I used a 10-inch lens on 8x10 film, and focused at the far edge of the shadow, stopping down to f/45 for depth of field.

very short exposure can freeze each water droplet, suggesting a solid, glass-like substance, while a very long exposure can produce an image in which the water takes on a flowing or misty appearance. Usually an intermediate shutter speed, perhaps 1/30 or 1/60 second, produces an image most like our visual impression, combining both sharp and flowing effects.

These examples should serve to indicate the nature of the decisions the photographer must make, regardless of the specific subject. Throughout much of his work, the photographer encounters the competing issues of small aperture for depth of field and fast enough shutter speed to arrest subject motion. Only with a truly stationary camera and subject, or when we can tolerate a certain degree of image movement on the film, do we have a relatively unrestricted choice of shutter speeds.

Figure 9–7. Wynne Bullock, *Sea Palms.* This is an excellent example of the multiple-exposure effect. The negative was exposed several times using a very small lens stop, producing the cumulative image. If each exposure were short the final picture would have been made up of many sharp images—a completely different effect. (Courtesy Center for Creative Photography, University of Arizona.)

Reciprocity Effect

The use of very long exposure times raises another potential problem because of the *reciprocity effect* (its full title is "failure of the Reciprocity Law"). Since it relates to exposure, the reciprocity effect is fully discussed in Book 2, but a few comments should be made here. We take for granted the relationship of shutter speeds and apertures; a change from 1/60 to 1/30 second is equivalent to opening the aperture by one stop. The same is *not* true, however, when exposure times are very long (or very short). Because of the reciprocity effect, if our meter indicates an exposure time of 4 seconds, we may actually have to give 10 seconds or so to secure the densities we expect.

For purposes of this volume, it is sufficient to issue a warning: If the indicated correct exposure time is longer than one second, or longer than about 1/8 second with some color films, you may have to adjust the exposure (and filtration, with color film) to compensate for the reciprocity effect. Instructions can be found with the film data sheet, or obtained from the manufacturer. Since the correction required differs from film to film, compensation is rarely indicated on exposure meters, and the photographer must determine the adjustment himself. An exception is the Sinarsix focal-plane meter, which has, among various dials for special purposes, one that indicates reciprocity effect adjustment. However, even this should be considered as only a guide for careful experimentation. Since the reciprocity effect alters the negative contrast (by altering the low-density areas before the high-density areas), further compensation is required by reducing film development.

Focus and Aperture

The use of a tripod implies that the photographer will have time to make a very careful check of the ground glass or viewfinder image. All visual relationships should be carefully examined, including the relative positioning of different subject areas, location of the borders, parallax (if any),◁ and, of course, focus and depth of field.

See page 13

With subjects of great depth, focus must be adjusted carefully, using the principle of focusing about one third of the way from the nearest to the farthest objects that must be sharp.◁ Some medium-format camera viewing systems include a magnifier that permits very precise examination of focus; with a view camera, I urge you

See page 51

to survey the ground glass carefully using a magnifying lupe. I use a pair of "distant" eyeglasses equipped with flip-down magnifying lenses, which allow for sharp, fast, and comfortable focusing at about 5 inches from the ground glass

Once the plane of sharpest focus has been established, the lens is stopped down to include the required foreground and background areas, and focus is again checked if the image is bright enough. With a single-lens reflex camera, the manual "stop down" lever will permit a visual check of the approximate depth of field, but remember that greater demands will be placed on depth of field in subsequent enlarging than with the viewfinder image.

In compositions involving near-far relationships, my opinion is that we should usually favor the near in focusing. The close parts of the image that have "presence" require maximum sharpness, even at the expense of less critical focus for distant areas. This is a subjective choice and will differ from one photograph to another, but I often try to bring the near and "touchable" elements into maximum sharpness, and only then concern myself with the focus at greater distances.

I also think that any part of the subject that is to be out of focus should be *definitely* so. Slight unclarity can be much more distressing than obvious out-of-focus softness, since the latter can usually be ignored by the eye, which is then helped to concentrate on the

Figure 9–8. *Factory building, San Francisco.* The problem was to position the camera for minimum confusion of edges and shapes. I suggest trying to visualize slight changes in camera position; the clearances of the roof lines and overhead wires, and other subtle relationships, may be lost with even small movement of the camera. The photograph does reveal one defect: the camera back was not precisely vertical, and slight convergence is apparent at the right edge. Inserting the 8x10 film holder may have caused the back to sag a little. Older cameras, especially wooden ones, are subject to wear and misalignment, and should be checked if you have doubts.

See page 52

focused areas. Selective or differential focus◁ can be very helpful aesthetically, by contrasting sharply defined planes with others that are definitely out of focus.

Extreme depth of a subject will tax the depth of field capability of a lens. In situations where the near and far areas are well separated in the field, the view camera's adjustments may offer a solution. By tilting the lens and film plane, the photographer can align the depth of field region with the important planes of the subject.◁

See Chapter 10

Such adjustments are also the only means of avoiding convergence in the image of lines that are parallel in the subject, when the camera axis is not perpendicular to them. With a small- or medium-format camera, lacking adjustments, there is little that can be done about such convergences except to try to make use of them effectively in the composition. A few lenses for 35mm cameras, and some medium-format cameras, permit a limited degree of adjustment for "perspective control" through tilting or shifting of the

See page 65

lens.◁ These lenses can be used following the principles outlined in Chapter 10.

Figure 9–9. *Boards and Thistles, San Francisco.* This represents an image typical of the Group f/64 period (1932), in this case a definitely two-dimensional composition in which the "movement" and balance are on a single plane. There is little depth in the composition except for the implied space behind the boards (which are actually part of the wall of an old barn). I used an 8x10 camera and 12-inch Goerz Dagor lens, with the film plane parallel to the boards both vertically and horizontally. Obviously, a tripod was necessary. I recall that my only problem was a strong wind moving the foliage; I had to wait for a quiet moment between gusts which would permit a 1/5 second exposure at f/32.

View-Camera Adjustments

Figure 10–1. *Rail Fence, Thistle and Teton Range, Wyoming.* I used a 4x5 view camera and 121mm Schneider Super Angulon lens, with Wratten #12 filter. The tripod was fully extended so that the line of sight allowed for ample separation between the top of the fence and the base of the mountains. I stood on a sturdy camera case to manage this position.

The camera was thus pointed down (as the high horizon line shows). The focal plane can be considered a straight line from the near thistle to the distant mountains, and I tilted the camera back backwards to match the plane of focus. No convergence problems existed even though the back was not in full vertical position. Had any rectangular structure, such as a barn, appeared in the scene, I would have set the back vertical and used the front tilt to correct the focus. As the thistle was quite close to the camera, I used a small amount of back swing to further correct the overall focus.

The view camera provides adjustments that allow us to alter the relationship between the lens axis and the film plane. With a non-adjustable camera this relationship is fixed: the lens axis is always perpendicular to the film plane, and passes through the center of it. The view-camera adjustments (sometimes called camera movements) permit shifting and tilting of the lens and film up and down or sideways in relation to each other. Knowing how to use these adjustments gives us an extraordinary degree of control over the content and focus of the image.

Reviewing the basic components of a view camera, note that the front standard and rear standard are independent, supported on a rail or bed and connected only by a flexible bellows. The front standard, which carries the lens, and the rear standard, containing the ground-glass viewing screen, are each fitted with separate pivots and locks that allow them to be moved and tilted in virtually any direction, within limits of the bellows's flexibility.

These adjustments provide control of three separate functions: the position of the image borders, the plane of focus, and the shape of the image. The controls are not entirely independent; in making an adjustment to alter one of the image properties, we may also be causing a change in another. But for learning purposes we first consider them separately.

RISING, FALLING, AND SLIDING ADJUSTMENTS

As a starting point, we will discuss the mechanisms that keep the lensboard and film plane parallel to each other (unless they have

been deliberately set at a different orientation using the tilt or swing adjustments). Most modern view cameras are equipped with rising, falling, and sliding adjustments at both the front and rear standards; some flat-bed and other designs have fewer adjustments at the rear than at the front. In either case, these adjustments are used primarily to control the position and the borders of the image, without altering its geometry (shape).

See page 54

See Figure 5–11

To understand the operation of these controls, recall our discussion of lens coverage.◁ All lenses project a cone of light, forming a circular image at the film plane within which the film area is located.◁ If we keep the lensboard and film plane parallel but shift either lens or film laterally in any direction, the effect is to shift the image-circle in relation to the film, so that a different subject area falls on the rectangular film area.

See Figure 10–2

For example, if we raise the lens, we will see on the ground glass that more of the top of our subject comes into the image area (at the *bottom* of the ground glass, since the image is inverted), while we lose a comparable area at the bottom of the subject.◁ Use of the rear *falling* adjustment (on cameras equipped with it) lowers the film in relation to the lens, producing the same effect. Similarly, sliding the front assembly to the right (or the back to the left) will reveal more of the right portion of our subject area and less of the left, and so on.

From this description, and seeing these changes on the ground glass for the first time, it may appear that the effect is the same as simply turning the entire camera. In either case, we "reframe" the subject, including more at one edge and eliminating a portion at the other edge. The important difference, however, is that turning the camera alters the image geometry—the actual shape of the image—while using the sliding adjustments of a view camera does not.

The image geometry is primarily controlled by the position of the film plane in relation to the subject. When we point a non-adjustable camera in a different direction, we can observe the shape of the image changing (especially if using a short focal length lens with nearby subjects). This change in image geometry is due to the change in orientation of the camera back. Use of the sliding adjustments, however, does not change the angle of the camera back in relation to the subject, and no change in image shape results.

See Figure 10–5

The classic example of this difference is photographing a tall building.◁ With a non-adjustable camera, we must point the camera upward to include the top of the building. In the resulting image the parallel vertical lines of the building are not parallel; they con-

Figure 10–2. *Effect of rising front.*
The rising front adjustment can be
used to alter the position of the
image within the borders, while
keeping the lensboard and film
plane parallel. The drawing shows
the image of a subject repositioned
through this lens shift. Since the
subject is rectangular, tilting the
camera to include the top of the
structure would cause convergence;
if the camera back is kept vertical
and the rising front adjustment
used, no convergence will occur.
The same principle applies (in
reverse) with the falling back, if
available, and to the use of the
sliding front and back. However,
the rising front and sliding front
move the lens, and the relationship
of near and far subjects will change.

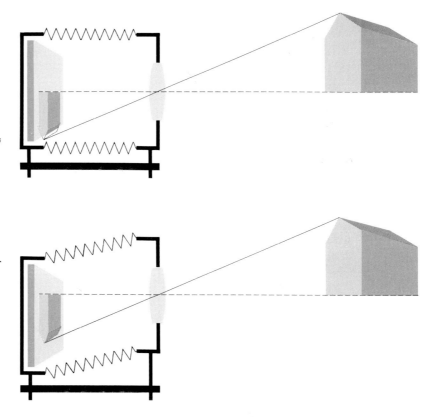

See Figure 10–3

verge. The cause of the convergence is the fact that the building
facade is vertical but our camera back is not, since the camera is
pointed up. If we use a view camera, carefully leveled with the back
parallel to the facade, and raise the lens to include the top of the
building, the vertical lines will remain parallel in the image.

Convergence is an important concept, and one often misunder-
stood. When a rectangular subject is viewed head-on, all parallel
lines of the subject appear to be parallel. However, when viewed
from an angle, the parallel lines appear to converge (become closer
together) as they become more distant. This is a normal visual
phenomenon, and one used by painters when they want to convey
a sense of distance and depth (the third dimension) on the two-
dimensional surface of the canvas. They relate the converging lines
to a vanishing point, since this concept is useful when drawing
parallel lines in perspective.◁

Thus convergence is not necessarily a fault, but often an im-
portant part of an image in lending a sense of depth and perspective.
In photography, however, convergence can appear exaggerated and

Figure 10–3. *Perspective.* The concept of vanishing points, used by artists when drawing in perspective, applies to photographs as well. In the case of a building photographed from an angle, the parallel horizontal lines of both sides of the building converge at two vanishing points. If the swing back adjustment is used to keep the camera back parallel to one of the building surfaces, the parallel lines of that side will be parallel in the photograph.

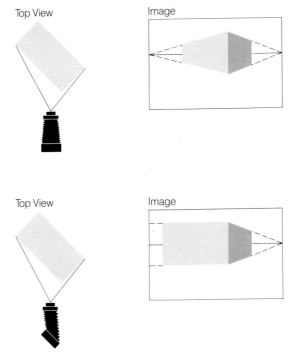

unreal because of differences between the camera and the eye. In the eye, the image is formed on the curved surface of the retina, while the film in a camera is flat. The eye has the additional advantage of being connected to the human brain. When we look up at a tall building, the eye-brain system assures us that the vertical lines are parallel, and we suffer no sense of disorientation. In a photograph made with the camera improperly aligned, the converging lines of a building can give the appearance that the structure is leaning or falling. The adjustments of a view camera allow us to restore the image of the building to its expected natural shape.

The rule in photography is that *when convergence of parallel lines is to be avoided, the camera back must be parallel to the lines.* Thus if we level our view camera with its back vertical, and then use the rising front (or falling back) to center the building in the ground glass, the vertical lines will be parallel. *Horizontal* convergence presents a similar situation. If we want to photograph a building head-on but are prevented from doing so by an obstruction (a tree, for example), we can position the camera to one side of the building facade and use the sliding front and rear adjustments to center the building in the image area. If we keep the camera back parallel to the building, we will avoid convergence.◁

See Figure 10–14

Figure 10–4. *Railroad tracks.* A good example of perspective, in this case involving a single vanishing point, since all important lines in the subject are parallel to each other. Such converging lines can be important in lending a sense of depth to the photograph.

Side View

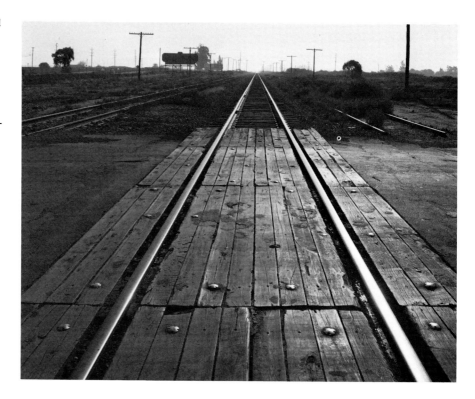

Figure 10–5. *Using adjustments to control convergence.* The rising front can be used to "look up" at a tall building while keeping the camera back vertical to avoid convergence.

(A) If the entire camera is pointed up to include the top of the building, the parallel sides of the building will converge in the image.

(B) With the camera carefully leveled, the rising front may be applied to maintain the correct geometric rendering.

In cases where the camera's rising front is inadequate to bring the top of the building into the image area, the falling back may be added. If necessary, the camera may be pointed upward and the lens and film planes tilted to vertical, providing the same effect as added rising front capability. The lens's coverage will limit the total of such adjustments. When photographing a building head-on, as in this example, the camera back must be parallel to the building in the horizontal direction, as well as being vertical.

A

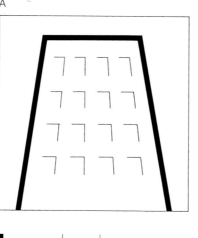

B

It may appear from this discussion that architectural subjects are the only ones where camera adjustments are required, but in fact they merely provide the most convenient examples. Other situations where rising, falling, and sliding adjustments are used will be discussed later in this chapter. However, a few observations and cautions should be made at this point.

As discussed, opposite sliding adjustments at opposite ends of the camera have the same effect in principle—rising front and falling back, sliding the front to the right or the back to the left, and so on. Thus if a camera has only limited adjustment of one standard in a particular direction, we can employ the opposite sliding adjustment at the other standard to increase the effect. I must point out, however, that these "opposites" are similar but not identical, for one important reason. Any adjustment that moves the lens laterally will alter the viewpoint slightly, and thus may disturb critical near-far juxtapositions. We can shift the camera back in any direction without affecting the viewpoint, but a corresponding shift of the camera front does move the lens and alter the viewpoint slightly. There are situations in which a mere one-inch change of viewpoint may cause interference of foreground objects with distant ones, so you should be aware of this potential difficulty.

Vignetting

Another problem you must beware of is vignetting, which occurs when part of the negative area falls outside the image-circle of the lens and thus receives no exposure. Since many of the adjustments involve shifting the ground glass and film in relation to the image-circle, there is considerable risk of vignetting, especially when using a lens with an image-circle only slightly larger than the film format.

See page 149

See Figure 10–6

See page 34

Any adjustment that moves the lens axis away from the center of the ground glass carries the risk of vignetting; such adjustments include all the sliding controls, plus any swing or tilt of the lens.◁ Swings and tilts of the back, however, do not generally produce vignetting, since the position of the lens axis remains relatively fixed in relation to the film.◁ Note also that vignetting can occur with a lens of good coverage caused by the presence of a lens shade or filter attachment, which may reduce the effective size of the image-circle. Another potential source of vignetting, discussed in Chapter 4,◁ is a bellows that is pinched or sagging.

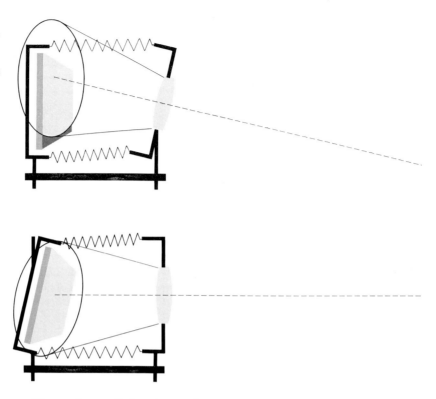

Figure 10–6. *Vignetting caused by lens tilt.* The use of any adjustment that moves the lens axis away from the center of the film area may cause vignetting. From the drawings it can be seen that tilting the lens risks vignetting, while tilting the camera back generally does not.

Vignetting will first be visible at the corners of the ground glass, and these should be checked carefully after the adjustments have been made. In some cases the vignetting will not be visible until the lens has been stopped down. If your camera has a ground glass with corners cut off to permit air to escape, look through these corners and through the lens; the *entire* aperture should be visible or vignetting will occur. You can also check for vignetting by looking through the camera from the front, to see if the corners and edges of the ground glass are visible through the lens.

Illumination Fall-Off

The edge of a lens's image-circle invariably receives less illumination and shows poorer definition than the center, although these effects are not usually noticeable with a non-adjustable camera. When adjustments are used, however, a part of the negative that is in the extreme edge of the image-circle often shows a marked fall-off in density.◁ You may find that the edge of the negative farthest from the lens axis requires holding back during printing (see Book

See Figure 10–6

3) if uniform densities are desired. In early days the picture-taking lens was often used as the enlarging lens, so that the illumination fall-off recorded during the exposure would be counteracted during enlarging. This system worked quite well in many instances, but the final image quality is superior if enlarging is done with a lens designed specifically for that purpose. If poor edge sharpness is a problem, it may help to use the lens well stopped down. With a lens of limited coverage or poor edge definition, it is advisable to use swings and tilts at the camera back, rather than at the front, to take advantage of the improved image quality near the center of the lens's field.

BACK SWINGS AND TILTS

We have already discussed the rule governing convergence of parallel lines: if we want to photograph them without convergence, we must keep the camera back parallel to the lines. The general rule for all subjects, with or without parallel lines, is that if we want to photograph without geometric distortion, we must keep the camera back parallel to the plane of the subject. In the case of the building discussed earlier,◁ we keep the back vertical to avoid vertical convergence, and we must align it parallel to the horizontal lines of the building to avoid horizontal convergence. In short, if we keep the plane of the camera back parallel to the plane of the building facade we will achieve a geometrically accurate rendering of the facade.

See page 142

The reason the back alignment is so important can be seen by considering what happens to the image-forming light as it travels from the lens to the film plane. If two subjects of equal height are imaged at different distances behind the lens, the image that travels farther from lens to film will be larger, and the image formed closer to the lens will be smaller. If we change these distances by tilting or swinging the back, we will change the sizes accordingly. The rear swings and tilts thus give us considerable freedom to alter the apparent shape of our subject.

Consider again the case of the tall rectangular building photographed head-on from ground level. We know that the top of the building is equal in width to the bottom, but the top *appears* smaller, being farther away. In correcting convergence, we orient the camera back in such a way that the top and bottom of the building are of

equal width on the film, in which case the lines connecting them (the vertical lines of the building) do not converge, but are parallel.

Similar corrections are helpful with natural subjects. A row of pine trees is made up of vertical shapes, and we can maintain their parallel nature by keeping the camera back vertical when photographing them. With other subjects that are of less regular shape we may be able to tolerate some distortion, in which case we will be free to use the tilt and swing back to control focus (see below). There are also situations where we use the swing or tilt of the back to *exaggerate* the convergence effect, providing an apparently "steeper" perspective. In such cases we tilt the back in the direction opposite the one required to reduce convergence.

Since the tilts and swings of the rear standard do not move the film laterally in relation to the lens axis, we can use them with little fear of vignetting, although illumination fall-off may occur. These adjustments do alter the position of the film in relation to the plane of focus, and they must often be used in conjunction with the front tilts to control sharpness and depth of field, as discussed below.

FRONT SWINGS AND TILTS

Tilting the lens is used to adjust the plane of focus. We can visualize the effect of lens tilts if we consider three important planes: the film plane, the plane of the lensboard (i.e., a plane through the lens perpendicular to its axis), and the plane in the subject area that is sharply imaged on the film. With a non-adjustable camera, these three planes are always parallel. When we tilt the lens, however, the plane of focus in the subject also tilts in the same direction, but to a greater degree than the tilt applied to the lens.

When the lens is tilted, the subject's plane of focus can be envisioned as a taut string stretching from the nearest to the farthest points that are sharply focused. Lines drawn through the film plane and lensboard will intersect with this imaginary string at one point.◁ This principle, known as the Scheimpflug Rule, can help us anticipate the effect of a lens tilt or swing, although it is seldom practical to locate the intersection of these lines precisely.

If we are photographing a building, for example, we usually keep the lensboard and film plane parallel to the building, and use the rising front if necessary to cover the top of the building. Keeping the back vertical avoids convergence, and the vertical lensboard

See Figure 10–8

A

B

Figure 10–7. *Courthouse, Bridge-port, California (detail).* (A) To make this photograph I used the maximum rising front adjustment possible without producing unsharp or vignetted corners. The back was swung horizontally to assure sharp focus across the building facade, not to overcome horizontal convergence.

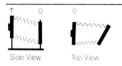

(B) Intentional convergence re-sulted from keeping the lens and film in the same position as A but tilting the camera upward. Note that the central vertical line, the left edge of the window frame, is vertical in the photograph, stabiliz-ing the visual effect of the image.

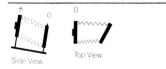

provides sharp focus over the entire facade of the building. All three planes are thus parallel, and do not intersect.

If, however, we want to photograph the building and bring its foreground into focus, we might not secure adequate depth of field unless we employ the lens tilt. We would usually leave the camera back in its vertical position for geometric accuracy in recording the building, but tilt the lens forward to bring more of the fore-ground into focus. We thus compromise precise sharpness over parts of the building front to secure focus in the foreground, and would rely on stopping down the lens to bring the entire building, and additional foreground areas, into focus.

Note from Figure 10–8 that we must be sure that the depth of field when stopped down extends behind the principal subject plane to the base of the building, and ahead of it to the building's top and important foreground areas. This depth of field region extends on both sides of the plane of sharpest focus, as with a non-adjustable camera, but it is no longer of uniform "thickness." The area of the subject plane closest to the lens will have the least depth of field, and more distant regions will have greater depth.

This camera configuration, where the lens is tilted forward and the back is vertical, occurs frequently in landscape and architectural work. In setting up the camera, we point it down to encompass the desired foreground, and then return the back to its vertical position. The effective forward tilt of the lens is then often about right for correcting the plane of focus,◁ although it may be necessary to raise the lens and refine the focus.

See Figure 10–9

Lens tilts are frequently used to secure depth of field over a long receding foreground.◁ It may be sufficient to tilt the lens forward slightly to achieve the desired depth, but when greater lens tilt is required, we must remember the risk of vignetting. In such cases it is usually preferable to use a combination of forward lens tilt and backward tilt of the rear standard to achieve focus.◁ This can be accomplished by tilting the lens forward until just before vignetting sets in, and then tilting the ground glass backward as required. By minimizing the tilt of the rear standard, we minimize geometric

See Figure 10–4

See Figure 10–10

Figure 10–8. *Focus and depth of field with lens tilted.* (A) When photographing only the facade of a building, the camera back and lensboard can be kept in the vertical position, and the depth of field region extends in front of and behind the primary focus plane.

(B) If important foreground areas must be included in the depth of field region the lens can be tilted forward. The primary focus plane, indicated by the dotted line, then intersects the planes of the lensboard and film at a single point. The depth of field region extends on either side of the plane of focus. Note that the camera back has been kept in the vertical position to maintain accurate rendering of the building.

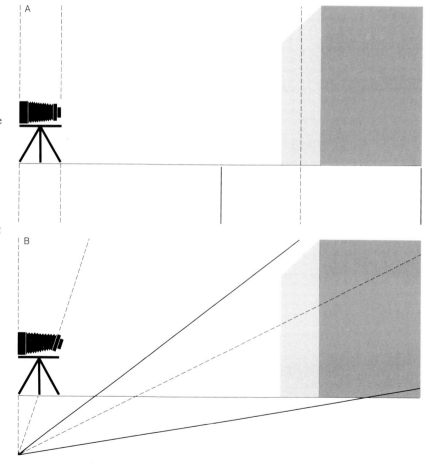

See Figure 10–6

distortion, although this is not usually of critical importance with a landscape subject. The rear tilts, of course, involve little risk of vignetting, so that, when working with non-rectilinear subjects, I focus with the tilting back if possible.◁

I should point out here that when a specific plane of focus in the subject is desired, there are a number of possible camera configurations that will achieve the same focus plane. From Figure 10–10 you will note that any combination of front and rear tilts that intersect along the line of the subject plane will ensure focus on that plane. Our choice of camera configuration will usually be determined by such factors as the need to keep the back vertical and the limits of lens coverage.

Once the lens has been tilted to the desired position, you can use the sliding adjustment to move the image within the ground-glass

Figure 10–9. *Monument Valley.*
This photograph is typical of those
where the subject requires keeping
the camera back vertical, in this
case to avoid distortion of the
"monuments" in the distance.
Pointing the camera down and re-
turning the back to the vertical
position provided about the right
tilt of the lens to correct focus,
with only minor additional lens
adjustment. I used a 10-inch Wide
Field Ektar, which provides con-
siderable room for adjustments on
8x10 film. Note, however, that the
desert in the lower left corner is not
sharp. Even with a very small stop
I could not achieve focus every-
where; the near rock is only about
four feet from the camera.

area, again *within limits of lens coverage.* If the camera has been
aligned properly, focus will not be altered, since the imaginary lines
through the lensboard and camera back do not move.

Another issue that should be mentioned is the location of the
axis of the tilts. Most view cameras permit tilting the lens and film
plane about an axis in the middle of the plane. This construction,
called axis tilts, is the most convenient, since the tilting function
disturbs the focus least. Cameras designed in such a way that the
pivot is located at the base, near the monorail or bed, require com-
plete readjustment of the focus when the tilt is used, as in Figure 4–4.

The examples cited, which involve forward tilt of the lens, apply
equally to the sideways swings of the lens. Here the subject is
likely to be a wall or row of trees that recede from nearby on the
right side of the photograph to more distant on the left. We can
accommodate this subject plane by swinging the lens to the right

Side View

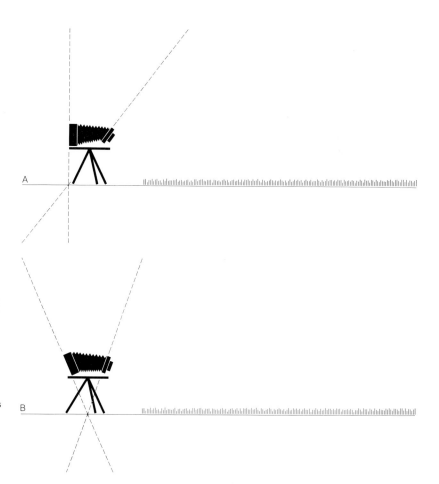

Figure 10–10. *Receding foreground.*
(A) When the subject is the ground
or a plane close to it, the lens can
be tilted forward until its plane
intersects the plane of the camera
back at the ground. The extreme
degree of tilt shown requires a lens
of great coverage or, perhaps, rais-
ing the back to avoid vignetting.

(B) With no parallel vertical lines
in the subject, the back tilt can be
used in conjunction with lens tilt
to control the plane of focus. Tilt-
ing the back causes distortion of
shape, but it is usually acceptable
with subjects of irregular shape.

See Figure 10–13

and/or the back to the left,◁ using the same principles that apply with the tilts.

It should also be noted that telephoto lenses for view camera use do not behave in exactly the same manner as conventional lenses. For example, when the rising front is used with the back and subject plane vertical, a slight degree of upward tilt of the lens may be required to keep the subject plane in focus, whereas a conventional lens would be aligned so that its lensboard is vertical. Some degree of image shift and geometric distortion may occur with a telephoto lens as it is tilted because of the location of its rear nodal point ahead of the lensboard.

Figure 10–11. *Roots, Hawaii.* With an irregular shape such as these roots, the camera back can be used to correct the focus. In this case, the lens (a 5-inch Ross Wide Angle) did not have sufficient coverage to secure focus without help from the rear tilt.

Side View

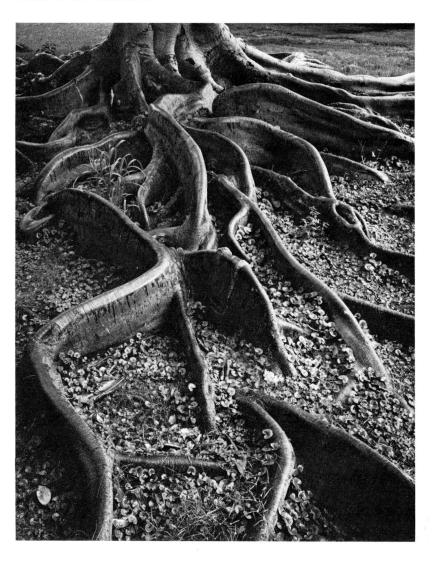

USE OF THE ADJUSTMENTS

In practice, the various adjustments of the camera are used in a complementary manner to achieve the desired image geometry and focus plane position. Frequently, several adjustments are required at the same time, and altering one may change the appropriate position for other settings.

It is important always to begin with the camera *in normal position, with all adjustments at zero.* If the tripod has been properly set up,◁ and the camera leveled with the adjustments zeroed, you can then apply the adjustments one by one to achieve the effect you want. The adjustments, especially the swings and tilts, are very sensitive and should be used to the minimum. It is easy to overadjust without thinking, and you may then sometimes have to unravel a complex series of adjustments to arrive at a basically simple configuration that gives the desired effects.

The first decision to make is to determine whether convergence of parallel lines in the subject must be avoided; if so, keep the camera back parallel to the lines. We usually know immediately whether we will be working with such a constraint and can act

See page 129

Figure 10–12. *Church, Santa Cruz, California.* These photographs show some of the difficulties that may be encountered with non-parallel surfaces. The surface of the stone arch is set at an angle to the church facade.

(A) Having positioned the camera so that the church door is centered in the arch, I used the rising front to the limit, and then tilted the camera upward and swung the back to the vertical position. I reached the limit of coverage of the 90mm Schneider Super Angulon lens, and the fall-off of illumination at the upper part of the image is obvious. I kept the camera back parallel to the *church,* and convergence is visible in the foreground arch.

Side View Top View

(B) The alternative, aligning the back parallel to the *arch* to avoid convergence there, causes disturbing distortion of the church building itself. The additional fall-off of illumination and vignetting resulted from swinging the lens parallel to the arch.

Side View Top View

A

B

accordingly. In cases where we are, any series of adjustments can be made provided the parallel relationship between camera back and subject plane is maintained. If, for example, the rising-front/falling-back adjustments fail to provide sufficient lens shift, we can point the camera upward and then use the back tilt to restore the film plane to the vertical position. In most cases we would also tilt

Figure 10–13. *Conservatory, Golden Gate Park, San Francisco.* The problem of maintaining focus in the foreground is exactly like that of Figure 10–8, except that the foreground is at the right side of the image area. I used the swing front to secure focus; use of the rear swing would have distorted the shape of the main building. In addition, I shifted the back to the left to keep the building on the lens axis, thereby avoiding the characteristic distortion of short focal length lenses (see page 158). The distortion on the right is ac-ceptable in that part of the subject. The photograph was made with a 90mm Super Angulon lens on Polaroid Type 55 Land film.

Top View

A

B

C

Figure 10–14. *House, Hollister, California.* These photographs illustrate the use of lateral adjustments.

(A) Photographed head-on, the left window shutter is partly concealed behind the post, and my own reflection appears in the glass.

Top View

(B) Moving to one side eliminates both problems, but since I turned the camera to return the door to the center of the image, the back was no longer parallel to the wall and the horizontal lines show convergence.

Top View

(C) From the same camera position as B, I rotated the camera to the right to bring the back and lensboard parallel to the building. I then used the sliding adjustments to shift the ground glass to the right and the lens to the left. The result is that the image of the door is centered without convergence, and the problems encountered in A are similarly eliminated.

Top View

the lensboard to vertical to ensure focus over a vertical plane. Note that the final configuration of the camera is identical in the relationships of lens, film plane, and subject plane, to that achieved by using the rising-front or falling-back, but with greater displacement of the lens in relation to the film. We must, of course, check carefully for vignetting.

If using a short focal length lens, we may also find that the camera rail or bed intrudes in the picture area. This will be visible in the ground glass (more definitely as the lens is stopped down) or by sighting from the end of the rail through the lens, observing if the rail intrudes on the area of the ground glass. With a monorail

camera we can eliminate this problem by positioning the front standard quite close to the front end of the rail, adjusting focus by moving the rear standard. Many flat-bed cameras have a "drop bed" capability,◁ which allows lowering the bed and lens below their normal position to keep the bed from intruding in the image area. The lens is then tilted parallel to the back, and the rising front is used to center the lens on the film. It may be preferable to turn the camera 90° on its side using the tripod head pivot, and then apply the sliding front and back as rising and falling adjustments. This procedure often gives quite a large total shift of the lens, and again we must check for vignetting.

The same principles that apply to photographing a building arise in other situations. If we are photographing a rectangular subject from an angle, and we wish to preserve the rectangular shape, the camera back must be parallel to the plane of the rectangle. One instance where this occurs is in photographing a mirror, window, or other reflective surface. Photographed head-on, the surface will reflect an image of the camera. We can avoid this reflection by moving the camera to one side, and then using the sliding front and back to bring the image into the picture area. Both the lens-board and film plane must be kept parallel to the surface to ensure correct geometry and focus over the entire surface.◁

See Figure 4–6

See Figure 10–14

"Wide-Angle Distortion"

See page 106

Although the term "wide-angle distortion" is usually used improperly,◁ there is a kind of distortion that results from the geometry of image formation with a short lens. Since short focal length implies that the lens is physically close to the film, rays of light focused at the edges of the image area fall at a relatively severe angle, and regular shapes such as circles or squares will be visibly distorted.◁ If an important subject area becomes distorted because of this characteristic, it is sometimes possible to adjust the camera in such a way that the important subject area remains on the axis of

See Figure 10–15

Figure 10–15. *Distortion caused by short lens-to-film distance.* When using a short focal length lens, the projection of a circular image at the edge of the field shows distortion (in the same way that a flashlight in the position of the lens would project a circular beam at the center of a flat field, but an elongated one at the edge). The effect is most severe when the use of adjustments has shifted the image area to the edge of the lens field.

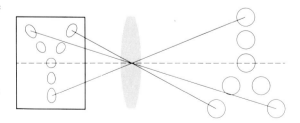

Figure 10–16. *Rice Silos, Sacramento Valley.* I used a 10-inch Wide Field Ektar with an 8x10 camera. The camera was carefully leveled, and both front and rear standards were vertical and parallel to the building plane. I then raised the lens to include the top of the structure. Note the distortion of the circular tops of the silos, which are near the edge of the lens field. The distortion is caused by the relatively short lens-to-film distance, and the off-axis position of the lens caused by use of the rising and sliding adjustments.

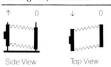

Side View Top View

the lens, but still near the edge of the image. The camera is set up with all adjustments at zero, and the subject is centered in the image area. The rear shifts can then be used to move the principal subject closer to the edge of the photograph, while still keeping it "on axis" in relation to the lens, as seen in Figure 10–13.

Summary

A few points bear repeating and emphasizing. First, beware of vignetting! It can be hard to see on the ground glass because it may appear only when the lens is stopped down, and the image may then be too dim to see clearly.

Second, the adjustments are critical. Examine the ground glass very carefully as each adjustment is applied using a magnifying

Figure 10–17. *Stream, Sea, and Clouds, Rodeo Lagoon, California.* I used a 90mm Schneider Super Angulon lens with Polaroid Type 55 Land film. I pointed the camera down to include the near expanse of the stream and then tilted the camera's rear standard backward to adjust the focal plane. I could have used lens tilt instead, but with the possibility of reduced brilliance at the top of the image resulting from illumination fall-off near the edge of the lens field. The camera configuration causes exaggeration of the foreground stream, but with interesting compositional effect. Note that the horizon appears slightly curved; this is due to a slight curvature in the film, exaggerated by the short focal length of the lens.

Side View

lupe. The best way to test (and to learn about) the adjustments is to use Polaroid 4x5 film. I have encountered numerous instances where a test photograph with Polaroid film revealed inadequate depth of field or vignetting that was not apparent (or was overlooked!) on the ground glass.

I should also point out that certain corrections can be made during the enlarging of negatives that are similar to adjustments of the view camera. Slight tilting of the easel may be possible to alter or correct the image shape, but this procedure will be limited by the depth of field of the enlarging lens and aperture, unless the enlarger permits tilting of both lens *and* film planes, as some do.

Finally, it must be said that the operation of a view camera is complex and requires time to learn. The examples in the illustrations and text of this chapter should help convey the basic concepts. However, I strongly recommend practice at every opportunity to develop a fluid and natural feeling for the controls of the view camera, and an appreciation of the very great potential for improved image management they offer.

Chapter 11 Meters and Accessories

Figure 11–1. *Aspens, New Mexico.*
This is typical of subjects whose
surfaces are so small they require a
narrow-angle or spot meter for
accurate reading. In this case I had
two basic values to contend with,
the tree trunks and the dark forest
background.

The meter I used was a Weston
adapted to read about a 5° area, but
the dark forest values were too low
to read accurately with that meter.
I would have no difficulty today
with such a subject, using one of
the new very sensitive spot meters.

The term *accessories* has come to include a host of photographic
gadgets of questionable value, but my intention in this chapter is
to describe only worthwhile tools. The exposure meter, of course,
is critical to any photographer, and its characteristics and correct
operation must be fully understood. We will consider here only
the different designs and functions of meters, and leave the issue
of interpreting exposure readings for Book 2. Certain other acces-
sories are of great importance, and in some cases can make the
difference between a successful photograph and a failure. You
should realize, of course, that a list of "essential" accessories will
differ from one photographer to another, and even from one photo-
graph to the next.

EXPOSURE METERS

Although too often taken for granted today, the exposure meter is
a much more recent arrival in the history of photography than the
camera. When I began working in Yosemite in about 1920, expo-
sures were arrived at by empirical methods or by reference to a set
of tables—and everyone had a different set of tables. I learned from
experience how to judge the exposure conditions at Yosemite,
where the light is fairly consistent, but when I went on to New
Mexico, and later to New England, I found different light situa-
tions, and I had to start all over again!

My first meter was a Wynne Actinometer, in which a small wedge of sensitive paper was rotated between comparison-patch areas of greenish gray, one for sunlight and a lighter one for low-light conditions—an early form of the high-low meter scale. The central sensitive paper wedge darkened in value when exposed to light, and the time it required to match either of the patches was set on a dial and converted to an exposure reading. The system was surprisingly accurate, although some found it very difficult to make a precise visual match of the values.

Exposure meters have developed rapidly, and meters today are very accurate and dependable. I recommend that you carefully consider the exposure meter at the same time you choose a camera; while cost may be a limitation, the meter should be viewed as a long-term investment every bit as important as the camera itself. Many photographers choose small cameras with metering systems built in, primarily because of the convenience. My approach to photography, however, depends on the use of a separate spot meter, tested for accuracy. Only with such a meter can we precisely measure the individual luminance values (i.e., brightnesses) of the subject and use this information to determine exposure and development procedures. In addition, if the procedures for measuring individual luminances are fully understood, you will find the principles helpful even when using a small camera with automation or built-in meter. Many professional photographers do employ

Figure 11–2. *Exposure meters*. The three general types of exposure meter are, from left, the general-purpose reflected light meter, the incident light meter, and the spot meter.

the metering system in their cameras as their primary light-measuring instrument, and, properly understood and calibrated, it can provide excellent results. These approaches will be described in Book 2.

Elements of a Meter

Exposure meters contain at least the following elements: an electronic cell that responds to light in a predictable way, a power supply, and a dial or other means for calculating camera exposures based on the indicated light intensity. Nearly all exposure meters twenty years ago used the selenium cell to measure light. With such meters, like the old reliable Weston Masters I through V, the selenium cell itself is the power source, since the cell converts the light striking it directly into electric current to give a reading on an ammeter. This reading is then usually transferred to a calculator dial that indicates correct exposure. One limitation of this system, however, is that relatively high minimum light values are required to generate a measurable amount of current. Thus these meters are not useful under very low light conditions.

Much greater low-light sensitivity became possible with the cadmium sulfide (CdS) cell. A CdS cell changes its *resistance* to electric current depending on the amount of light striking it. The cell simply regulates the current from a battery rather than creating electric energy, so it is much more sensitive. However, the CdS cell has the unfortunate property of "drifting," sometimes taking several seconds to settle into its final reading. This property is related to the cell's "memory"; exposing a CdS cell to bright light can temporarily affect subsequent readings taken in lower light levels.

Recent meters usually contain a silicon-blue or gallium arsenide photocell. These offer good sensitivity characteristics with little or no memory and drift, and, like the CdS cell, require a battery. Such cells are now commonly used in cameras with automatic exposure or built-in metering, as well as in hand-held meters such as the Gossen Luna-Pro SBC. Another recent development is the digital meter, like the Pentax digital spot meter, which reads in illuminated numerals rather than with a meter needle. The elimination of the delicate needle movement offers a great advantage in the ruggedness and long-term accuracy of such meters. With new meter designs appearing frequently, I recommend that the reader survey available models carefully when considering a purchase.

Incident Light Meters

Incident light is the illumination that falls on the subject from all light sources. It can be measured using an incident light meter held *at the subject* and pointed *toward the camera*. The standard unit of incident light is the foot-candle (ft-c), which was originally defined as the amount of light falling on a surface one foot from a "standard candle."

An incident light meter can be recognized by the presence of either a diffusing disc or hemisphere over the meter cell. The flat disc is directional, and permits individual measurement of several light sources, while the hemisphere is non-directional. To use the meter, the photographer stands at the subject and either holds the meter parallel to an important plane (with the disc) or directs it toward the camera (with the hemisphere). The incident meter is used often in studio photography, where the separate light sources can be individually controlled. Some reflected light meters can be converted to make incident light readings. The incident meter does not, however, give any indication of the difference between a light subject and a dark one, since these qualities can be evaluated only by measuring the light actually reflected from the subject, rather than the light falling on it.

Reflected Light Meters

A surface reflects the light falling on it (the incident light) in proportion to its inherent reflectance. It is because of the difference in reflectance values that we perceive a black object as black and a white object as white, whether we view them in direct sunlight or a dimly lighted room. A deep black fabric may reflect only 3 or 4 percent of the incident light, while a white material may reflect 90 percent or more (magnesium carbonate, white chalk, reflects about 98 percent). *The total reflected light from a surface (its luminance) depends on the amount of light incident upon the surface and the reflectance of the surface.* The units of luminance are candles-per-square-foot (c/ft²), although other units are sometimes used, or an arbitrary scale of numbers may appear on the meter dial. A reflected light meter is always pointed *at the subject* from the direction of the camera, along the lens axis if possible.

A general-purpose reflected light meter measures the light from a fairly large area of the subject, about 30° in extent, and its reading is the average of all luminances within that area. The average

is interpreted by the meter as a single exposure value, regardless of the luminance range (or subject contrast) present in the meter's field. Such a reading gives no indication of individual luminances unless the meter is held close to a single-luminance subject area. Some general-purpose meters have accessory narrow-angle attachments to facilitate such readings.

The best way to read individual luminances is to use a spot meter, which measures a very small subject area, usually 1°. These meters contain an optical viewing system where the reading area is indicated as a small circle, and only light falling in this small area affects the meter cell. Such meters offer the great advantage of being able to take luminance readings of individual areas of the subject from the camera's position. By taking separate readings of the full range of significant subject luminances, from darkest to lightest, we can precisely adjust the exposure to suit the subject. The Zone System is helpful in understanding the relationships of subject luminances, film densities, and print values; it is fully discussed in Book 2 of this series.

Batteries. To an ever increasing extent, the photographer is at the mercy of batteries—for his camera, for his meter, for his flash. It is important not to interchange batteries unless you are absolutely sure they are equivalent. The instructions for your equipment should give the battery type required, and others that are equivalent. In normal use, batteries last about a year in most equipment, and should be replaced if there is the slightest doubt of their capacity. By all means, carry spare batteries for *every* piece of equipment that uses them.

FILTERS

Good quality filters are an important investment for both black-and-white and color photography. In black-and-white, careful use of filters permits simulation of the existing value relationships of a subject, or selective departure from the realistic rendering. The most natural simulation of color relationships in black-and-white is achieved using a panchromatic film with a light yellow (K2) filter; the effects of certain other filters are shown in Figure 11–3. The general principle to remember is that a filter will lighten its

own color and darken the complementary color as recorded on black-and-white film.

Several types of filters are used in color photography, including those that modify the color of the light (light-balancing filters) and others that create subtle variations of image color (color-compensating filters). Ultraviolet (UV) and skylight filters are used in black-and-white photography to reduce overexposure effects caused by the presence of ultraviolet radiation, and with color films to reduce the bluish cast apparent in many photographs made outdoors.

The most widely used filters today are dyed optical glass. Such filters are very durable and of high optical quality. They are also quite expensive, but since most situations can be handled with four to six filters, the total investment is less than for a fine lens or exposure meter. Glass filters are available with threaded mounts that attach directly to the front of most small- and medium-format cameras, since the diameters and thread specifications have been standardized.

Gelatin filters are optically excellent and less expensive than glass, but they must be handled with great care. They are available in 2-, 3-, and 4-inch squares, and can be safely stored in a notebook using small pockets or envelopes. I prefer gel filters for view camera use, since a single filter adapter can be used with a variety of lenses of different diameters. I also use gel filters for small- and medium-

Figure 11–3. *Some essential filters.* I suggest the photographer acquire these in gel form as part of his basic equipment. A polarizer, available in glass form, is also a helpful accessory.

Filter	Description	Effect
No. 6 (K-1)	light yellow	Haze control and slight "correction" effect to produce approximately natural rendering with panchromatic film.
No. 8 (K-2)	medium yellow	Full correction; lowers value of blue sky and enhances clouds, etc.
No. 12 (minus-blue)	deep yellow	Very useful for landscape; further deepens blue values.
No. 25 (A)	red	Provides strong contrast in landscape, with very deep sky values.
No. 58	green	Reduces blue and red values, and enhances greens in landscape.
No. 47	blue	Increases atmospheric effect, and lightens sky.
UV		Filters out ultraviolet for haze control (especially with color film).

format cameras, using an adapter attached to the lens. The Hasselblad lens hood accepts 3-inch square gels; for 35 mm cameras the 2-inch square gels are usually large enough.

Since a filter is part of the optical system, its quality is important. While most glass filters are of very high quality, I suggest avoiding bargains since a poor quality filter can defeat the purpose of buying superior lenses. By adding elements to the optical system, filters can also increase flare and inter-reflections. Many good quality glass filters are optically coated to reduce this problem. Whenever two or more gel filters are used, it is best to locate one in front of the lens and the other behind it (a simple matter with view-camera lenses, though not possible with others). Each filter will then face a coated lens surface, and the problem of inter-reflections is reduced.

See page 68

Filters are assigned a filter factor, listed by the manufacturer, unless their density is so small it can be disregarded. The factor indicates the exposure increase required to compensate for the light lost because of the filter. Like other exposure factors,◁ the filter factor is multiplied by the exposure time or converted to f-stops to correct the aperture. The factor is usually correct for average daylight. During the early morning or late afternoon, when the light is warmer (more red), the factor for a yellow or red filter is less than in the middle of the day, and higher factors are required for these filters at high altitudes.

The polarizer is a unique filter that eliminates certain kinds of glare and reflection at the polarizing angle. It is also the only means of darkening the sky in color photographs, although its effect is dependent on the position of the sun in relation to the sky area photographed. The effect of the polarizer changes as the filter is rotated, and it should be turned while viewing through it to determine the optimum orientation for each subject. The filter factor for a polarizer is usually 2.5; it is not correct to assume that the exposure factor increases as the amount of polarization increases, since this would result in overexposure of the non-polarized areas.

Filters are an important part of photography. Since their use affects the image values, they will be discussed in greater detail in Book 2.

ELECTRONIC FLASH

Advances in technology have made small electronic flash units extremely versatile, and at the same time have dramatically reduced their size. Many professional photographers carry small

units for coping with emergency low-light situations. Although artificial light and flash will be dealt with in detail in a later volume, it is worthwhile to consider these electronic flash units briefly here, at least in their role as emergency accessories.

An electronic flash unit produces an extremely brief pulse of light, often of about 1/1000-second duration, and it is thus very useful for stopping the motion of a subject. Current models are often automated, using a sensor to detect the flash illumination as it is reflected from the subject, and terminate the flash pulse when sufficient exposure is received. Since flash illumination depends on the distance from the flash unit to the subject, a nearby subject will require only a portion of the full flash pulse. The sensor thus may terminate the flash after only a fraction of the total output, producing a pulse that may be as short as 1/30,000 second, or even less.

In their early development, automatic flash units simply drained off the remaining electrical energy not used to produce the flash and, in effect, discarded it. Most current units, however, use thyristor circuits to store the unused portion of electrical energy for the next flash—a far more efficient system that yields more flashes from a set of batteries and faster recycling times if short or moderate subject distances predominate.

Another issue involved in selecting such a flash unit is the location of the flash sensor. The most compact units often have the

Figure 11–4. *Electronic flash.* Small portable electronic flash units often incorporate automatic exposure sensing. With this model, the sensor can be mounted separately on the camera if the flash is used from a different position (to side-light the subject, for example), thus ensuring that only the light actually reaching the camera is used for exposure control.

sensor mounted in the front of the flash head itself, limiting the unit to use with the flash mounted on the camera, or very close to it. For more complex lighting, such as bounce flash, the sensor should be removable, so that it can be directed at the subject from the camera regardless of the position of the flash head. Another design is intermediate in its flexibility, allowing the flash head to be tilted up or sideways for bounce flash while the sensor remains directed at the subject.

Using flash indirectly, bounced from a ceiling or wall, provides softer light quality than direct flash, but the smaller units may not have sufficient power for such use. The larger, professional systems usually have a separate battery pack that provides ample power. These units may also include provision for using more than one flash head, and can be adapted for use with an umbrella or other diffuse-light system. Some are designed to be used without a re-flector, since "bare bulb" flash uses all reflective surfaces in a room to give a softer quality to the light.

To avoid total dependence on the automated flash systems, it is useful to know the basic exposure calculation required with non-automatic flash. The light output for each flash unit is calibrated in terms of a "guide number" that, with electronic flash, is a fixed number for a given film speed (with a conventional flashbulb, the guide number may change with a change of shutter speed as well). The correct aperture for "average" conditions is the guide number divided by the distance from flash to subject. Thus a flash with a guide number of 80 would require an aperture of f/8 when used at a subject distance of 10 feet (80 ÷ 10 = 8), and f/16 when used at 5 feet. The guide number listed by the manufacturer may prove optimistic in some cases, and it should always be checked by expos-ing a test roll under typical working conditions.

You should also note that not all environments are "average," and a very large or dark room will require an additional f-stop or more of exposure. In addition, the color of the walls will affect the color of the image. This principle applies to any type of light re-flected from walls or other surfaces near the subject. I have had some surprising and unpleasant results from reflected light—poor exposures with black-and-white and distressing color effects with color photography.

Each electronic flash unit also has a characteristic "recycling time" to recharge between flashes, indicated by a ready light on the flash unit. The recycling time becomes longer as the batteries lose energy. With most units the ready light comes on after the capacitors have reached roughly 80 percent of their full charge, so

using the flash immediately after the light comes on may produce underexposure.

A final reminder: electronic flash can be synchronized with a conventional leaf shutter at all speeds, but focal-plane shutters have a maximum speed for synchronizing.◁ Check your camera's instructions if it is equipped with a focal-plane shutter, to determine the maximum speed permitted with electronic flash.

See page 86

ACCESSORIES

There are a number of items that I consider essential or very helpful.

Camera cases. Although many small-camera photographers use lightweight, soft-sided camera bags, these provide little protection against bumping and jarring the delicate equipment. I am always surprised when I see several cameras, a gaggle of lenses, filters, meters, et cetera, rattling around in a soft bag with a complement of refuse and dust. Sometimes the professional is the worst offender! My preference is for the rigid aluminum cases, which can be separated into compartments using strong plastic or metal dividers, or blocks of foam cut out to hold the equipment. Such a case should be examined for quality of construction and adaptability for the equipment it is to contain. Equipment should fit snugly in the compartments, protected by thick padding. The case must also provide a good seal against dirt and moisture. Piano hinges are best for the top; hinges that sag in time will keep the top from closing securely and allow dust to enter. My favorites are cases strong enough to stand on, since the added height is often helpful.

Camera cases are frequently made of dark materials, but the cameras and film will be better protected from heat if the case is white or of metallic aluminum. A white case absorbs less of the sun's energy, and will remain cooler inside than a dark one. Depending on the materials, it may be possible to paint a case white. Be certain to choose a paint that will bond successfully to the case and will not crack or peel off. A titanium or enamel paint is very effective in reflecting the sun's heat.

Cable release. The conventional cable release usually has a smooth action, but a lack of flexibility of the cable and the enclosing tube can cause trouble. A cable that is too short or stiff can impart vibration to the shutter and camera, reducing the sharpness of the image. When selecting a cable release, be sure the threads are compatible with your camera or shutter, and that the cable is of large enough diameter that it will not jam inside the shutter. Occasionally you will encounter a cable that extends too far into the shutter, or otherwise interferes with the mechanism. The use of the cable release and other release devices is described in Chapter 6.◁

See page 91

Focusing magnifiers. For view cameras, a good quality magnifier will permit close examination of the ground glass to check focus. The most convenient are the lupe variety, which can be rested on the ground glass. A good lupe will contain at least two elements, permitting better correction than is possible with a single lens. If the eyepiece is adjustable, it should be focused on the ground side of the ground glass, which is always the surface facing the lens. For those who wear eyeglasses, flip-up accessory lenses that pro-

Figure 11–5. *"Chimney" view-finder for the Hasselblad.* The finder shown includes a built-in magnifying lens to help with accurate focusing on the ground glass. The magnifier has a focus adjustment for the eye. Magnifiers without focus adjustment can be fitted with a corrective lens for users who wear glasses.

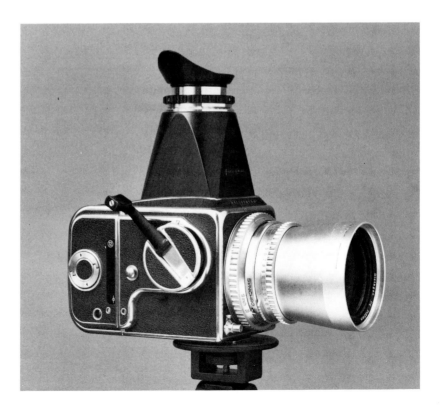

vide the desired reading or magnified focus can be fitted to standard frames by an optician. I do not recommend bifocals, since they can make ground-glass focusing difficult, and they provide the wrong focus when looking down to check footing while picking one's way over rough terrain.

Some view cameras have accessory focusing hoods that attach to the back of the camera. These usually incorporate a magnifying lens and a mirror, providing a right-side-up image for viewing and composing. They do add to the bulk of the camera ensemble, however, and I prefer direct ground-glass viewing using a lupe to focus. For medium-format cameras, the use of a pentaprism finder is usually desirable, since it provides an erect and laterally corrected image at eye level. However, the less expensive hoods for these cameras usually contain a magnifying lens, and permit precise focusing and composition. With both medium- and small-format cameras, it may be possible for eyeglass wearers to attach correcting lenses of various diopters (powers) to permit use of the viewfinder without wearing glasses.

Focusing cloth. Use of a view camera requires a focusing cloth to reduce stray light falling on the ground glass, and a good focusing cloth is a rare item! The cloth must be large enough to shield the ground glass, heavy enough to remain in place in a breeze, and really opaque. The inside should be dull black fabric and the outside should be white, to reflect the sun's light and heat. The white side can also be used to reflect light into the shadows of small subjects during exposure. The fabric should not be too "slippery" or the cloth will tend to slide off the camera and the photographer. Clamps on the camera can be used to secure the cloth in place, or small hooks can be attached to the camera and the cloth fitted with matching grommets. Weights are sometimes sewn into the corners of the cloth to keep it in place in the wind. However, I have known of cases of eye injury caused by weighted corners flapping in the wind, and I had a focusing screen broken by one; I have avoided them ever since.

Notebook. No photographer should be without one! It should contain a copy of your equipment check list, to avoid the frustration of forgetting some essential piece of equipment, plus lens and shutter calibrations, film data, and so on. In addition, note pages

allow recording of exposure data and instructions on development of each negative or roll of film. Examples of exposure record pages, adapted to contemporary materials, will be shown in Book 2.

Changing bag. A changing bag is a light-proof fabric bag with sleeves that allows the photographer to perform certain tasks in the field with camera and film fully protected from light. For example, the changing bag can be used for loading and unloading sheet film holders, or a roll-film camera that has jammed can be opened inside the bag and the film removed or rethreaded. For roll-film cameras, a bag of about 2x2 feet, expandable to a height of at least one foot, is sufficient, but for loading sheet films, I prefer a bag of about 3x3 feet, with a minimum height of 18 inches. I consider a good changing bag a necessity, but a few admonitions are in order.

First, examine the bag before purchase to be certain it is well constructed. The end of the bag is usually closed by single or double zippers, and should have a cloth overhang for extra protection from light. The two sleeves should be securely sewn to the bag with double seams, and the elastic bands around the arms should be snug, but not so tight as to interfere with circulation. You can pull down coat or jacket sleeves over them to give further protection.

Second, use the bag on a flat, level surface to keep the contents in position, and be certain that it is thoroughly free from dust before use. In warm weather, the hands and fingers will become moist, and it is very important not to touch the surface of the negatives. It is always best to use the bag in subdued light, and using it in the shade, or indoors, will provide cooler conditions. Some photographers who travel frequently by car prefer to use a light-tight box with removable lid and sleeves.

In my early days, when films were slower, I changed film by crawling head-first into my opaque sleeping bag and suffering a sweltering hour or so in an extremely uncomfortable position. The modern changing bag is a great improvement!

Levels. Many view cameras and tripods are equipped with levels, but these are often quite small and may give only approximate leveling. A small carpenter's or mechanic's level will be helpful, especially if you are photographing critical subjects such as architecture. Many modern small- and medium-format cameras, how-

ever, have enough curves and decorative ridges to make it difficult to find a flat surface from which to take a level. A 2- or 3-inch base is necessary, and if the camera sits flush with the tripod top platform, the horizontal levels can be taken there. Vertical level can be taken from the front rim of the lens.

I also recommend acquiring a fine carpenter's protractor level, since it allows establishing not only the vertical and horizontal levels, but intermediate angles. This ability can be valuable when photographing a rectangular subject that is not positioned vertically, such as a painting hanging on a wall. Use the protractor level to read the angle of the subject, and then set the camera back at the same angle to keep it parallel with the subject.

Lens cleaning equipment. A lens cleaning kit should include tissue (*not* the kind sold for eyeglasses), lens cleaning fluid, a camel's-hair brush, and either an air bulb or can of compressed air. A *very* gentle vacuum, if available, is the best means of cleaning dust without touching the lens surface; remember, the lens coatings are quite delicate. When cleaning is necessary because of mist or salt spray, apply a drop of cleaning fluid to a soft wad of the tissue and swab very gently. Do not apply the fluid directly to the lens, since it might run down inside the lens barrel. The camel's-hair brush can be used to remove stubborn dust, but you should never touch the bristles with your fingers or use it for cleaning other camera surfaces, since grease or oil can be transferred to the bristles and then to the lens. Under adverse conditions of dust, rain, or mist (especially salt water spray) it is advisable to keep a lens cap or an ordinary UV or clear glass filter over the lens, at least until just before exposing.

Lead foil bags. Numerous claims have been made about airport security X-ray machines that are safe for films, and numerous complaints have been heard from traveling photographers who find their film has been fogged mysteriously. Lead foil bags are sold for carrying film when X-ray inspection is likely, and they are certainly a worthwhile form of insurance. You should also demand *visual* inspection of all camera and film cases whenever possible.

Model release forms. If you photograph people, you should carry these, although the exact requirements for the form are often debated. Any of the fairly complete and detailed forms should suffice for most purposes, but if in doubt, consult an attorney knowledgeable in this area. If you photograph minors, you should have a form that provides for parental permission.

Photography of personal property—land, structures, and so on—is also subject to permission of the owner, which should be obtained in writing whenever possible. The legal problems have become increasingly complex in recent years.

Insurance. Not strictly an accessory, but essential nonetheless! Equipment is constantly rising in value, and it should certainly be protected by insurance. A good camera dealer can suggest an agency or insurance company that handles camera policies. Be sure to list every item in detail, and look for a policy that covers property and liability. Records of the serial numbers of cameras and lenses, and lists of all accessories, are important in case of loss by fire or theft. Some photographers engrave a "code" (numbers, letters, or symbols) on their cameras and on lens barrels, exposure meters, etc. These should not deface the equipment, but can be quite helpful in identification and proof of ownership. Those who travel outside the country should have complete lists of their equipment.

Chapter 12

Special-Purpose Equipment and Techniques

It is impossible to fully discuss in a single volume the many specialized applications of photography and related techniques. Most such special situations, however, can be managed at a basic level by applying a sound understanding of the principles of photography. I present in this chapter some of the considerations that arise in certain special applications, but I also urge the reader to seek out more detailed information as his work requires.

Figure 12–1. James Alinder, *Savannah Saw Works*. An example of the extremely wide field of view of a moving-lens camera, in this case the Panon.

CLOSE-UP AND MACRO PHOTOGRAPHY

Special-purpose close-up lenses are available for photographing small subjects very close to the camera. In addition, most conventional lenses can be adapted for close-up work using either a supplementary lens or a focus extension system such as an accessory bellows. Supplementary lenses have already been discussed,◁ and while they may be convenient and economical, they usually do not yield the optimum image quality.

See page 65

Maximum image sharpness is usually secured by using increased lens extension to achieve close focusing distances. The special macro lenses◁ are specifically corrected for close focusing. With small cameras, a supplementary bellows or extension tubes can be used with a conventional lens to achieve close-focus distances. In many cases ,the image quality is improved at magnifications of 1:1 or greater if the lens is reversed, so that the "rear" element faces the subject. Adapter brackets are available to permit reversing the lens,

See page 63

but you should consult the manufacturer's recommendations or conduct comparison tests before using this procedure. With a view camera, the required extension is usually attained by using the standard bellows.

It is worthwhile remembering that, if you wish to obtain 1:1 (i.e., life-size) images of a subject, the total extension of the lens must be twice its focal length.◁ See page 69 Note also that, if you cannot achieve the desired magnification because of insufficient length of the bellows or extension tubes, changing to a shorter focal length lens will increase the magnification. However, the short focal lengths must be physically closer to the subject, with the result that the space available for lighting or adjusting the subject becomes quite small.

One unavoidable result of close focusing distances, whether achieved using supplementary lenses or focus extenders, is that the depth of field becomes extremely shallow, measured in inches or fractions of an inch. As the magnification increases, the depth of field decreases. It is therefore almost always necessary to use a very small aperture with the camera mounted on a tripod or laboratory stand, and to be critically selective in focusing.

A second reason for using a tripod is that the relatively large magnification of the image also magnifies movement of the camera during exposure, just as using a long focal length lens does.◁ See page 117 Even with a tripod, very small movements, like the vibrations caused by the mirror of a single-lens reflex camera, are magnified to the point where they can cause image degradation. Many single-lens reflex cameras provide a manual means to raise the mirror before exposure to reduce this effect (vibration caused by the mirror returning to its viewing position can be ignored, since it occurs after the shutter has closed). This mirror lock-up control should certainly be used at high magnifications.

Precise focusing when very close to the subject is best accomplished by moving the entire camera closer to or farther away from the subject, rather than by adjusting the lens-to-film distance. When working close to the subject, the very shallow depth of field makes the camera-to-subject distance critical, and a small adjustment in this distance brings different planes of the subject quickly into focus.* If we want to alter the magnification, we make a small

*This operation is the reverse of normal working procedure, where the depth of *focus* (i.e., the distance *behind* the lens through which the film can be moved without significantly disturbing focus) is the critical element. Normally, we focus by making small changes in the lens-to-film distance, and change the image size by moving the camera closer to or farther from the subject.

change in the lens extension, and then re-establish the focus by again moving the entire camera. Thus the best small-camera bellows systems permit fine adjustments of the camera position, similar to the sliding monorail of a view camera.

Exposure correction is required when the lens is extended to make close-up photographs, since the intensity of light reaching the

Figure 12–2. *35mm camera with bellows.* The unit shown permits swinging the lens for control of the focus plane (most lenses for 35mm cameras do not provide sufficient coverage to allow swinging except at large extensions). Note the double-rail construction: the entire camera unit can be moved toward or away from the subject on the lower rails for precisely the desired image size and for accurate focusing.

film diminishes as the lens-to-film distance increases (in inverse proportion to the *square* of the distance). Any metering system that operates through the lens, such as those common among single-lens reflex cameras or the focal-plane meters for view cameras,◁ will automatically compensate for this fall-off, and no further correction is required. Similarly, many macro lenses include a mechanism that compensates for lens extension. However, when not otherwise corrected, the exposure must be adjusted according to the formula for the lens extension factor given in Chapter 5.◁

See page 66

See page 68

COPYING

The requirements for copy photography overlap those for close-ups, but frequently special equipment and techniques are involved. Copy cameras are usually mounted on vertical stands with a baseboard, resembling a photographic enlarger (in fact, enlargers can often be converted for copy work). Such cameras should be equipped with

See page 64

process or enlarging lenses◁ to provide the flat field necessary for optimum copying of flat originals.

Copy camera systems also include lighting, usually arranged in banks on either side of the baseboard for even illumination. The lights should be directed at the copy subject at a 45° angle, so that any specular glare from the surface is reflected to the side, away from the lens. It is extremely important to check for even distribution of the illumination, since any unevenness will be visible in the copy. An incident light meter can be used to make readings from the corners and center of the subject area, and these readings should match precisely. If no incident meter is available, make reflected light readings from a gray card or clean white sheet of paper in the same areas, holding the meter as near the lens axis as possible.

Conventional reflector floodlights are usually brightest in their central areas, and fall off toward the edges of the field. By directing this bright spot at the far edge of the copy camera base, you can ensure that the area closest to the lamp receives light from the weaker borders of the light's cone, thus helping balance the illumination. Do not trust your eyes to judge the uniformity of illumination, but make careful measurements with a meter.

Persistent glare problems require careful lighting. Changing the angle of the lighting may help, but the even distribution of light must not be disturbed. Difficult subjects may require cross-polarization—polarizing filters placed at one orientation over each light, and a polarizer rotated 90° from these placed over the lens. I have found that cross-polarization is useful with nearly all copy subjects.

The Polaroid MP-4 Multipurpose camera is an excellent copy system, in addition to being adaptable to many other applications. The basic camera is mounted on a vertical stand equipped with baseboard and lights. A number of interchangeable lenses are available, and different backs can be attached for using Polaroid or conventional film. Accessories adapt the camera for use with a microscope or other instruments, or for conventional photography and enlarging.

PANORAMIC AND ULTRAWIDE-ANGLE PHOTOGRAPHY

In addition to the short focal length lenses available for most cameras, certain equipment has been designed specifically for photo-

graphing very wide or panoramic fields. The panoramic camera has existed in a number of configurations for many decades, usually intended for landscape or special function (banquet and group) photographs. Some early models, like the famous Cirkut camera of the early 1900s, operated by turning the entire camera during exposure, using a geared platform to move the film behind a slot in precise synchronization with the movement of the camera. Such instruments were able to expose a full 360° field (or more or less if desired) on a single long strip of film.

Figure 12–3. *Panoramic camera.* The Widelux camera uses a moving lens to produce an ultrawide field of view. The lens is shown here in mid-cycle, swinging from right to left during the exposure.

The alternate design for panoramic cameras is to pivot the lens while keeping the camera body stationary. This design survives today in the Widelux, a small-format panoramic with a lens that swings through an arc during the exposure. The film is held in place in a semicircular curve at the rear of the camera, and it is exposed through a slit shutter that pivots with the lens. The current Widelux is a 35mm camera (a 120 roll-film version, the Panon, was made in the 1950s), which has a field of view in the horizontal direction of about 140°. It produces an image of roughly 1x2¼ inches, with none of the distortion that would appear if an extremely short focus lens were used to approximate its extreme field of view.

In using such a camera, it is important that it be precisely leveled before exposing. Many panoramic cameras have a level built in, and the use of a tripod is usually desirable. However, unusual compositional effects can be obtained by tilting the camera up or down. In addition, if the subject moves during the exposure, you can expect severe distortion. The subject will be radically compressed if

it moves in the direction opposite the swing of the lens, and expanded if it moves in the same direction.

A composite panoramic image can be made using any conventional camera with normal lens and splicing together adjacent image areas. The camera is simply turned a measured amount between exposures (a tripod head that is marked with degree indications is helpful), so that the resulting series of images overlap. Accurate joining of the images will be possible only if the lens is pivoted about its rear nodal point. A bracket can be purchased or constructed to permit positioning of the rear nodal point over the axis of the tripod center column. (The procedure for locating the rear nodal point is described on page 68.) The resulting separate images must be carefully printed to matching densities to minimize the visibility of the splices.

Since it is difficult to join the images invisibly, it is often effective to separate the component photographs by a narrow and accurately measured space. Or, if the completed image is to be framed, the edges can be brought together and then covered with a thin strip of card, carefully cut to a width of about 1/8 to 3/16 inch. The screen effect is often more pleasing than a poorly matched junction of the prints.

See page 63

The more conventional approach to making very wide field photographs is to use a very short focus lens (computer assistance in lens design has produced a number of excellent ultrawide and fish-eye lenses).◁ In addition, a number of cameras have been designed for wide-field photography, including the Brooks Veri-Wide, Zeiss Hologon, and the Hasselblad SWC (Super-Wide). The Hasselblad Super-Wide has a field of view of 90° measured diagonally within the conventional 2¼-square format. The lens is a 38mm Zeiss Biogon permanently attached to the camera body. Since this lens extends close to the film plane, the mirror viewing assembly of the standard Hasselblad body is not required, and a separate optical viewfinder replaces the reflex system (with the attendant parallax◁).

See page 13

UNDERWATER PHOTOGRAPHY

Waterproof cameras, and housings to protect conventional cameras, are available for underwater photography. One of the most popular examples is the Nikonos, made by Nikon, a water-resistant

35mm camera that can also be used for conventional photography under adverse conditions, such as rain, snow, or dust. Two of the interchangeable lenses for the Nikonos (15mm and 28mm) are corrected only for use underwater, however, while the 35mm and 80mm lenses can also be used above water.

The lenses designed only for underwater use are specifically computed to take into account the refractive index of water. This

Figure 12–4. *Underwater camera.*

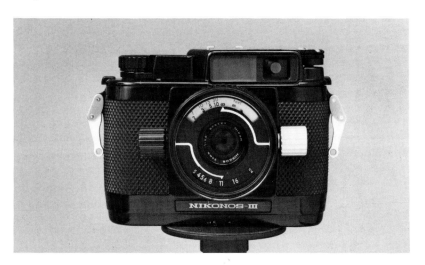

difference of refractive index also causes a change in image magnification and field of view for the lenses that can be used either in air or in water. The 35mm lens used underwater, for example, gives an angle of view of 46° (somewhat narrower than a conventional "normal" lens), but when used above water the 35mm lens has a rather wide field of view of 62°. Short focal length lenses have the additional advantage underwater of permitting a short camera-to-subject distance for improved sharpness; water contains suspended particles that usually lend a murky appearance to photographs made at long focus distances.

Underwater housings are made of plastic or cast aluminum for many cameras. Such housing appear bulky, but underwater much of the weight is offset by their buoyancy. In selecting such a housing, it is important to check that the controls are precise and easily operated, and that accurate viewing is provided. The housings for the Hasselblad include a prism viewfinder or interchangeable frame finders.

Because of the density of the water, the illumination will fall off quite quickly as the depth increases; an underwater reflected light meter can be used to determine exposures. At great depths, or

when optimum color balance is desired, an underwater flash unit is often essential.

The color density characteristics of the water also require the use of filters in most instances. In general, black-and-white films benefit from a yellow or orange filter to cut the haze and improve contrast. Color films require a yellow or amber filter to counteract the blue quality of the underwater light.

With any camera used underwater, be sure not to exceed the maximum rated depth. The Nikonos is tested to 160 feet, and the Hasselblad housings are tested at a pressure equivalent to 500 feet below the surface. Such housings and cameras are designed to resist corrosion from salt water, but it is a good practice to rinse the unit in fresh water and dry it before dismantling or storing.

STEREOSCOPIC PHOTOGRAPHY

Stereoscopic photography simulates the effect of binocular vision by using two separate photographs made from positions separated (usually) by the distance between the human eyes—2½ inches is about the standard interocular distance. If the image made from the left position is then shown to the left eye, and that from the right position to the right eye, the brain can reconstruct the original scene with a sense of depth and space. This principle has been known since before photography was invented, and some laborious

Figure 12–5. *Stereoscopic camera.* The Stereo Realist has the viewfinder lens at center and the two picture-making lenses at either side. The lenses are separated at a distance about equal to the distance between the eyes.

drawings were attempted making use of this phenomenon before cameras appeared.

The most direct way to make stereoscopic images is to use a stereoscopic camera, which is fitted with two identical lenses that each record images at the same instant from slightly different positions. The Stereo Realist camera was available until fairly recently, and still can be found as used equipment. Adapters have also been made for converting conventional cameras to make stereoscopic images; at this writing, I know of only one made by Pentax for their 35mm cameras.

The advantage of a stereo camera or attachment is that it enables you to make the required two images simultaneously. Without special equipment, stereoscopic images can be made with any camera by simply making two exposures, moving the camera about 2½ inches between exposures. The two photographs then correspond to a "left-eye view" and a "right-eye view," and can be viewed in one of the antique or modern stereoscopic viewers. A sliding bracket can be constructed to facilitate shifting the camera without disturbing the tripod. If simultaneous exposures are required, two cameras can be mounted in tandem and triggered by a special single release mechanism.

It should be noted that the required change in camera position (the interocular distance) for the two exposures will differ as the distance to the subject changes. For close-up and microscopic subjects, a very small difference in viewpoint will suffice. On the other hand, a scene made up of only distant objects may benefit from enhanced stereoscopic effect by moving the camera more than the standard 2 to 3 inches. This exaggerated separation of the viewpoints produces what is known as "giant vision." At the extreme, early photographers discovered they could provide extraordinary depth in photographs of the moon by simply waiting between exposures made from a fixed camera position. The movement of the earth and moon during the interval assured that the viewpoint of the second photograph would be significantly different from the first, and the stereo effect is quite startling, if somewhat unreal.

An effect known as "pseudo stereo" is based on simply exchanging the right and left images when viewing, so that the right eye sees the left image and vice versa. The result is that the delineation of subject remains precise, but the impression of depth is reversed, with astonishing effect. This effect cannot be reproduced on the page, but is certainly worth experimenting with. I believe it has definite aesthetic potential.

AERIAL PHOTOGRAPHY Various specialized aerial cameras have been made, usually rigid-body large-format cameras equipped with a lens designed for and fixed at infinity focus. Conventional cameras can be used successfully for aerial photography, provided a few precautions are taken.

If you hire a small airplane or helicopter for aerial photography, you should examine it to be sure the windows open and provide good visibility for photographing. Photographing through the windows of small airplanes will cause a definite loss of image quality, and the plastic may add unwanted polarizing effects. Opening the window means you and the camera may be subjected to strong wind blasts, and you should choose equipment accordingly. A solid-body camera is usually best, but if a bellows camera must be used, be sure to shield it from the air stream.

It will be necessary to isolate the camera from the vibrations of the airplane (your body can act as a "shock absorber"). There will be little or no demand for depth of field, so it is usually possible to use moderate apertures and the fastest shutter speeds. You can help ensure sharpness by panning the camera to follow the subject, especially at low altitudes.◁ You should try to anticipate interruptions of your field by structural components of the airplane and by its shadow on the ground below. Needless to say, a high-wing airplane is essential.

See page 118

Lenses of normal to moderately long focal lengths are generally best. You should also be equipped with suitable filters, at least yellow and red to aid in penetrating atmospheric haze when using black-and-white film. A polarizer will be very useful with black-and-white or color film to reduce the glare from the sun and ground surfaces, and to provide some control over the rendering of the sky when it appears in a photograph. Aerial photography is a complex subject, and you should seek out additional reference material before seriously entering the field.

POLAROID LAND CAMERAS AND FILMS

I have mentioned Polaroid materials earlier, but I would like to emphasize here the benefits of being able to make an exposure and see the results immediately. This ability is of particular value when

a test is needed of lighting, exposure, or focus, but also when you simply want to be sure of your results. Several Polaroid films offer uniquely beautiful image tonalities, and are well suited for use as the final image. I will briefly mention here several systems of potential value for the serious photographer; for a more detailed treatment of the Polaroid systems, see my *Polaroid Land Photography*.

The 4x5 films have been available for many years now, and are widely used for both test photographs and final images. An adapter back, Model 545, inserts under the ground glass of a 4x5 camera in place of the conventional holder, and serves as both the Polaroid film holder and the processing system. Type 52 Land film can yield beautiful and delicate black-and-white prints. Type 55 Positive/ Negative Land film, as its name implies, produces both a black-and-white "proof" print and a full-scale negative for subsequent printing and enlarging. In addition, Polacolor 2 Type 58 is available

Figure 12–6. *Polaroid camera.* The Model 600SE uses pack films and permits interchanging lenses. It is designed chiefly for professional and industrial applications.

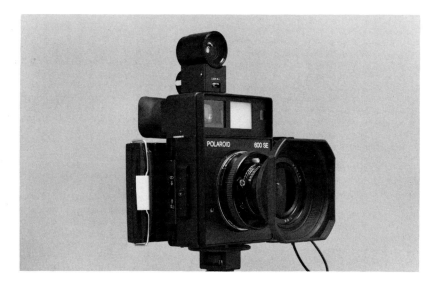

for making color prints and Type 51 is a high-contrast film suitable for contrast enhancement or graphic arts applications.

For medium-format cameras, Polaroid makes 8-exposure film packs that can be used with many such cameras by means of accessory backs available from the camera manufacturers. The pack films measure about 3½x4½ inches, although many medium-format cameras use only part of this area. Negatives of superb quality can be made with Type 665 Land film. Type 667 and Type 107 are 3000 ASA–equivalent black-and-white print films, and Type 668 and 108 are Polacolor 2 print films.

Polaroid has recently introduced the 600 SE camera, a pack-film, viewfinder/rangefinder camera similar to some press camera designs.◁ This camera, which replaces the Model 195 as Polaroid's professional-level camera, is available with interchangeable lenses, and also permits interchanging the backs. Polaroid pack films can also be adapted for use in a 4x5 view camera using the Model 405 holder, but they do not, of course, show the entire 4x5 image area.

In the 8x10 format, Polaroid has a film cassette and separate processor for making 8x10 color prints using Type 808 Polacolor 2. The cassette, containing the negative only, is loaded into the camera and exposed like a conventional 8x10 film. The cassette is then aligned with a sheet of print material and inserted into the motorized processor. The resulting 8x10 prints are of extraordinary quality and richness, and this system has become popular with advertising and commercial photographers.

The SX-70 system is the most technologically complex and automatic of all. The recently introduced Sonar cameras focus themselves using a reflected beam of very high frequency sound waves. They are also fully automatic in exposure determination and the motorized processing of the film. Several other models of SX-70 and Pronto! cameras are available, all of which use the remarkable self-contained SX-70 film units.

All Polaroid photographic systems process the film by passing it through a roller mechanism, which spreads developing reagent between the negative and positive layers. It is thus essential that the rollers of any Polaroid camera or holder be kept extremely clean and free of dust particles. The way the film is drawn through the rollers is also very important; the processing pull must be smooth, straight, and of moderate speed. Polaroid maintains excellent customer support services to help with any problems that may be encountered.

Kodak also produces an "instant" color system which was initially directed mostly to amateur use. They also manufacture an adapter back for their instant films, which I have not tested.

Appendix

LENS FORMULAS

Lenses are available in a great variety of configurations, and the principles of optical design are complex. Nevertheless, conventional lenses obey certain principles which can be expressed in basic formulas, and these are sometimes useful to the photographer. The formulas on pages 192–194 relate to the drawing below, in which a simple lens has been used to replace the more typical compound lens. The important quantities are

 F, the lens focal length
 O, the size of the subject ("object size")
 I, the size of the image
 u, the distance from the subject to the lens rear nodal plane
 v, the distance from the rear nodal plane to the image
 M, the magnification of the image in relation to the subject size.

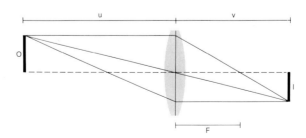

One of the fundamental formulas in optics is the following:

$$\frac{1}{u} + \frac{1}{v} = \frac{1}{F} \tag{1}$$

Using this formula, you can, for instance, figure out the bellows extension (v) required to photograph a subject at a certain distance (u) with a given lens focal length (F). (In this formula, and all others, the units must be identical. If you use the focal length in inches, you must convert the subject distance to inches also.) For example, if you want to photograph a subject one foot in front of the lens using a 4-inch focal length, you would first re-write the formula to solve for v:

$$\frac{1}{v} = \frac{1}{F} - \frac{1}{u}$$

Then,

$$\frac{1}{v} = \frac{1}{4} - \frac{1}{12} = \frac{1}{6}$$

See page 68

or, v = 6 inches, the distance required from lens nodal plane to film. Remember that, for these calculations to be accurate, the distances must be measured from the lens nodal plane.◁

The second basic formula is the following:

$$\frac{I}{O} = \frac{v}{u} = M \tag{2}$$

Thus the magnification of the image is equal to the ratio of image and object *sizes,* which equals the ratio of image and object *distances.* If the image size is 4 inches, with a subject 2 feet (24 inches) high, the magnification is given by:

$$M = \frac{4}{24} = \frac{1}{6} = 0.167$$

The magnification will be smaller than 1 if the image is smaller than the subject, and greater than 1 if the image is larger (i.e., "magnified").

See page 69

Note that these two formulas explain the special conditions that prevail when making a life-size (1:1) photograph.◁ If the image size is equal to the subject size, then I ÷ O = 1, the magnification, and, from formula (2), v must also be equal to u, since their ratio is also 1. Looking at formula (1), you will see that substituting u for v gives

$$\frac{2}{u} = \frac{1}{F}$$

or, u = 2F. Thus the subject distance must be equal to twice the focal length of the lens. Similar substitution of v for u gives v = 2F, the bellows extension required is also equal to twice the focal length.

Formulas (1) and (2) can be combined algebraically to yield two others, which facilitate certain calculations:

$$v = (M + 1)F$$

and

$$u = \left(\frac{1}{M} + 1\right)F$$

For example, you may need to know what focal length lens to use to produce a certain image size of a given subject. If you want to make a 5-inch-high image of a subject that is 2 inches high, using a camera with a maximum bellows extension of 14 inches, what focal length lens is required?

$$I = 5 \text{ inches}$$
$$O = 2 \text{ inches}$$
$$v = 14 \text{ inches}$$
$$F = ?$$

First, solve for M:

$$M = \frac{I}{O} = \frac{5}{2} = 2.5$$

Then solve the formula v = (M + 1) F for F:

$$14 = (2.5 + 1)F = 3.5F$$

$$\text{or } F = \frac{14}{3.5} = 4.$$

Thus the longest focal length you can use is a 4-inch (about 100mm) lens.

As another example, suppose you want to project 35mm slides on a screen that is 60 inches wide, using a 5-inch lens. How far away from the projector must the screen be?

In this case the image size, I, is 60 inches, and the subject is the slide, which is about 1.5 inches wide. Thus

$$I = 60 \text{ inches}$$
$$O = 1.5 \text{ inches}$$
$$\text{so } M = 40.$$

With a 5-inch lens, the distance from the lens to the image, v, can be found by solving

$$v = (M + 1)F$$
$$v = (41) (5)$$
$$v = 205 \text{ inches (about 17 feet)}.$$

Note that this assumes that the slides are all projected horizontally. If some are to be projected vertically, the height of the screen must be known and used as the desired image size in the same calculations.

Similar problems may arise involving the determination of the required focal length lens to make a certain size enlargement in the darkroom or in other special circumstances. I do not suggest that these formulas be commited to memory, but they may prove useful as reference information. You should have no difficulty using them, except where the lens is of retrofocus or telephoto design, in which case the nodal plane must be located and used in measuring all distances.◁

See page 68

Hyperfocal Distance and Depth of Field

Hyperfocal distance and the limits of depth of field can be calculated if special circumstances warrant it; usually it is sufficient to refer to the engraved depth of field scale on the lens barrel or to tables that accompany most lenses. The hyperfocal distance, H, is found by using the following formula:

$$H = \frac{F^2}{(f) (c)}$$

where F = lens focal length
f = f-number
c = diameter of maximum
circle of confusion

For typical lenses for 35mm cameras, the standard acceptable circle of confusion is usually about 1/750 to 1/1000 inch. Manufacturers of large-format lenses may use less critical standards for calculating depth of field scales, since the negative is usually enlarged less than small-camera negatives.

Once the hyperfocal distance is known, the limits of depth of field for any subject distance (u) are given by the following formulas:

The near limit of depth of field, $D_n = \dfrac{Hu}{H + u}$

The far limit of depth of field, $D_f = \dfrac{Hu}{H - u}$

These formulas will be found to be sufficiently accurate for use when the subject distances are large, but not for close-ups.

Index

References in italics refer to illustrations

Aberrations, lens, 7, 64, 74–75
 astigmatism, 77
 chromatic, 53, 75–76
 coma, 76
 curvature of field, 76
 distortion, 77
 focus shift caused by, 53
 spherical, 53, 75
Accessories, 163, 172–177
Achromat lenses, 75
Acutance, 73–74
Adjustments. *See* View camera
 adjustments
Aerial photography, 188
Alfred Stieglitz, New York (c. 1940), *14*
Alinder, James, *Savannah Saw Works*,
 177
Angle of view, and coverage, 54–55
Anticipation, 109–110, 120
Aperture, 16, 46–47
 adjustment for lens extension
 factor, 69
 calibration of, 66–67
 defined, 8, 46
 as factor affecting depth of field,
 49–50
 focus and, with tripod use, 136–139
 of mirror lenses, 61
 priority, 19
 scales for depth of field and, 50–52

Apochromat lenses, 75
Arca Swiss lens shade, 72
Aspens, New Mexico, *162*
Astigmatism, 77
Automatic exposure systems, 18–19
Automation
 defined, 2
 in small cameras, 10
Auto-wind mechanism, 18, 120
Averaging meter readings, 18
Axis tilt, 153
 See also View camera adjustments

Backs. *See* Camera backs
Back swings and tilts, 148–149
 See also View camera adjustments
Bag bellows, 34, 35, 59
Batteries, 167
Bellows, 34
 bag, 34, 35, 59
 for close-up photography, 180
 "double extension," 34
 extension factor, 34, 68–69
 folding or sag, 34–35, 146
 function of, 34
 lens tilt with, 65
 light leaks in, 35–36
 reflections, internal, 36–37
 shape of, 34–35

Blair Stapp, Artist (Moss Landing, California), 26
Boards of Thistles, San Francisco, 138
Bogen shutter tester, 92
Brassai, Yosemite Valley, 1973, 112
Bronica camera, 58–59
Brooks Veri-Wide camera, 184
Buckthorn Mountain, Tonquin Valley, Canada, 102
Bulb and air hose, for shutter operation, 91–92
Bullock, Wynne, *Sea Palms,* 135

Cable release, 39, 91, 173
Cadmium sulfide (CdS) cell, 165
Calumet exposure meter, 66
Camera, basic, 6–8
Camera adjustments. *See* View camera adjustments
Camera backs, 27
 and ground glass, 37–39
 for Polaroid film, 27, 37, 41
Camera cases, 172
Camera position, 96–97, 98
 with hand-held cameras, 113–114
 and subjective properties of lenses, 106–107
Canon cameras, 15
Cartier-Bresson, Henri
 Children Playing in the Ruins, 108
 The Decisive Moment (book), 109–110
Cascade, 81
Catadioptric (mirror) lens, 59–61
Center weighted exposure system, 18
Changing bag, 175
Chromatic aberration, 53, 75–76
Church, Santa Cruz, California, 155
Church and Road, Bodega, California, 94
Circle of confusion, depth of field and, 50
Cirkut camera, 183
City Hall, Monterey, California, 4, 5
Close-up photography, 69, 179–181, 187
Coated lenses, 47, 69–71
Coma, 76
Compur shutter, 82–83
Conservatory, Golden Gate Park, San Francisco, 156

Convergence, 98
 -control lenses, 65
 correction of, 106, 142–144, 148–149, 155
Converter lenses, 65, 66
Convertible lenses, 52, 64
Copal Square shutter, 84
Copy photography, 180–181
 lenses for, 64–65
Cottonwood Tree Trunk, Santa Fe, 60
Courthouse, Bridgeport, California, 150
Coverage, angle of view and, 54–55
Curvature of field, 76
Custom House Plaza, Monterey, California, 103, 104

Darkslides, 39–41
Dawn, Autumn, Great Smoky Mountains, 42
Dennis Purcell and Rails, San Francisco, 58
Density, 136, 147–148
Depth of field, 115, 139
 and circle of confusion, 50
 in close-up photography, 180
 defined, 48
 factors affecting, 48–49
 of fish-eye lens, 63
 focus and, 48–54
 and focus shift, 52–53
 and hyperfocal distance, 52, 115
 lens tilt and, 151
 of long focal length lenses, 59
 of mirror lenses, 61
 rule of thumb for, 51
 scales, 50–52
 of short focal length lenses, 57
 with single-lens reflex cameras, 15, 16
 with tripod use, 123, 133, 134
 with twin-lens reflex cameras, 23
Diaphragm, 7–8, 46
 automatic, 15, 16
 See also Aperture
Diffraction, 4–5, 74
Diffusion, lens attachments for, 64
Diopters, 66 and n, 74
Distortion, 77
"Dry-shooting," 107

Efficiency, shutter, 88–91
8 × 10 format, 3, 29, 190
 image size of, 46, 54
 See also Large-format cameras; View
 cameras
Electronic flash, 169–172
 synchronization for, 24, 86–88, 172
Electronic shutter, 25, 83
Electrostatic effects, elimination of, 40
Engraving, lenses for, 64–65
Enlargers, used in copy photography,
 181
Enlarging lenses, 64–65, 182
Exposure, 79–82
 filter factor, 169
 formula for, 80
Exposure meters, 163–167
 in automatic exposure systems,
 18–19
 batteries for, 167
 for close-up photography, 181
 for copy photography, 182
 elements of, 165
 focal-plane, 66–67, 136
 incident light, 166, 182
 reflected light, 166–167, 185
 spot, 164, 167
Exposures, time, 80, 123
 and reciprocity effect, 136
Extraocular imbalance, 113
Eyeglasses
 as aid to focusing, 137
 to correct extraocular imbalance, 113
 focusing problems for persons with,
 113, 115, 173–174

Factory building, San Francisco, 137
Field cameras, 33–34
Field compensation, 13, 23
Film holders, for view camera, 39–41
Film plane adjustments, depth of field
 and, 49
 See also View camera adjustments
Film speed, 81–82, 120, 133
Filter(s), 2, 167–169
 for aerial photography, 188
 clear glass, for lens protection, 120
 color-compensating, 168
 for copy photography, 182
 to correct focus shift, 53
 factor, 169

flare from, 72
 light-balancing, 168
 materials in, 168–169
 neutral density, 61
 polarizer, 72, 169, 183, 188
 skylight, 120, 168
 ultraviolet (UV), 76, 120, 168
 for underwater photography, 186
Fish-eye lenses, 63, 184
Flare
 and bellows reflections, 36–37
 reflections and, in lenses and filters,
 69–73
Flare (Colton Hall, Monterey,
 California), *70*
Flash
 electronic, 169–172
 synchronization with, 24, 86–88, 172
 for underwater photography, 186
"Flat bed" construction, of view
 cameras, 31–32
 camera adjustments with, 32–33,
 142, 158
Focal length
 and aperture, 46
 converter-lens effect on, 66
 and coverage, 54
 defined, 44
 as factor affecting depth of field,
 48–49
 and image management, 101–107
 of lenses, 44–46
 lenses, long, 59–61, 81, 101
 lenses, short, 57–59, 63, 157,
 158–159, 182
 of "normal" lens, 55–57
 in pinhole camera, 5
 and subjective properties of lenses,
 106–107
Focal-plane shutters, 10, 16, 25, 79,
 83–85
 care of, 93
 characteristics of, 85–86
 efficiency of, 90–91
 flash synchronization with, 86–88,
 172
Focus, focusing
 for close-up photography, 179–181
 cloth, 174
 defined, 48
 and depth of field, 48–54, 115

with hand-held cameras, 114–115
and hyperfocal distance, 52, 115
infrared, 53–54
magnifiers and aids, 17, 25, 136–137,
 159–161, 173–174
with pinhole camera, 4, 5
with rangefinder, 10, 11–15
and rear nodal point of lens, 44, 154,
 184
selective or differential, 139
shift, 52–53, 75
with single-lens reflex cameras, 17,
 26
with tripod, 136–139
zone, 115
See also Depth of field
4×5 format, 3, 29, 66
 image size of, 45–46
 Polaroid film/backs for, 41, 189–190
 See also View cameras
Front swings and tilts, 149–154
 See also View camera adjustments
f-stop. *See* Aperture

Gallium arsenide photocell, 165
Gas tank and signs, San Francisco, 62
Georgia O'Keeffe and Orville Cox,
 Canyon de Chelly, Arizona, 9
"Giant vision," 187
Gossen Luna-Pro meter, 165
Graflock system, 37, 41
Graf Variable lens, 64
Ground glass
 camera back and, 37–39
 image management with, 100
 in press cameras, 33
 in reflex cameras, 22, 25
 in view cameras, 30, 37–39, 146–147
Grounding, 40

Half Dome, Cottonwood Trees,
 Yosemite Valley, 28
Hand-held cameras, 109–110, 120–121
 equipment for, 119–120
 focusing with, 114–115
 holding technique for, 110–113
 position and viewpoint of, 113–114
 shutter speed with, 111, 116–119
Hasselblad cameras and equipment, 64,
 71, 93, 184
 lens hood, 169

single-lens reflex, 24, 25, 27
 for underwater photography, 185, 186
Hine, Lewis, *Carolina Cotton Mill,* 51
House, Hollister, California, 157
Hulls, San Francisco, 72
Hyperfocal distance, 52, 115

Illumination fall-off, 68, 147–148, 149
Image circle, of view cameras, 54–55
Image formation, of lenses, 44–46
Image management, 95–96
 and anticipation, 109–110
 and camera position, 96–97, 98
 defined, 3, 95
 by exploring the subject, 96–101
 by interchanging lenses, 101–107
 and parallax effect, 100–101
 and perspective, 98
 and subject distance, 97–100, 103
 and subjective properties of lenses,
 106–107
 with tripod use, 123
 and viewfinder, 100–101
 and visualization, 3, 95–96
 See also Visualization
Incident light meter, 166–167, 182
Inertia, of focal-plane shutter, 84–85
Infrared focus, 53–54
Insurance, 177
Intensity, of light, 67–68, 79–80, 181

Landscape, perspective in, 98
Large-format cameras, 29–31
 advantages and disadvantages of, 29
 field cameras, 33–34
 film size for, 29
 press cameras, 33
 technical cameras, 33
 types of, 31–34
 visualization with, 29–31
 See also View cameras
Lartigue, Jacques Henri, *Grand Prix of*
 the Automobile Club of France,
 1912, 85
Lead foil bags, 176
Leaf shutters, 79, 82–83
 characteristics of, 85–86
 efficiency of, 88–90
 flash synchronization with, 86–88,
 172
 in single-lens reflex cameras, 24–25

Leica cameras and equipment, 13, 15
Leitz lens shades, 71
Lensboards, 34, 39, 59, 141–142
Lens cap, 79, 119–120
Lens(es), 43
 aberrations, 74–77
 for aerial photography, 188
 angle of view of, 54–55
 aperture, 46–47
 aperture calibration, 66–67
 in basic camera, 6–7
 cleaning equipment, 176
 coating of, 47, 69–71
 convergence-control, 65
 converter, 65
 convertible, 52, 64
 coverage, 54–55, 142
 and depth of field, 48–54
 enlarging, 64–65, 182
 extension (bellows) factor, 68–69, 181
 fish-eye, 63, 184
 and flare, 69–73
 focal length of, 34, 44–46, 48–49
 focus of, 48–54
 and focus shift, 52–53
 image formation by, 44–46
 interchangeable, 10, 13–15, 23,
 101–107
 long focal length, 59–61, 81, 101
 "macro," 57, 63, 69, 179–181
 normal, 55–57
 perspective-control, 65, 139
 portrait, 64, 106–107
 process, 43, 64–65, 182
 rear nodal point of, 44, 154, 184
 and reflections, 69–73
 resolution, 73–74
 shades, 36, 71–73
 "sharpness," 73–74
 short focal length, 57–59, 63, 157,
 158–159, 182
 soft-focus, 64
 subjective properties of, 106–107
 supplementary, 65–66, 179
 symmetrical, 64
 telephoto, 59, 154
 types of, 55–66
 for underwater photography, 185
 wide-angle, 11, 54, 57–59, 182–184
 zoom, 17, 61, 71, 101–103, 117
Levels, 175–176, 183

Light, intensity of, 67–68, 79–80, 181
Light leaks (bellows), 35–36
Linhof tripod, 126
Long focal length lenses, 59–61, 81, 101
Luminances, subject, 79–80, 166–167
Lupe, magnifying, 137, 159–161,
 173–174

"Macro" lenses, 57, 63, 69, 179–181
Majestic tripod, 125
Mamiya cameras and equipment, 23
Mariposa Courthouse, California, 97
Medium-format cameras, 21
 film size for, 21
 focusing aids for, 25, 174
 holding technique for, 111
 Polaroid film for, 189
 shutter care of, 93
 single-lens reflex cameras, 24–27
 twin-lens reflex cameras, 22–23
 types of, 22–27
 visualization with, 21
Microprisms, as focusing aid, 17
Mirror, in reflex system, 16, 17, 24–25,
 58, 180
Mirror (catadioptric) lens, 59–61
Mission San Xavier del Bac, Tucson,
 122
Model release forms, 177
Monochromatic color filter, 76
Monopods, 127
Monorail construction, of view
 cameras, 31, 33, 35
 camera adjustments with, 32,
 157–158
Monument Valley, 152
Moon and Half Dome, Yosemite
 Valley, 20
Mormon Temple, Manti, Utah, 128
Motion, subject, 57–58, 85–86,
 116–119, 133–135, 183–184
Motor drive, for 35mm cameras, 18,
 120
Mount Williamson, from Manzanar,
 California, xiv

Neutral density filter, 61
Nikon cameras and equipment, 15, 65,
 66, 184–185, 186
Notebook, 174–175

Old Faithful Geyser, Yellowstone National Park, 78

Packard shutter, 83
Panchromatic film, filters for, 167–169
Panning, 118–119, 188
Panon cameras, 183
Panoramic photography, 126, 182–184
Parallax problem, 13, 15, 23, 136
 and image management, 100–101
Pentax cameras and equipment, 24, 165, 187
Perspective, 106, 139
 -control lenses, 65, 139
 in image management, 98
 See also Convergence
Photojournalism, 114
Photomacrography, 17, 63
 See also Close-up photography
Photomicrography, 63
Pine Forest and Snow, Yosemite Valley, 38
Pinhole camera, 3–6, 44
Polarizer filter, 72, 169, 182, 188
Polaroid Land cameras and materials, 33, 118, 119, 182, 188–190
 adapter backs, 27, 37
 for check of camera adjustments, 161
 film holders, 39, 41
 visualization practice with, 2
Portrait lenses and portraiture, 33, 64, 106–107, 110
Portuguese Church, Davenport, California, 62
Pre-exposure, 71
Pre-focusing, 115
Press cameras, 33
Prism, in reflex optical system, 16, 23, 25–26
Process lenses, 43, 64–65, 182
Pronto! camera, 190
Protar lens, 82
"Pseudo stereo," 187

Quick-Set tripod, 125

Rail Fence, Thistle and Teton Range, Wyoming, 140
Railroad tracks, 145
Rangefinder, 11–15, 33
 defined, 10, 11

Reciprocity effect, 81, 136
Reflected light meter, 166–167, 185
Reflections, and flare, 69–73
Refraction, 74
 defined, 44
Refractive index of water, 185
Remote controls, for shutter operation, 92
Resolution, 73–74
Resonant vibration, camera-tripod, 126, 131
Retrofocus design, in short focal length lenses, 58
Rice Silos, Sacramento Valley, 159
Rising, falling, and sliding adjustments, 65, 141–148, 156
 See also View camera adjustments
Rocks, Alabama Hills, California, 132, 134
Rollei cameras and equipment, 22, 23, 26, 65
Roots, Hawaii, 154

Sand Dunes, Sunrise, Death Valley National Monument, California, ca. 1948, frontispiece
Scales, depth of field, 50–52
Scheimpflug Rule, 149
Schneider Symmar lenses, 64
Selenium cell, 165
Self-timer, for shutter operation, 92
Sentinel Rock and Pine Tree, Yosemite Valley, 99
"Sharpness," 73–74
 with pinhole camera, 4–5
Short focal length lenses, 57–59, 63, 157, 182
 and "wide-angle distortion," 158–159
Shutter(s), 7, 79
 calibration of, 92
 care of, 93
 characteristics of, 85–91
 efficiency of, 88–91
 electronic, 25, 83
 evolution of, 79
 and exposure, 79–82
 and flash synchronization, 86–88
 operation of, 91–92, 119
 testers, 92
 types of, 82–85
 See also Focal-plane shutter; Leaf shutter

Shutter speed(s), 24, 80–82
 adjustment for lens extension factor,
 69
 in aerial photography, 188
 and film speed, 120
 with hand-held cameras, 111,
 116–119
 with long focal length lenses, 81
 with moving subjects, 116–119, 133,
 135
 priority, in automatic exposure
 system, 19
Sig-Tec shutter tester, 92
Silicon-blue photocell, 165
Sinar shutter, 83
Sinarsix exposure meter, 66, 136
Single-lens reflex cameras, 10
 close-up photography with, 180–181
 holding technique for, 111, 113
 lenses for, 10, 58–59, 61
 medium-format, 24–27
 mirror vibration in, 17, 24–25, 119,
 180
 small-format, 15–18
Skylight filter, 120, 168
Small-format cameras, 9–10
 automatic exposure systems for,
 18–19
 lenses for, 57, 61, 69
 35mm format, 10–18
 view camera compared to, 9
 See also 35mm cameras
Smith, W. Eugene, 109
Softar soft-focus attachments, 64
Soft-focus lenses, 64
Sonar camera, 190
Spherical aberration, 53, 75
Spot reading meter, 18, 164
Stereoscopic photography, 186–187
Stream, Sea, and Clouds, Rodeo
 Lagoon, California, 160
Subject
 distance, 48–49, 97–100, 103,
 106–107
 image management and, 96–101
 motion, 57–58, 85–86, 116–119,
 133–135, 183–184
Supplementary lenses, 65–66, 179
SX-70 system, 190
Symmetrical lenses, 64
Synchronization, with flash, 24, 86–88,
 172

Technical cameras, 33
Telephoto lens, 59, 154
35mm cameras, 10–18
 holding techniques for, 111
 image size with, 45
 motor drive or auto-wind for, 120
 panoramic lenses for, 183
 perspective-control lenses for, 65, 139
 shutters used with, 10
 for underwater photography, 184–185
 visualization with, 3
 See also Single-lens reflex cameras;
 Viewfinder cameras
Tilt-All tripod, 125
Tilts
 back swings and, 148–149
 front swings and, 149–154
 See also View camera adjustments
Time exposure, 80, 123
Train, near Salinas, California, 118
Tripod(s), 123–124, 155
 accessories, 127
 camera settings, 133–139
 care of, 129
 center post, 125–126
 for close-up photography, 180
 focus and aperture with, 136–139
 head, 126–127
 and large-format cameras, 29
 legs, 124–125
 and long focal length lenses, 59
 and monopods, 127, 133
 with panoramic camera, 183
 positioning of, 129–131
 and reciprocity effect, 136
 resonant vibration of camera and,
 126, 131
 selection of, 123–124
 and slow shutter speeds, 118
 and subject motion, 133–135
 use of, 129–133
 weight of, 126–127, 131
"t-stops," 47
Twin-lens reflex cameras, 22–23

Ultraviolet (UV) filters, 76, 120, 168
Ultrawide-angle photography, 182–184
Underwater photography, 184–186

View camera(s), 31–33
 aperture calibration of, 66–67
 bellows, 34–37

camera backs, 37
close-up photography with, 180
components of, 34–41, 141
construction of, 31–32
convertible lenses for, 64
film holders for, 39–41
filter type recommended for, 168–169
focusing cloth for, 174
focusing magnifiers for, 173–174
focus of, 136–137
ground glass in, 37–39
image circle of, 54–55
leaf shutter for, 83
lensboards for, 39
lens extension with, 68
lens shades for, 72–73
locks for camera back of, 33
long focal length lenses for, 59, 154
short focal length lenses for, 59
small-format cameras compared to, 9
symmetrical lenses for, 64
visualization with, 3
View camera adjustments, 32–33, 65,
 141
 back swings and tilts, 148–149
 convergence controlled by, 106,
 142–144, 148–149, 155
 as factors affecting depth of field, 49
 front swings and tilts, 149–154
 illumination fall-off, 68, 147–148
 and image circle, 54–55
 rising, falling, and sliding, 65,
 141–148, 156
 use of, 155–161
 vignetting, 146–147
 "wide-angle distortion," 158–159
Viewfinder cameras, 10, 11–15
 holding technique for, 113
 in image management, 100–101
 interchangeable lenses with, 13–15
 large-format, 30
 and parallax problem, 13, 15, 23,
 100–101, 136
 and press cameras, 33

Viewpoint, with hand-held cameras,
 113–114
Vignetting, 6, 72–73, 146–147
 avoidance of, with lens tilt, 151–152
 caused by bellows sag, 34–35, 146
 checks for, 157, 158, 159, 161
Visualization, 1–3, 100
 with basic camera, 6–8
 black cut-out card for, 104
 defined, 1
 "dry-shooting," 107
 image management and, 3, 95–96
 with large-format cameras, 29–31
 with medium-format cameras, 21
 pinhole camera and, 3–6
 with Polaroid film, 2
 See also Image management
Voigtlander process lens, 43

Water, photography of, 134–135
 See also Underwater photography
Waterhouse stops, 46
Weston, Edward, 36
Weston Master meters, 165
"Wide-angle distortion," 158–159
Wide-angle lenses, 11, 54, 57–59,
 182–184
Widelux camera, 183
Wind, subject motion caused by, 133,
 134
Wooden Shutters, Columbia Farm, Los
 Angeles, 130
Wratten filters, 2, 76
Wynne Actinometer, 164

Yosemite Falls and Azaleas, 56

Zeiss cameras and lenses, 43, 63, 64,
 184
Zone focusing, 115
Zone System, 85, 115, 167
Zoom lenses, 17, 61, 71, 101–103, 117